1.00

Andy Grundberg

A FIRESIDE BOOK
PUBLISHED BY SIMON & SCHUSTER INC.
NEW YORK LONDON TORONTO SYDNEY TOKYO

GRUNDBERG'S
GOOF · PROOF
PHOTOGRAPHY
G U I D E

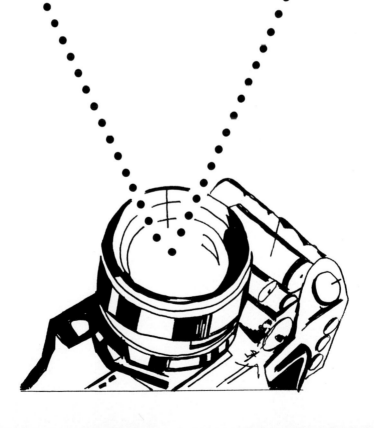

Fireside
Simon & Schuster Building
Rockefeller Center
1230 Avenue of the Americas
New York, New York 10020

Designed by Marysarah Quinn
Manufactured in the United States of America

1 3 5 7 9 10 8 6 4 2

Library of Congress Cataloging in Publication Data

Grundberg, Andy.
Grundberg's goof-proof photography guide / Andy Grundberg.
p. cm.
1. Photography. I. Title. II. Title: Goof-proof photography
guide.
TR145.G78 1989
771—dc20 89-35554
 CIP
ISBN 0-671-67291-6

To my father,
the first photographer I ever knew,
and my mother,
who now has a camera of her own

PICTURE CREDITS

ACKNOWLEDGMENTS

I would like to thank all my colleagues in the photographic press: Julia Scully, who gave me my start; Herbert Keppler, who taught me more than I can remember about cameras; and all my friends who until recently labored at *Modern Photography*, whose counsel has been invaluable over the years. At *The New York Times*, Michael Leahy, Constance Rosenblum, and Joan Faust have been supportive beyond the call of editorial necessity, as was Jack Schwartz when I started writing the paper's camera column three years ago.

Among the many representatives of photographic manufacturers who helped by supplying information and illustrations, my special thanks to Michael Sullivan of Eastman Kodak Company, Betsy Kommer of Leica U.S.A., Joel Samberg of Olympus Corp., Arthur Nolan of Pentax, Inc., Joe Strear on behalf of Nikon Inc., Norman Steen on behalf of Chinon, Inc., Stephen R. Brown on behalf of Yashica Inc., Tina Williams on behalf of Fuji Photo Film Co., Inc., Phyllis Cohen on behalf of Agfa, Inc., Jean Doynow on behalf of Ricoh Corp., James MacLean on behalf of Minolta Corp., and Terry Shea on behalf of Canon U.S.A.

An author could not ask for a more gifted and knowledgeable illustrator than Frank Schwarz, whose drawings make clear some of my more abstruse passages. Nor could I ask for a more sympathetic and enthusiastic editor than Cindy Lao, who has guided this book to its present form.

Table of Contents

Introduction

Chances are you're one of these kinds of people:

- You are about to buy a camera for the first time, and you want to know something about how to use it to take pictures. Or you could be holding that first camera in your hands right now, but you're not sure how it works.
- You already have a camera you know how to operate, but you aren't totally satisfied with the pictures you're getting back from the lab. You want to know how to get better pictures and whether that means you need to spend money on a more sophisticated and expensive camera.
- You're a photographer ready to expand your horizons, "trading up" from a relatively simple, inexpensive camera to one that offers more versatility and creative control. You probably feel frustrated by the limited features of your present camera, yet are anxious about taking the step toward "serious" photography, which has always seemed steeped in mysterious technical lore and forbidding instruction manuals.

• You are an experienced hand at photography—the proud owner of a single-lens-reflex camera, electronic flash unit, tripod, filters, and all the rest. The technical side of photography doesn't faze you, but you're wondering whether the new automatic-focusing cameras you've been hearing about will give you better pictures than you're getting now—and whether they're worth the price.

If you fit into one of these categories, this book should prove useful to you. At least I've tried to appeal to people who face problems like those outlined above. But before you turn the page and find out exactly what's in store, let me tell you what this book isn't.

This is not a textbook about photography. There are plenty of those already, and by and large they are excruciatingly boring. They start out telling us about things such as how to load film onto developing reels and then go on to even more exciting topics such as color theory and lens construction. They are written very, very seriously and are very, very dry. Believe me, I've fallen asleep over some of the best of them.

Today, most camera owners have very little reason to develop their own film—most (more than 95 percent, anyway) shoot in color, and when the roll is done it goes off to the drugstore or directly to a processing lab—so I'm not going to belabor film development. What I am going to attempt to do is acquaint you with some of photography's immutable first principles without boring you to tears. I'll mention theory only when it relates to everyday practice, and if I think you're about to doze off in the back of the room, I'll tell a joke.

I'll focus on 35-millimeter cameras throughout because 35-millimeter film is the format of our time. Cameras that are designed for 35-millimeter film outsell all other kinds of cameras combined. They are used to take snapshots of vacations and graduations and to take pictures for magazines, newspapers, and annual reports. As explained in Chapter One, they fall into two broad categories, one of which you probably own (or will own).

This is not a book about how to win prizes at the local camera-club competition. I'm a firm believer in self-improvement,

but I'm not a fan of "how to" books that tell you your pictures will be better if you learn some "rules" of composition. If you want to improve your pictures artistically rather than technically, look at pictures: go to museums, buy books full of photographs, take courses and workshops with photographers you admire. If, on the other hand, you want to know why your pictures of snow turned out gray or why Aunt Harriet and Uncle Bill are out of focus, you're in the right place.

I've tried to keep things as simple as possible because I know many people are afflicted with technophobia. They just can't deal with any kind of mechanical or electronic apparatus. I have friends who are so disconcerted by machinery that they start sweating every time they have to wind their watches. And cameras are even worse: they have dials and buttons and doors that swing open at the press of a latch. Brrrrr . . . it's enough to make the skin crawl.

To make things worse, many camera makers and journalists in the photo trade engage in a mystifying "camera speak" guaranteed to turn off ordinary folks. Does your SLR have an LCD that warns of insufficient TTL flash or maybe a plain ordinary LED? Do multipattern metering and multiprogram auto exposure have anything to do with you—or each other? It's getting so that you need a course in photo jargon as a prerequisite for learning about photography itself.

It's my hope (and sometimes my pride) to be understandable. The book is arranged so that as concepts are introduced they are spelled out and explained. For those of you who like to skip around, the more difficult photographic terms appear in boldface type when they are first mentioned.

In photography, technology changes quickly. New cameras are introduced every couple of months, along with new lenses, flash units, and all the rest. The principles of photography, however, remain constant. That's why I've arranged the book to cover the basic camera functions first, then I move on to examine film types, lenses and other accessories, camera care, and a variety of shooting situations. There's even a quick quiz to test how expert a photographer you really are.

The end of the book is devoted to a selective and admittedly subjective guide to cameras on the market as of this writing. You

won't find a discussion of every camera under the sun (there are hundreds) because I've tried to select models representative of different camera types, functions, and features. I'll also discuss new and innovative models that might appeal to readers of this book. But before you decide on what camera is for you, "try on" a few at the camera shop. For many, the ideal camera is the one that feels the best when it's being used.

Well, enough warming up. Let's go take a look at photography from the inside out!

ONE

Cameras: What They Do and How They Do It

Simple wooden boxes, brass lenses, and glass plates have metamorphosed into the auto-exposing, auto-focusing, auto-just-about-everything cameras of today. A word or two about apertures and shutter speeds, the battle between the point-and-shoots and the single-lens-reflexes, and a new contender.

Today, taking pictures is simple.

Compared to what the first photographers had to put up with 150 years ago, our lives are easy. We buy film, stick it in a recess in the back of a camera, close the hatch, and fire away. The most strenuous part of the whole process is waiting for the pictures to come back from the processing lab.

But the photographers of yore, who had to coat their own emulsions on heavy glass plates and develop their negatives on the spot, had one advantage over us: they knew photography inside out. Mostly by trial and error, they learned what their equipment could do and what it couldn't, and they figured out how to make adjustments to ensure that their negatives would produce decent-looking pictures.

Today, both the fuss and bother and the trial and error have

been removed from the process of picture taking. Practically anyone can take a picture with one of today's electronic cameras. Three steps are essential to taking a picture: loading the film, focusing, and making the exposure. And today's 35-millimeter cameras—the format used by practically all amateur and most professional photographers—handle all three steps automatically.

Of course, if this were all there was to successful photography, this would be a very short book.

The evolution of the modern 35-millimeter camera is one of the success stories of twentieth-century technology. The benefits have been enormous, with more and more people taking better and better pictures, often without knowing the first thing about the cameras they're using. But electronic systems have not replaced the essential functions of cameras; they've only substituted for or elaborated on them. And they haven't yet eliminated the one essential ingredient of all good photographs: the photographer.

Unfortunately, relatively few photographers understand exactly how these cameras produce pictures. The cameras are making decisions for us—about how light or dark the pictures will be, about what will be in sharp focus—and we rely on them to get things right. When they don't, we figure it's the camera's fault. It isn't. It's ours because we haven't bothered to learn enough about our cameras, lenses, and other equipment to know when a picture is going to turn out fine or, if it won't, what we can do about it.

To understand how to get better pictures more consistently, we need a better understanding of how the processes of photography work. To start our journey, let's go back to the early days of photography and work our way forward, looking at how cameras have accomplished their straightforward tasks. Along the way you'll be introduced to some of photography's most basic principles.

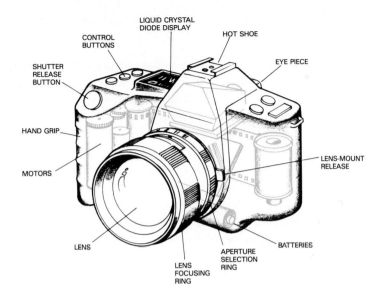

LIQUID CRYSTAL
DIODE DISPLAY

HOT SHOE

CONTROL
BUTTONS

EYE PIECE

SHUTTER
RELEASE
BUTTON

HAND GRIP

LENS-MOUNT
RELEASE

MOTORS

LENS

BATTERIES

APERTURE
SELECTION
RING

LENS
FOCUSING
RING

A typical 35-millimeter camera of single-lens-reflex (SLR) design. The controls and features shown are explained later in this chapter. (Some may be absent on all-automatic cameras, including point-and-shoot models.)

IN THE BEGINNING

Cameras are basically light-tight little boxes with an opening at one end and a light-sensitive emulsion at the opposite end. The word camera comes from Latin and literally means "room," so to start with, think of cameras as dark little rooms that produce pictures.

The light-sensitive emulsion placed inside cameras is, in our day and age, known as **film**. In the case of 35-millimeter cameras, the film is a length of thin, flexible plastic coated on one side with several layers of chemicals spread evenly across the surface. When this emulsion is exposed to light coming through the camera, a **latent image** is formed. When the film is taken out of the camera and developed, the image is no longer latent, it is permanently (more or less) visible to the naked eye.

The sides of 35-millimeter film are lined with sprocket holes. These are used to advance the length of film about an inch and a half after every exposure so that consecutive shots don't overlap.

(Originally, these sprocket holes served to advance the film inside a movie camera, since the 35-millimeter format was first used in making motion pictures.) The film comes loaded in light-tight cartridges in lengths that usually provide for 12, 24, or 36 exposures.

Lenses are what make an identifiable image out of the light that enters the camera and strikes the film. Lenses are collections of glass (and sometimes plastic) pieces shaped and assembled so they can focus light on the film. Think of lenses as middlemen between the world in front of the camera and the film inside it. A point of light outside the camera enters the lens, gets bent around and turned upside down, and emerges at the film plane as a point of light.

To make sure the light hitting the film is a point and not a fuzzy-edged cone of light, the distance between the lens and the film has to be adjusted by a process known as **focusing**. How much focusing adjustment is needed depends on the distance of the subject from the lens. In some cameras the lens-to-film distance is adjusted by expanding or contracting the depth of the camera itself; in 35-millimeter cameras, however, only the lens moves.

In the mid-nineteenth century, when photography was still in its infancy, that's all there was to a camera: a light-tight box that could be lengthened or shortened, accordion fashion, with a lens in front and a plate coated with gooey chemicals at the back. To take a picture, early photographers simply uncapped the lens, counted to ten, and then put the cap back on.

THEN CAME APERTURES, SHUTTER SPEEDS, AND FOCUSING SYSTEMS

Things are no longer this simple. To regulate the amount of light entering the camera through the lens, two controls have been added: a **lens diaphragm** and a **shutter**. The diaphragm consists of several interconnected blades that can be adjusted to make bigger or smaller openings within the lens. The "hole" that the blades form in the middle of the lens is called the **aperture**. Its size

is adjusted in **f-stops,** or just plain "stops," represented by rather peculiar numbers: f/2.8, f/4, f/5.6, f/8, f/11, f/16, and so on. Math majors may recognize that these numbers form a logarithmic series, but I won't bore the rest of you with the intricate details about how they came to be this way. Let's just remember two things for now:

1. The lower the number, the wider the lens opening.
2. Going up the scale (from a low number to a higher one), each stop lets through only half as much light as the one before it. Going down the scale (from a high to a lower number), each stop lets through twice as much light. In other words, an aperture of f/4 lets in half as much light as f/2.8 because it forms a smaller hole. An aperture of f/8 lets in twice the light as f/11 because it represents a larger hole. Easy, huh?

Shutters, which are either in the lens or in the camera itself, regulate the length of time that light is allowed to strike the film. Some use blades **(leaf shutters)**, and some use curtains **(focal-plane shutters)**. Some have gears and some have fancy electronics to time their operations, but all are essentially blackout devices with the ability to open and close very rapidly. Their speeds are represented in a much more straightforward manner than lens apertures: 1, ½, ¼, ⅛, ¹⁄₁₅, ¹⁄₃₀, ¹⁄₆₀, ¹⁄₁₂₅, and so on. You'll notice that this is a simple arithmetical series representing a second and fractions of a second.

Let's remember two things about shutters:

1. The smaller the fraction of time, the less light that hits the film.
2. Going from one fraction of a second to the next smaller fraction in the series halves the exposure. Going from one fraction to the next larger one in the series doubles the exposure.

Here is the important point of the discussion: lens apertures and shutter speeds, each of which governs the amount of light hitting the film, have a direct, one-to-one correspondence or relationship. An extra "stop" of light coming through the lens aperture is exactly equivalent to doubling the shutter speed, so "stopping down" the

lens one stop is the same as choosing the next fastest shutter speed *in terms of exposure.* In short, then, lens apertures and shutter speeds work together to control **exposure,** which we can think of as a combination of the intensity and the duration of light striking the film.

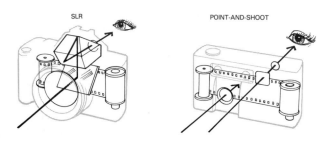

A single-lens-reflex camera (left) is designed so that you view the subject through the lens, just as it will appear on film. Point-and-shoot cameras (right) work differently, using a separate optical system for viewing.

As cameras evolved into modern mechanical devices, focusing methods also changed. Instead of the camera expanding or contracting, the lens now does the focusing. By turning a ring on the lens barrel, photographers can adjust the distance of the lens's glass elements from the film plane. When a lens is focused at a subject 10 feet away, it sticks out more than when it is focused at the clouds.

How we look into the camera and sight our subject has changed, too. Early photographers had to frame and focus using the upside-down image projected directly by the lens. Some cameras still work this way, but far more familiar to us are those with **viewfinder** or **reflex** viewing. A viewfinder is a separate, windowlike lens that projects an image of the subject at which the lens is pointed. It approximates what the image will look like on film. A reflex system, by comparison, is far more accurate since it uses a series of mirrors to reflect the image entering the camera up to a viewing screen.

The two viewing systems entail two distinct ways of arriving at

precise focus. Since a reflex system projects the image as it appears through the lens, focusing can be judged more or less directly by observing the image on the viewing screen. With a viewfinder system, however, a separate optical system is used, called a **rangefinder**. The differences between these two systems will be examined at length later in this chapter.

INTRODUCING . . . THE MODERN SINGLE-LENS REFLEX

When I first started photographing, I used an Argus C3 camera. It was shaped like a box of kitchen matches, but it was built like a tank. It used 35-millimeter film—the most popular size today—and boasted a number of "modern" features: lenses that could be taken off and on, a rangefinder for focusing, and a self-timer for putting yourself in the picture. Nevertheless, it was a chore to use. It had no built-in exposure meter so I had to carry a separate meter, transferring its readings to the camera for each exposure. Its rangefinder was in a separate window next to the viewfinder, which required considerable head wagging when framing and focusing. To wind the film I had to turn a knurled wheel while holding a catch out of the way. Rewinding was even slower, the film counter had to be reset with every roll of film, and changing lenses required major disassembly of the front of the camera.

The Argus C3 was an up-to-date camera in the 1940s but not in the 1960s, so once I had the photography bug I bought myself the best, most modern camera I could afford: a Minolta SRT-101. My Minolta was fairly typical of the cameras of its day, designed to appeal to the plump midsection of the advanced-amateur market. It, too, used 35-millimeter film, but it had a through-the-lens reflex viewing system and offered a range of interchangeable lenses that twisted on and off. This was hot stuff in 1968, at a time when much of the world was shooting snapshots with 126 Instamatic film, the diminutive "amateur" format that Kodak introduced in 1963.

Compared to today's cameras that do practically everything for the photographer—including, on a few models, clicking the

shutter—my SRT-101 is a real relic, but many of its features have since become standard. For instance, it has a built-in **exposure meter** that is coupled to both the shutter speed and the aperture. Turning either the shutter dial or the aperture ring moves a pointer inside the viewfinder; when the pointer lines up with the meter needle, the recommended exposure is set. To achieve this, the lens mount includes a lug that links the camera body and the aperture ring.

The Minolta's shutter is of the focal-plane design common to 35-millimeter reflex cameras, with adjustable speeds of from 1 second to $1/1000$ second, plus a "bulb" setting for longer exposures. When it was new, its $1/1000$ second "top speed" was about as fast as shutters were able to perform. The shutter was also designed to synchronize with an electronic flash unit at all speeds up to $1/60$ second.

AND NOW, FRIENDS, THE ELECTRONIC MARVELS OF TODAY

But that is ancient history compared to the cameras now available. No longer do you have to turn a ring on the lens or a dial atop the camera body to get proper exposure. No longer do you have to rely on rangefinders and other focusing aids to get sharp pictures. You don't even have to know how to wind the film to the next frame anymore. All of these functions and more can now be taken care of electronically.

In essence, cameras have gone from being all-mechanical instruments to being electromechanical ones, chock-full of micro-chips, miniature motors, circuit boards, and blinking red lights. Some even have the effrontery to talk to you while you're lining up a shot, letting you know, for example, when there's not enough light for a sharp exposure.

You might compare today's 35-millimeter cameras to the latest crop of automobiles. They both remain largely mechanical in some primary functions, but they are both increasingly dependent on electronic controls. Just as some cars won't start until you've put the transmission in neutral, some cameras won't fire until the

subject is in focus. All the technology in today's cars hasn't done away with driver's licenses, however—we still need to know how to move them down the road without running into things. In the same way, electronic automation in cameras hasn't replaced photographic know-how.

Now that that's off my chest, let's take a close look at the *kinds* of 35-millimeter cameras in use today.

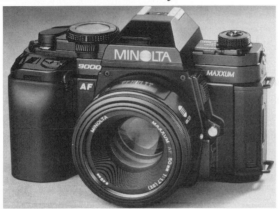

A modern example of an auto-focus single-lens-reflex camera, the Minolta Maxxum 9000. Besides having the latest electronic controls, it is distinguished by its interchangeable lens mount, focal-plane shutter, and direct, through-the-lens viewing of the image.

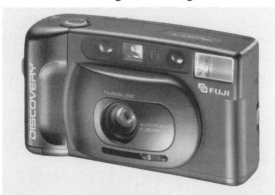

A typical "auto-everything" point-and-shoot camera, the Fuji Discovery 60, intended for casual snapshooting. It has a separate viewfinder, a leaf shutter, and fewer controls than a single-lens-reflex.

Generally speaking, there are two basic types of 35-millimeter cameras: **single-lens-reflex** cameras (often abbreviated SLRs), which let you compose, meter, and focus using the image provided by an interchangeable-mount lens, and **point-and-shoot** (also known as lens/shutter) cameras, which have separate viewfinders located above and to the side of their fixed-mount lenses. Point-and-shoot cameras generally have leaf shutters that are built into the lens; SLRs generally have focal-plane shutters located deep within the camera body, next to the film.

With both types of cameras, the trend has been toward increasing automation and sophistication. SLRs now feature automatic focusing and exposure, both of which are tied in with automatic control of an electronic flash. Point-and-shoots have started sporting zoom lenses, just like their more expensive and more versatile cousins. Despite these advances, however, the two types have remained quite distinct.

Point-and-shoot cameras—which I also like to call "auto everything" cameras—have revolutionized amateur photography in the last decade. Their popularity reinvigorated both the camera industry and sales of 35-millimeter film. They spelled the end of Kodak's cassette-style Instamatic formats and had a great deal to do with the sales decline of the same company's Disc film and cameras. Two things have made point-and-shoots so successful: they produce high-quality pictures because they use a larger film format than Kodak's Instamatic and Disc cameras, and they make taking a picture a one-step affair.

Before point-and-shoots, snapshot photographers didn't like 35-millimeter film because it had a long tongue that had to be stuck into a small slot on a take-up spool and then wound up before closing the back. This was *complicated*. But point-and-shoot cameras pioneered the idea of **auto loading**—stick the tongue across the film gate, close the back, and *whir*. . . you're ready to take the first picture.

Before point-and-shoots, 35-millimeter film had to be rewound at the end of the roll. Darned *inconvenient*! So these cameras have motors that not only wind the film as you expose it but also rewind it when the roll is used up.

Focus? Adjust shutter speeds and apertures? Snapshooters

don't want the hassle of dealing with technical stuff. Too *intricate.* So point-and-shoot cameras have automatic focusing, automatic exposure, and when there's not enough light, automatic flash. You can see why people started buying point-and-shoots like hotcakes. And not just snapshooters bought them; as word got out, even grizzled old pros and autophobic photographers like myself latched onto them, "just for fun."

(Until point-and-shoot cameras came along, the alternative to an SLR was called a rangefinder camera. It featured a separate viewfinder, like today's point-and-shoot cameras, that was integrated with a rangefinder, the optical device used for focusing. When the two images displayed by the rangefinder exactly overlapped or lined up side by side, the subject was in focus. As in the legendary Leica M series, such a system provided for quick and quite speedy framing and focusing, but it was completely manual— no auto exposure, no auto wind and rewind, no auto flash. Rangefinders, R.I.P.)

Today, you can buy point-and-shoot cameras that are a tad more complicated than they used to be. Take lenses, for example: a standard or "normal" lens on a point-and-shoot usually has a **focal length** of from 50 to 38 millimeters. (Focal lengths are calculated according to some pretty serious optical formulas; suffice it to say here that it's a way of judging how much a lens will magnify or shrink a scene.) This kind of lens is fine for most snapshot purposes; however, some photographers think longer lenses (that is, ones with focal lengths greater than 50 millimeters) produce better portraits.

But remember, the lens that comes with a point-and-shoot camera is the only lens you have. You cannot twist them on and off as you can with an SLR. The solution? Manufacturers have designed twin-lensed point-and-shoots with one "semi" wide-angle lens and one "sort of" telephoto lens built in. You simply flip a switch to swing one lens or the other in front of the film.

Pentax, when it introduced the IQ Zoom, did the twin-lensed camera one better. As its name suggests, the IQ Zoom has a built-in **zoom lens**—the first point-and-shoot to have one. Again, you flip a switch on the camera and the lens zooms from a moderately wide-angle view to a fairly compressed or telephoto view. As with

all zoom lenses, you get not just the shortest and longest focal lengths but every focal length in between. In other words, you can adjust the lens continuously from wide-angle to telephoto settings. The viewfinder adjusts its field of view at the same time. Needless to say, virtually every camera maker now has a zoom-lensed point-and-shoot in its lineup.

If point-and-shoot cameras are best summed up by the word "fun," the word for SLRs is "versatile." They take a great variety of lenses. Their exposure systems can be as automatic as a point-and-shoot or controlled completely by the photographer. They can focus on an ant or take pictures of the moon through a telescope. They've been around for about fifty years, which tells you something about both their adaptability and their reliability.

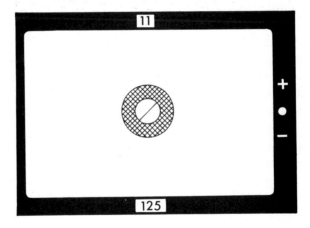

The focusing screen of a conventional, manual-focusing SLR, showing two central focusing aids—a split-image rangefinder surrounded by a microprism collar and, outside the image area, windows that indicate the aperture and shutter-speed settings. Obviously, auto-focusing cameras don't need rangefinders or microprisms in their viewfinders.

With a single-lens-reflex camera, what's inside the finder is the same as what's "seen" by the lens. A pivoting mirror inside the camera body reflects the image from the lens into a prism, which turns it upright so it can be viewed at eye level from behind the

camera. The user focuses by making the image on the screen appear sharp, either directly or via intermediary focusing aids, which can include a **microprism,** a **split-image rangefinder,** or a combination of both.

The rangefinder spot inside an SLR looks a lot like the rangefinder spot in a rangefinder camera, but it is less discriminating and more difficult to discern. Nevertheless, SLR focusing can be just as accurate as rangefinder focusing in most situations, sometimes more accurate. Which times are these? Primarily when doing close-up or "macro" photography, as well as when telephoto lenses are used.

SLRs outshine nonreflex cameras in any situation in which the view through the camera has to match exactly the scene recorded by the lens. SLRs also work best with focal lengths from 90 millimeters up, with extremely wide-angle lenses, with macro lenses used in taking extreme close-ups and, perhaps most important these days, with zoom lenses. Variety is the operative distinction: SLR systems offer a whole range of focal-length lenses including a choice of zoom lenses. With point-and-shoots, the lens that comes with the camera is your only lens.

(A word to the wise: for years, SLRs were sold together with a so-called normal lens. This lens, with a focal length of 50 to 55 millimeters, produces a view through the viewfinder that is the same size as what you see when not looking through the camera. This doesn't mean a normal lens has any advantages in picture-taking terms. Nowadays, it makes more sense to start with a zoom lens in the range of 35 to 100 millimeters to learn which focal lengths you use the most. If you find yourself using the 35-millimeter setting all the time, you might want to make a 35-millimeter lens your first accessory purchase. Chapter Eight has more information for SLR users about choosing lenses.)

Because SLRs are designed to do many kinds of jobs well, their viewing systems have to make compromises in some areas. Wide-angle lenses are hard to focus. So are lenses with relatively small maximum apertures—f/4.5 or f/5.6, say—since they allow less light into the viewing system to begin with.

Due to their mechanical differences, SLRs and point-and-shoot cameras are different in operation. The click of a point-and-shoot

camera is relatively quiet because it doesn't have a flip-flopping rapid-return mirror, something SLR design requires. Point-and-shoot cameras are generally smaller and lighter, in large part because their mechanical innards are simpler. Does this mean they are less prone to breakdown? Not necessarily, since SLR cameras are often designed to be used more frequently and under more demanding conditions than their younger siblings.

THE SHAPE OF THINGS TO COME?

Despite the vast changes that have taken place within 35-millimeter cameras since the 1960s, including the dramatic shift from mechanical to electronic controls, the outsides have stayed pretty much the same. The typical camera body is still a pudgy rectangle about the size of a deli ham sandwich, with a lens stuck in the middle like an oversized toothpick.

This basic form, shared by both point-and-shoot and single-lens-reflex cameras, has persevered since the original 35-millimeter Leica was shaped by its inventor, Oskar Barnack, in 1924. Barnack put the shutter button on the top at the right-hand side and the rewind knob on the top left, and there they stayed for the next sixty years.

The shape of the first Leica and virtually all 35-millimeter cameras that followed was partly determined by practical considerations, such as the need to keep the film flat by scrolling it across long guide rails. Other aspects of standard camera design seem more arbitrary, as left-handers like myself know too well. I had to learn to use my right eye for sighting through an SLR; otherwise I risked sticking the camera's protruding wind lever through my cheek.

All of this may be changing, however. In 1988 camera designers began to break out of the mold. Electronic systems are responsible in part since they are more flexible than mechanical connections such as gears and springs. There also seems to be an urge to be different, in an era when all cameras tend to look, feel, and act alike, at least superficially.

The new breed of camera looks like a video recorder. The resemblance may even be intentional. So far there are a handful of models in the class, all made in Japan, but you can bet there will soon be others of what those in the camera industry are calling "new concept" cameras.

The new breed of camera design, called a hybrid or "new concept" model, combines elements of point-and-shoot simplicity with some of the advanced features of SLRs. Introduced in the late eighties, hybrid cameras like the Ricoh Mirai 105, shown, are a new wrinkle in 35-millimeter photography.

(The early entrants are the Yashica Samurai, the Chinon Genesis, the Ricoh Mirai, and the Olympus Infinity Super Zoom 300. All but the Olympus are SLR designs, and all offer the kind of automatic controls of exposure, focus, and flash you'd expect to find in a point-and-shoot. For individual reports on these unconventional cameras, see the buying guide in Chapter Fifteen.)

What kind of photographer needs the features of these new hybrids? Their success will probably be at the expense of traditional beginner-level SLRs—a category in which sales figures have been declining. Of course the creators of this new breed of picture-taking instruments hope to create a whole new breed of photographers—including, perhaps, a large percentage of people

who want to pretend they're really using a video camera without spending the thousand or more bucks it takes to buy one.

A REVIEW OF CHAPTER ONE

1. A camera is a light-tight box with a lens on one end and film at the other. The lens aperture controls the amount of light entering the camera, and the shutter controls how long the light is allowed to hit the film. Focusing the lens makes the image appear sharp.
2. Lens apertures and shutter speeds have a one-to-one relationship; that is, opening the aperture one stop is the same as doubling the shutter speed.
3. To show what will appear on film, 35-millimeter cameras have either viewfinders or reflex viewing systems. They have built-in exposure meters to judge exposure.
4. The focal length of a lens determines how wide or narrow a view the camera will record. In 35-millimeter photography a lens of about 50 millimeters is considered "normal"; those that are shorter are called wide angle, and those that are longer are commonly referred to as telephoto. Zoom lenses provide a wide variety of focal length choices.
5. Two basic kinds of 35-millimeter cameras are available today: point-and-shoot cameras, with viewfinders and one-step, all-automatic operation, and single-lens-reflex cameras, which have interchangeable lenses and more versatility in terms of user control. "Hybrid" models combine some of the features of both.

TWO

Exposure Made Easier

We discover a world made of gray, the
vagaries of incidence and reflection,
varieties of exposure automation, methods
of exposure measurement, modes of
programmed auto exposure, and the
vicissitudes of backlighting.

E xposure meters didn't exist when photography was invented.
Those who pioneered the new medium simply uncapped
their lenses until the exposure felt right. They learned by trial and
error to judge how much light was enough to produce a decent
picture.

In the 1930s, however, the exposure meter became an integral
part of every photographer's equipment. It measured the light
striking it and suggested a range of appropriate combinations of
apertures and shutter speeds. You picked the one that seemed best
for your purposes and transferred it to the camera. Exposure
meters became an important part of every photographer's bag of
equipment, in part because of the growing popularity of color slide
films—which are more particular about getting the right amount of
light than black-and-white films. From there it was only a short
step to the modern era of built-in meters and a slightly greater leap
to automatic exposure.

The first cameras with built-in exposure meters offered only
one way of setting the right exposure—manually. You turned

either the aperture ring or the shutter-speed dial to match the meter needle to a preset mark. Today's manual-metering cameras use a variant of this method, usually with plus and minus symbols instead of needles to tell you how to adjust the camera's controls.

The first **automatic-exposure** systems for single-lens-reflex cameras, marketed in the late '60s and early '70s, let you set one control and forget about the other. With one variant, you set the aperture and the camera's meter determined what it considered the appropriate shutter speed. With the other, you set the shutter speed and the camera took care of the lens aperture.

Fully automatic exposure—what is now called **programmed exposure automation**—arrived first in the forerunners to today's point-and-shoot cameras. It simply took the early auto-exposure systems to their logical conclusion: in program mode, the camera sets both the aperture and the shutter speed. This is accomplished with programmed ROM chips and other computer wonders, and in most cases program metering produces properly exposed photographs.

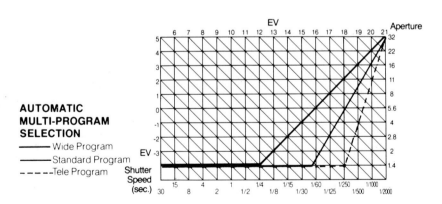

AUTOMATIC MULTI-PROGRAM SELECTION
—— Wide Program
—— Standard Program
– – – –Tele Program

Programmed auto exposure uses instructions built into the camera's computer chip to arrive at the proper aperture and shutter-speed settings. Cameras like the Maxxum 7000i have more than one program setting, as shown in the chart above; the tele program, for example, shifts to fast shutter speeds more quickly than the standard program.

Today, programmed exposure automation is built into every point-and-shoot camera, and it is available on many SLRs as well. While it is the only way to measure and achieve proper exposure with a point-and-shoot, most SLRs give you a choice. You can use it or you can set either the aperture or the shutter speed and have the camera do the rest. On some models you can even choose to revert to manual.

But is programmed automatic exposure a guarantee of 100 percent success in picture taking? Not if the person using it has no idea what exposure meters do and how they can be fooled. In short, simply owning a camera with six high-tech exposure modes doesn't substitute for knowing some photo basics.

It's time, then, to take a short, elementary tour of how exposure meters work.

SEEING THE WORLD IN GRAY

No matter how simple or sophisticated, virtually all exposure meters see the world as a dreary blanket of gray. In technical terms, the shade that meters see is called **18 percent gray,** and it isn't a bad color to have on your living room wall (especially if you like to display framed photographs there). Eighteen percent gray represents the mean (or average) light reflectance of an "average" real-life scene, as determined by Kodak and other trustworthy authorities on the subject.

Reality, however, is not so monochromatic and monotonous as meters would like it to be. This is where exposure mistakes creep in. If the overall scene in front of your lens is either darker or lighter than the "average" shade the camera's meter presumes, slavishly following its idea of "correct" exposure will give you either overexposed or underexposed pictures.

The task in metering, then, is to translate the variegated tones and colors of the world in a way that matches them to photographic materials. To do this you have to be able to judge the world by the meter's standard of 18 percent gray. It helps to know what that gray looks like, and Kodak and others have obliged by selling what

are called gray cards, which have been painted or printed the exact shade a meter expects to see.

A gray card, if you have the patience to use it, is an inexpensive, invaluable aid for determining precise exposure. Once you've selected what you want to shoot, you simply put the gray card in front of the lens and in the same light as your subject, and take a meter reading from its surface. Since the gray card reflects the amount of light that the meter assumes is average, the exposure will be right on the button.

If you don't mind carrying an 8-by-10-inch piece of gray cardboard with you at all times, most of your metering problems are now solved. You can get the same accuracy, in somewhat more compact form, with a hand-held meter designed to measure **incident light**. Incident exposure metering means measuring the light falling *on* the subject rather than the light reflecting *from* the subject, which is what a **reflected light** reading measures. Since the amount of incident light is independent of the tones of the subject, it accurately represents the average amount of light in the scene.

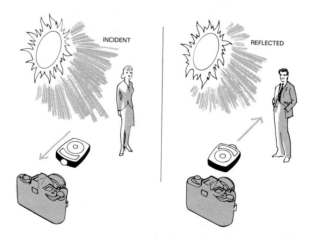

Reflected and incident light metering compared: A reflected reading (right) measures the amount of light reflecting from a subject and thus is prone to error. (This is the kind of metering system built into 35-millimeter cameras.) An incident reading measures the amount of light falling on the subject.

Hand-held meters usually have a translucent plastic dome or disk to diffuse the light before it reaches the metering cell, thereby producing a miniaturized version of 18 percent gray for the cell's examination. Of course such meters weigh more than gray cards, and they cost more as well. And there are times when they can be inconvenient to use. For instance, to take an incident reading you generally have to move in front of the camera to approximately the same position as your subject. If that subject is a ravine or waterfall, this can be more than inconvenient.

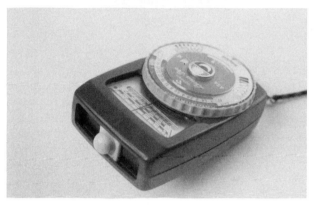

A hand-held meter with its built-in incident dome in place over the light-sensitive cell. To meter accurately in this mode, you should stand in front of the camera and point the meter back at the lens (see illus., opposite page). If you're at the edge of the Grand Canyon, this might not be so easy.

For these reasons, the vast majority of photographers learn to rely on the reflected-light meter built into their camera. No matter what kind of light-sensitive receptor the camera has—silicon and gallium photo diodes are among the most commonly used today— the problems are the same. The photographer has to judge whether the subject or scene at hand is predominantly lighter or darker than 18 percent gray. If it is lighter—a sandy beach, say, or a snow-covered lane—additional exposure is in order. If it is darker—a black cat in a coal bin is the archetypal example—less exposure is needed.

Even ordinary landscape scenes, half ground and half sky, are

enough to cause most ordinary meters to go awry, so experienced photographers learn to compensate manually. This is why practically every auto-exposure SLR camera ever made has an extra control for **exposure compensation**, which overrides the meter's automatic mistakes.

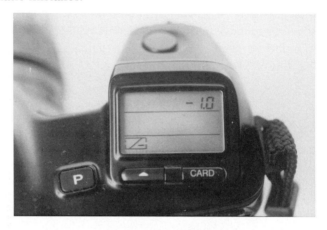

The liquid-crystal display atop the Minolta Maxxum 7000i tells you, among other things, how much exposure compensation (plus or minus) has been selected—here, minus one stop. On older automatic cameras, exposure compensation is set on a dial; with the Minolta, a "mode" switch accomplishes the same thing.

How much more or less exposure depends on the subject at hand. The black cat might take two full stops less, depending on the film used, but if you simply line up the arrows or dots inside the finder to match the meter's recommended exposure, that black cat is going to come out 18 percent gray. Strange, perhaps, but true.

Exposure meters can be fooled in other, more insidious ways. For example, if even a tiny sliver of the sun sneaks into the lens, its extreme brightness will override the rest of the scene, tricking the meter into underexposing. If you're photographing a sunset, this can sometimes lead to dramatic pictures, with the foreground rendered in silhouette. It's important to know why this happens so that you can decide what kind of effect you want.

The most common thorn in an exposure meter's side is called **backlighting.** Suppose you are taking a portrait of a friend, with

the sky behind his head. Because the sky is so much brighter than his face, the meter will expose as if the important thing in the picture is the sky. The result: a dark, underexposed face against an 18 percent sky.

A backlit portrait is perhaps the most common situation in which exposure errors occur. Because the brightest light comes from behind the subject, the camera's meter will underexpose the face unless you add an extra stop or two of exposure, use flash, or press the backlight button on your camera.

Underexposed backlighted portraits are so common in amateur photographs that some camera makers have added **backlight buttons** to their point-and-shoots, and even some basic SLRs. When pressed, the camera shifts its program to increase the exposure one to two stops. Still other cameras attempt to deal with the problem automatically by using more than one sensor in the metering system. If they sense a backlighted situation, either the exposure program increases its exposure or a built-in flash fires to put more light on the subject in the foreground. (More about flash "fill" in Chapter Five.)

"WEIGHTED" METER READINGS

The first built-in exposure meters were designed like hand-held meters; they simply "read" a scene of a specific size and gave a measurement based on an overall interpretation. In other words, they gave as much importance to what was in the corners of the picture area as to what was in the center.

It didn't take long for someone to figure out that in most cases what is in the center of the finder is what the photographer wants to record. The edges, while important pictorially, aren't as vital to most exposures. So **spot meters** and then **center-weighted meters** were introduced. Spot meters work the way they sound: the meter is only sensitive to a small round spot in the center of the frame. Center-weighted meters give more importance to the center area but also account in lesser degree for the edges. The proportion of center-to-edge sensitivity depends on the manufacturer; some cameras have a 75–25 split, others a 60–40.

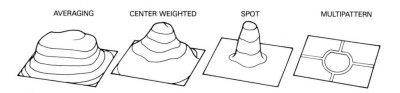

AVERAGING CENTER WEIGHTED SPOT MULTIPATTERN

These schematic drawings represent how different metering systems "see" the picture area, weighting their exposure measurements accordingly. The sensitivity levels of the multipattern metering system aren't shown because the weighting varies according to the lighting situation encountered.

The major drawback of spot meters is that they're so precise you always have to think about what they're reading. If the subject is off to the side, you have to make a reading by swinging the camera until the subject is in the center, "freeze" the reading by pressing the shutter button partway down, and then recompose. Only dedicated photographers want to go through this process. Center-weighted meters are more forgiving, but like averaging meters they, too, can be fooled by extremely bright backgrounds and backlighted situations.

MULTIPLE AREA METERING

As I said before, virtually all meters are designed to "see" only gray—whether they are built-in or hand-held, whether they read reflected or incident light, and whether they are designed to give overall readings, spot readings, or readings that emphasize the central area. There is, however, a new generation of meters that has the ability to sense the light levels in several areas of the frame, compare them to a "memory bank" of picture situations, and then make an educated guess as to what the best exposure should be. These multiple-area or **multipattern meters** can "recognize" backlit situations, for example, and open up the lens to better expose the central subject.

These "intelligent" metering systems, so far found only in SLRs, have been named different things by different manufacturers: Multipattern Metering, Matrix Metering, EVM ("evaluative metering"), AMP ("automatic multipattern"), or even ESP ("electro selective pattern"). No matter what the name, however, all use sophisticated computer modeling techniques to try to decipher the characteristics of the scene in front of the lens. Unlike center-weighted metering, each of their several sectors is measured independently.

These systems perform pretty much as advertised, increasing exposure in situations, such as backlighting, that commonly fool garden-variety meters (and garden-variety photographers as well). The only trouble with them, at least for advanced photographers, is that they don't tell their putative masters what they are doing. In other words, the amount of backlight compensation the camera chooses to give might not match what the photographer has in mind. Since one doesn't know what adjustment the camera has made, there's no surefire way to override it.

If we're lucky, though, a display inside the viewfinder will let us know what aperture and shutter speed the meter is calling for. With a little experience we can judge for ourselves whether the aperture is too big or the shutter speed too slow, and adjust the controls ourselves. Cameras without this feedback feature will only stunt your growth as a photographer.

MAKING EXPOSURES AUTOMATIC

How are the meter readings translated into actual exposures on film? A good question. The answer is that it all depends on the exposure *mode* being used.

Once upon a time there were two rings used to set proper exposure on single-lens-reflex cameras: one, a dial atop the camera, set the speed of the shutter; the other, a band wrapped around the lens, set the aperture. As I mentioned at the beginning of the chapter, you turned one or the other ring until the built-in meter needle lined up with a mark. It was a very simple system; so simple, in fact, that something like it is still found on many SLRs and still favored by stick-in-the-mud pros. But for tyros and technophobes, what is now called **manual mode** wasn't simple enough.

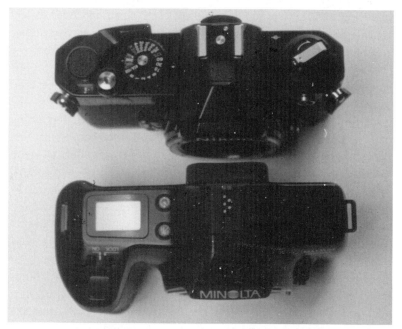

Old and new SLR controls compared. Where analog dials once ruled (top), liquid-crystal displays and selector buttons now predominate. One reason: the increasing complexity of program exposure modes.

Camera designers came to the rescue, introducing automatic exposure. This was just the ticket for the tyro; now only one ring had to be turned. Which ring it was depended on which of the two types of exposure automation the camera offered: aperture-preferred (meaning you set the aperture and the auto-exposure system set the shutter speed) or shutter-speed preferred (meaning you set the speed and the camera set the aperture). So chalk up two more exposure modes: **aperture-preferred automatic** and **shutter-speed-preferred automatic**.

Still, some people had trouble remembering to set a fast enough shutter speed in some situations, and others chose too large an aperture to get all of proverbial Aunt Harriet in focus. Besides, there was the pesky chore of remembering to set the appropriate ring to "A" for automatic in the first place. Again the camera designers came to the rescue, this time with programmed automatic exposure, or **program mode**.

This program or "P" mode is the secret ingredient found in all point-and-shoot cameras, and it is found as well in many sophisticated SLRs, even professional models. It lets the beginner fire away without the slightest clue about how the camera's exposure controls work, and it lets the hardened pro forget about the camera's controls in hair-raising and sometimes life-threatening situations. True, in most SLRs you still have to turn the dial to "P" to get started, but after that the camera effectively manages the selection of shutter speeds and apertures in the same way that less expensive point-and-shoot cameras do.

Program mode relies on some simple ideas about how pictures are made. One is that most are taken with the camera held in the hands rather than mounted on a stable tripod. So in low light the exposure system starts out with the lens wide open, resulting in the fastest shutter speed possible. (If the speed is below $\frac{1}{30}$ second even with the lens at its maximum aperture, some cameras will beep at you and refuse to take the picture!) Another assumption is that good sharpness front to back is equally as important as freezing subject motion. As the light gets brighter, the exposure system closes down the lens (that is, it makes the aperture smaller) at the same time that it increases the shutter speed.

But with SLRs and with point-and-shoots that have zoom

lenses, there is a complicating rub. Let's say you're carrying your favorite 135-millimeter telephoto lens. The "best" exposure for the 135-millimeter should guarantee a high enough shutter speed to avoid any lack of sharpness caused by vibrations, which are magnified by the lens as much as the image is. But the programmed exposure system is designed for a "normal" lens of about 50 millimeters. It may want to make the shutter speed $\frac{1}{60}$ second to keep the lens stopped down for best depth-of-field, whereas for a 135-millimeter lens, hand-held, you would want a speed of at least $\frac{1}{125}$ second.

One solution would be a choice of program modes, which is precisely what the most fancy of today's cameras have to offer. These multiple modes are keyed in to various ranges of lens focal lengths. Besides **normal program mode** for normal lenses, they may have built into their computer chips **high-speed program mode** and **depth-of-field program mode**. The former serves up faster shutter speeds by keeping the lens wide open longer; the latter delivers smaller apertures with correspondingly slower shutter speeds.

Today, in short, we have progressed from those primitive years when all one had to do was turn two rings and align a needle to the elegant simplicity of a dial (or often a liquid-crystal display, like those found on watches and laptop computers) that lets the tyro select among "P-N" (normal), "P-T" (telephoto), and "P-D" (depth of field), plus "A" (for aperture- or shutter-speed-preferred automatic exposure) and "M" (for old-style manual). Some cameras make it even more confusing by using other letters to signify the same functions, such as "P-A" for action pictures (like telephoto shots, these favor high shutter speeds).

Recognizing that the novice might not understand the choice of programmed exposure modes available (and who would blame us!), some camera designers have gone one step further and developed a program mode that automatically chooses whether to favor fast shutter speeds or small lens apertures by figuring out which lens is in use. Using focal-length information that is fed either mechanically or electronically from the lens mount to the exposure control center, the system adjusts the exposure program to suit the lens. This is called **focal-length indexing**.

So now there are four program-mode possibilities: normal, telephoto, and depth-of-field, each of which must be selected manually, plus the camera's own selection based on the lens in use (which may itself be split between "normal" and "action"). Depending on the elaborateness of your camera, you may have one, two, or all four. Point-and-shoot cameras typically offer only one exposure program, since more might complicate their operational simplicity.

If all this sounds like breeding a six-legged horse in the hope that it will run faster, you're not far off. In SLRs the quest to perfect programmed exposure automation has led to more complex camera controls, not simpler ones. To top it off, the manual settings that started all the redesign in the first place have, for the most part, been retained, since many SLR buyers like to be able to assume command of the controls as their skills advance.

But much has been learned in the effort to perfect programmed exposure in SLRs. It has spurred the development of computer-controlled electronics. Because of their electronic systems, today's cameras have fewer gear trains, cams, springs, and other moving parts that are prone to breakdown through wear and tear. As a result they are less expensive to build and therefore less expensive to buy (not accounting for inflation, of course). And they are edging closer to compatibility with that most fully electronic of image-making mediums, video.

Someday we may see an all-electronic camera with truly simplified programmed exposure automation. It may also tell us the time, double as a word processor, and allow us to tape our favorite movies off the television set. But even then consistent exposure metering in the real world will most likely remain a matter of skill, experience, and intuition—not of high technology.

A SUMMARY OF CHAPTER TWO

1. Exposure meters see everything as 18 percent gray. Therefore, adjustments have to be made for very dark subjects (less exposure) and very bright subjects (more exposure).
2. In certain situations, such as those that are backlit, reflected-

light meters can be fooled. Some cameras have backlight buttons to compensate for this situation, while others have sophisticated multiarea metering systems that take backlighting into account.

3. Exposure meters now control both the aperture and shutter speed of cameras through programmed exposure automation. The modes of program automation are designed to account for focal length and the speed of the subject being photographed.

THREE

Focusing the Automatic Way

An analysis of how cameras manage to focus themselves, how they can be fooled, and how they can be forced into doing what you want them to do, plus: active versus passive, single-shot versus continuous, and the advantages versus the disadvantages of auto focusing.

As we learned in Chapter One, focusing is the act of changing the distance between the lens and the film plane so that a hypothetical point of light in front of the lens registers on film as a point of light, not as a ghostly splotch. An image is said to be **in focus** if it appears perfectly sharp in the picture. If its edges look as though they're in the process of dissolving, the image is probably **out of focus**.

Focusing, like setting the exposure, used to be something we did by hand, by turning a ring around the lens. Simple enough, but it's not always as easy as it sounds. When the light is dim, or the subjects are fast-moving, or we have a camera in one hand and a canapé balanced on a champagne glass in the other, getting the lens into focus quickly and accurately can be a struggle. The result: fuzzy pictures.

A manual-focusing lens, left, compared to an automatic-focusing one. Note the absence of an aperture ring on the auto lens and its vestigial, but usable, manual-focusing collar.

To save us from such predicaments and to eliminate one more obstacle in the path of 35-millimeter cameras for Everyman, engineers have designed automatic-focusing systems that work with all the inconspicuous accuracy of automatic exposure systems. Point your camera at Aunt Harriet and in a fraction of a second a built-in motor has propelled the lens to a point where she is in pinpoint focus.

When automatic focusing first appeared in the 1970s, it was considered a convenience for tyros. Beginners, after all, were the ones who had the most trouble getting used to moving a lens into focus. Soon the point-and-shoot camera was born, combining auto focusing with auto exposure, auto loading, auto wind and rewind, and other automatic features. Its fundamental concept is to make quality picture taking a one-step, nontechnical enterprise.

At the same time it became obvious that even advanced photographers would enjoy the simple operation and speed of automatic focusing. After several less than successful attempts to create auto-focusing lenses for conventional SLRs, Minolta's Maxxum broke the ice with amateur photographers in the mid-1980s. Its integrated concept, with an SLR body that incorporated sophisticated auto-focusing circuitry and special lenses designed to

mate with the body's focusing motor, began the epochal shift from manual to auto-focusing 35-millimeter SLRs.

But just as automatic exposure offers camera users a choice of exposure modes and metering systems, automatic focusing has its own array of user options and functional types. To best take advantage of its performance, it helps to know what these are.

WHICH WILL IT BE, ACTIVE OR PASSIVE?

Just as there are basically two popular types of 35-millimeter cameras, there are essentially two types of auto-focusing systems now in use. One sends out a beam that bounces off the subject and then is "read" on its return by the camera. This is an **active system** and generally uses infrared light. A sound-based variant, found in some Polaroid instant cameras, uses ultrasonic waves instead.

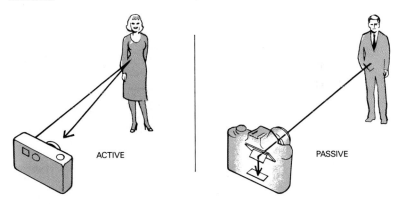

ACTIVE

PASSIVE

With active auto-focusing systems, found in point-and-shoots, a beam from the camera bounces off the subject and returns to the camera's rangefinder-like sensor (left). Passive auto-focusing systems, found in SLRs, utilize sophisticated computer sensors to measure the sharpness of the subject's edges, as seen through the lens (right).

The other auto-focus species goes by the name **phase detection**. Rather than actively send a beam of light or a sound

wave, it employs complex electronic circuitry to judge the sharpness of the image as it appears within the camera. Phase-detection systems are also called **passive systems** because they don't send out beams or waves but merely examine the light that enters the camera. They are, needless to say, more sophisticated than the active systems and more capable of making small distinctions in their focusing decisions.

Active-type auto focusing is the most popular system since it is found on virtually all of today's point-and-shoot cameras. Because of the requirements of its rangefinder-style sensor, the distance from close up to infinity is divided into segments or zones. So instead of turning the lens to the point of precise focus, the systems lock onto a focusing distance approximately the same as the camera-to-subject distance. This means that focus is rarely exact; it is, however, close enough to make all but the largest of enlargements look sharp. Some cameras provide as few as five zones, others as many as twenty. Obviously the more zones the better since the distinctions between distances will be finer.

Unless you have a focus-locking capability in your point-and-shoot camera, a picture like this one, taken through a window, will be focused on the foreground. Active auto-focusing systems always focus on the glass, not on the subject beyond it.

Active beam-based auto-focusing systems have at least one limitation besides the approximate nature of their focus: they don't do well shooting through windows or into mirrors because they focus on the plane of the window or mirror rather than on the subject beyond. For this reason (and several others as well) your model should have a method for locking the focus setting. With this feature, which is usually activated by holding the shutter button halfway down, you can focus on something far away and then recompose through the window or mirror without losing the distant focus setting.

Unlike point-and-shoot cameras, today's auto-focusing SLRs function by means of passive phase-detection systems. By comparing the contrast of adjacent areas within a small portion of the finder frame, the camera's microcircuitry can tell when exact focus is obtained. An integral motor then moves the lens into position. Focusing is exact, and the system easily adjusts for different lenses because the information it receives is always based on the lens in use.

As auto-focusing SLR users already have found, such systems are not only accurate but also quite speedy. With one exception, the lens is moved into focus by means of a motor in the camera body. A drive shaft links the camera motor and the lens mount. (The exception is Canon's line of EOS cameras, which manage the task with tiny motors built into the lenses themselves.) Just how fast a lens focuses depends largely on the amount of rotation built into its focusing mount. This in turn depends mainly on the focal length of the lens and on how close it focuses.

The major limitations of SLR phase-detection systems are their difficulties with some subject matter and with low-light situations. Because the circuitry that scans the subject looks for variations within the subject, it gets confused when confronted with a blank wall. The motor whirs, the lens goes from one extreme to the other, and finally the camera gives up. Even certain subjects that have distinguishing features will fool the system if their features do not match its expectations. It is common for auto-focusing systems to be designed to "read" vertical lines, for example, but if the lines in a particular subject are all horizontal, the systems won't recognize them.

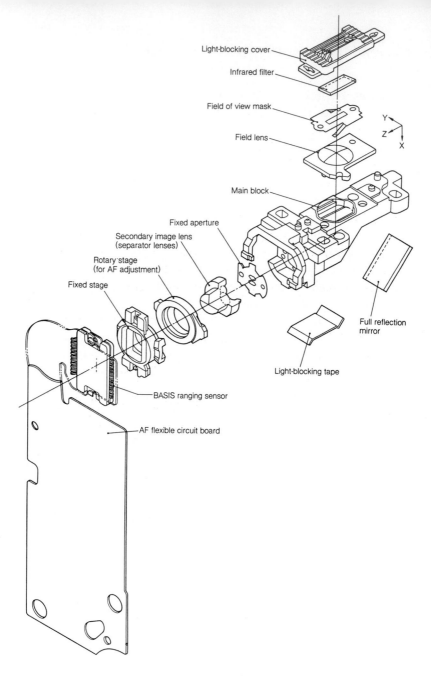

Light-blocking cover
Infrared filter
Field of view mask
Field lens
Main block
Fixed aperture
Secondary image lens
(separator lenses)
Rotary stage
(for AF adjustment)
Fixed stage
Full reflection
mirror
Light-blocking tape
BASIS ranging sensor
AF flexible circuit board

A schematic drawing of the internal workings of Canon's EOS
auto-focusing system shows the essential optical
mechanisms involved. A computer "brain" analyzes the input
from the focus sensor and relays the needed correction to a
motor that drives the lens into focus.

Phase-detection systems also require enough light on the subject so that they can distinguish what is in front of them. Early auto-focusing SLRs were limited in auto-focusing ability to light levels of EV2 or EV3. ("EV" means **exposure value,** a commonly used measurement of light in photography.) That's about what you might find in a dimly lit room or outside shortly after sunset. At night or in the dark, then, the system wouldn't work at all. Technology marches onward, however, so that the models currently leading the pack claim to continue to focus as low as EV −1.

Of course, in most low-light situations photographers would just as soon use a flash, so many auto-focusing SLRs are designed to work with specially engineered flash units that emit a patterned beam when the shutter release is pressed. The focus circuitry sees the beam and uses its pattern—usually a row of vertical bars—as its focusing target. This hybrid, part-active / part passive system works well as long as the beam alights on something within its range.

WHAT, MORE MODES?

Yes, just as automatic exposure offers a variety of "modes" for the photographer's amusement, there are auto-focusing modes, too. Basically, there are two that are popular, commonly called **single-shot** and **continuous**.

As the name suggests, single-shot auto focusing lets you focus and fire the camera once each time you press the shutter release. As you press, the lens moves into focus, the camera sets itself to the proper exposure, the lens stops down, the mirror flips up, and the shutter curtain opens and closes, all in the blink of an eye. Then the camera's integral winder or motor advances the film to the next frame and recocks the shutter.

Single-shot mode is the standard with point-and-shoot cameras. In fact, it's not only standard, it's just about all you can get. Auto-focusing SLRs, on the other hand, are almost all capable of both single-shot and continuous operation.

In continuous mode—sometimes called continuous servo

mode—much the same sequence of internal events occurs, but the lens keeps focusing as long as your finger remains on the release. This allows for auto focusing that involves active subjects and, with the camera set to motor operation, sequence shooting at a rate of up to several frames a second. But there is a significant wrinkle to continuous mode: the shutter can fire before the lens has reached correct focus.

This glitch in continuous mode focusing makes it less desirable for everyday shooting, which is why the instruction books encourage newcomers to SLR auto focusing to stick to the single-shot mode at first. Set to single shot, the camera will not fire until correct focus is reached. This has the advantage of ensuring well-focused pictures but the disadvantage of disabling the camera at certain crucial moments when you want to take a picture. There's nothing more frustrating than trying to record an evanescent moment and having your camera balk at taking the exposure. If it beeps at you while refusing to budge, it only makes matters worse.

A portrait like this one is the forte of auto focusing's single-shot mode, which locks the shutter until whatever is in the center of the frame is in focus. More active subjects may move out of focus while you compose the picture, stopping you from getting the shot.

The continuous mode was added to solve just this complaint, giving the advanced photographer a choice of ways to employ auto focusing. With the camera set to continuous mode, it will willingly fire away at pedestrians and other moving subjects, although no longer with the guarantee that they will appear sharp. Relatively fast motion, like kids going full tilt on a roller coaster, can easily outpace the speed of the auto-focus system.

In continuous mode, the shutter will fire even if the subject moves more quickly than the auto-focusing system's ability to keep up. Using a small aperture will usually keep the subject looking sharp, even if it isn't technically "in focus."

With most single-shot systems, once the shutter release is pressed halfway, the focus locks onto whatever is in the center of the frame. Recomposing thus often requires refocusing, which means you have to lift your finger off the shutter button and then press again. Or you can decide to prefocus on the important subject, lock in the focus, and recompose—something I find myself doing frequently. In continuous mode whatever is in the center of the frame at the moment the shutter fires is what the camera attempts to focus on.

The key continuous-mode advantage is that you don't have to

keep bobbing your finger up and down as you follow a moving subject or if you reconsider the picture at the last minute. But once again, every benefit has its flip side. I once tried to use the continuous mode while taking landscapes. The camera insisted on focusing on the faraway sky since that was what occupied the central area of the viewfinder. I wanted to get the foreground as sharp as the sky, so I had to switch to single-shot mode. Then I focused on a tree some thirty feet away and kept my finger on the release button while I recomposed. The lens's depth of field gave me a sharp picture from 15 feet to infinity.

There are two useful variants already in place on the auto-focus mode map. One is **trap mode** auto focus, which is built into Yashica's 230-AF and available in some other SLR cameras with the addition of a special back. You select a distance by pointing the camera, hit some buttons, and then whenever anything crosses the invisible focus zone the camera automatically fires, and it keeps firing until what is in the zone departs. It is a nifty idea for bird and wildlife photography or for surprising your friends.

Canon, in its line of EOS cameras, features a **depth-of-field mode**. Focus the lens once on the desired near limit of sharpness and again on the far limit, and the camera automatically sets both the focus and the lens aperture to ensure adequate crispness front to back.

THE LIMITATIONS OF AUTO FOCUSING

Besides being fast, accurate, and effortless, automatic focusing is a wonderful boon for partygoers, as I discovered the first time I brought a point-and-shoot to a party. With auto focusing in action, I could snap away without the bother of having to find a horizontal surface on which to stash my refreshments. Later on, as my visual acuity and inhibitions dropped precipitously, I could keep shooting even while dancing. All the while I knew I was getting sharply focused, properly exposed flash pictures.

At least I thought I was. The results were not the perfection I had expected. Automatic focusing, I discovered, has its limitations. Let's see what some of them are:

One of the most prominent limitations is that auto focusing has tunnel vision: it sees only the center of the scene. This is fine for a portrait of Aunt Harriet or any other picture in which we center the finder image on our subject, but it is not so fine for couples, such as a bride and groom. Instead of focusing the lens on their beaming faces, it may "decide" to focus on the concrete wall between them, perhaps ten feet away.

The trouble with auto focusing is its penchant for focusing on whatever is in the exact center of the frame, no matter what it is. Cameras with more than one auto-focusing sensor do better, eliminating the infamous "focus on the wall, not on the people" effect, illustrated here.

To cope with the rigidity of central focusing, sophisticated SLRs and the better point-and-shoot cameras have focus locks. These let you recompose after you focus on your subject centrally. Usually you just hold the shutter button down partway to lock focus. (This also usually locks the exposure reading, too.) But clearly we have here a case of a solution creating a problem that requires another solution. One wonders, in such instances, whether we aren't better off with the original problem left unsolved.

A much more ingenious attempt to alleviate the tunnel-vision problem was first engineered by Chinon. The Chinon Auto 3001 point-and-shoot camera has not one but three auto-focus sensors, which together span a rectangular section of the picture frame. If even a small piece of this rectangular area contains a close-up subject, the camera makes adjustments to try to get it in focus. Minolta has introduced an SLR version of the same concept in its second-generation Maxxum, the 7000i.

There are other gremlins lurking in the auto-focusing forest that make it less than a photographic panacea. The advanced phase-detection devices found in SLRs are extremely accurate in contrasty situations, but in low light or when the subject itself is without any distinguishing pattern, they slow down and sometimes lose their ability to function. This is too bad since these are exactly the times when human eyesight tends to fail as well.

(When both SLRs or point-and-shoot cameras can't figure out where to focus, they either lock up or "default" to a preset distance—usually infinity.)

In addition, auto focusing can slow the rate of rapid-fire motor drives and winders, which are fixtures on many of today's cameras. The focusing action takes so long that the motor drive has to sit and wait. It also speeds up the rate at which the camera's batteries get exhausted, which is no minor concern when you consider that most modern cameras are totally battery dependent. Take away their juice and they become fancy doorstops.

Finally, the systems introduced so far for interchangeable-lens SLRs require special auto-focusing lenses. These are fitted with lens mounts designed to accommodate the new mechanical and / or electrical connections to the body. This means a new line of lenses to replace those from pre-auto-focus days.

BUT FINALLY, A FEW GOOD WORDS

Let's face it, manually focusing a single-lens-reflex camera has never been fun. Especially troublesome are wide-angle lenses and lenses with small maximum apertures (like our beloved zooms). In

less than bright sunlight, the focusing screen can seem pretty dim. At other times the central "focusing aids" can black out or disappear.

Auto focusing renders most of these SLR focusing problems moot. The brightness of the focusing screen no longer matters, nor does our ability to discern exactly when a microprism dot "snaps" from jagged to smooth or when the two halves of a rangefinder circle come together. Auto focusing is especially a boon to those with impaired or declining eyesight or with a limited capacity for seeing things at close range.

For many of us, then, auto focusing is not only easier but also faster. But is it always faster? Not necessarily. Long lenses, in particular, can be focused more quickly by hand. That's because in general the larger the focal length of the lens, the greater the amount of focusing travel between infinity and close-up distances. A telephoto lens may have 210 degrees of barrel movement, while a wide-angle—even though it can focus closer—may turn through only 90 degrees. So auto-focus motors take longer to focus telephoto than wide-angle lenses.

In addition, the human hand can turn a lens barrel with incredible agility, starting at a fast rate for gross focus and then

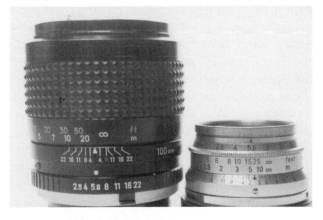

A typical wide-angle lens focuses in a tighter arc than a typical tele, as can be seen from the distance scales engraved on their lens barrels. (That's a 100-millimeter tele angle on the left and a 35-millimeter wide angle on the right.) The larger the arc, the longer auto focusing takes.

slowing down to fine-tune things. Some auto-focus motors are engineered to imitate this ability, but as yet the designer of the human body has the upper hand. Even with the fastest auto-focus cameras, I sometimes feel impatient as I listen to the motor whirring away in front of my face. In so-called single-shot mode, the wait can drive one batty.

If not always faster, auto focusing is indisputably more accurate. This is no small piece of cheese, especially when you consider that it is also more reliable. Whereas manual focusing depends on a fine-tuned connection between the human eye, brain, and nervous system, auto focusing is done by machine. Unlike your eyes, the machine doesn't get tired at the end of the day, sweat doesn't run off its brows when it's hot, and it doesn't need reading glasses. It does, however, require batteries.

There are practical limitations to what auto focusing can do. Sure, the focusing sensors in SLRs may become helpless when confronted by subjects that lack distinguishing features, like the blank wall mentioned previously. But try focusing on a blank wall using manual focusing techniques; it's almost impossible. The same goes for focusing at midnight: manual focusing is even tougher than auto focusing. And the sensors that do the job of finding focus automatically are being refined almost monthly; you can be sure that this year's cameras can focus in more situations and in lower light than last year's models.

So far we've been talking about using auto focusing "automatically"—with the specially designed lens motoring into precise focus at the behest of sensors built into the camera body. But these same auto-focus sensors can also come in mighty handy when old-fashioned manual lenses are used or when auto-focus lenses are switched so they can be turned manually. This trick is called "focus indication," "focus confirmation," or "the electronic rangefinder." You turn the lens by hand and lights go on in the finder to indicate when sharp focus is achieved. This combination of the speed of the human hand and the visual acuity of the modern auto-focus sensor is hard to beat. It also puts the photographer back in the driver's seat.

The trouble is that relatively few auto-focus SLRs accept manual-focus lenses from an earlier generation of cameras. Among

the makes that do are Chinon ("K" mount), Nikon, Olympus, and Pentax. Some manufacturers also offer tele-converters that allow certain of their manual lenses to auto focus; these include Nikon and Yashica (Yashica/Contax mount).

Since neither active nor passive types of auto-focusing systems know beans about the principles or practice of depth-of-field control, most auto-focus cameras need to be switched to manual focus when you want to control the zone of sharpness from front to back. Alternately, you can fool them into doing your bidding with some sleight of hand. In the next chapter we'll take a look at what depth-of-field is and how it can be controlled.

A REVIEW OF CHAPTER THREE

1. Focusing is the act of making a point of light in front of the lens appear as a point of light on film. If it registers on film as a blur, the subject is said to be out of focus.

2. Automatic focusing is a feature of both point-and-shoot and SLR cameras, although the two types of cameras use two different systems. Point-and-shoots send out a beam of light—a so-called active system. SLRs register the subject's sharpness as it comes through the lens—a passive, phase-detection system. Both systems have advantages and disadvantages.

3. Single-lens-reflex cameras with auto focusing capability usually have two focusing modes: single-shot, which locks the shutter until focus is achieved (useful for still subjects), and continuous, which lets the camera fire away at moving targets even if they aren't in exact focus. Other, less common modes include trap and depth-of-field.

4. Auto-focusing cameras by and large focus on whatever is in the center of the frame. To focus on off-center subjects you need to use the camera's focus lock, first centering the subject to focus and then recomposing.

5. Auto focusing requires special lenses designed to work with the system, but on some cameras manual-focusing lenses can be used in conjunction with signals in the viewfinder that tell you which direction to turn the lens and when focus is achieved.

FOUR

More on Focusing: The Advantages of Manual Control

We learn about depth–of–field, zone focusing, hyperfocal distances, and other arcane remnants of the era of manual focusing, and why we need to bother with them even though our cameras do the focusing for us.

Although the tide has turned toward automatic focusing, there are plenty of cameras in existence that need to be focused by hand, and there are still plenty of people buying manual-focusing SLRs, just as they did before the first Minolta Maxxum appeared. These folks either don't want the camera to focus for them or they don't want to pay the premium that auto-focusing cameras command.

For those of you who fit this description—and for everyone else who wants to know how to control focus for better pictures—a few words about the practice and principles of manual focusing are in order. Since manual focusing by definition excludes point-and-shoot cameras, this chapter is addressed primarily to the single-lens-reflex user.

Why would anyone still want to focus manually? Perhaps because that's what they grew up doing. But there's a better reason: because only manual focusing provides the kind of pictorial control experienced photographers want. By choosing a specific point of focus in combination with the aperture and focal length of your lens, you can make background objects disappear, you can shoot through fences, or you can have the entire picture sharp from front to back. The choice is yours *if* you know how focusing works.

Let's quickly review the way focus is achieved with manual-focusing SLR cameras.

FOCUSING AIDS IN REVIEW

Most standard SLR screens of recent vintage allow you to focus in any of three different ways. There's usually a central rangefinder spot, which is surrounded by a microprism collar, which is itself surrounded by an overall ground-glass (or Fresnel) screen. The arrangement of these focusing aids may vary or there may be only two of the three in evidence, depending on the screen. (With many SLRs the focusing screens arc interchangeable.) Let's look at each individually.

A **rangefinder spot** consists of two prisms that split the image into two sections, either horizontally or diagonally. You turn the lens until the two parts of the image line up as one. As owners of rangefinder Leicas know, this kind of focusing is one of the fastest, surest ways of making things sharp.

SLR rangefinder devices work best when the subject has distinct lines that run against the grain of the two prisms. Unfortunately, there are limitations when light enters the prisms at certain angles. With small apertures, close-up distances, and long focal-length lenses, one or both halves of the spot can dim or "black out." That's when the microprism collar can come in handy.

A **microprism** splits the image into a number of tiny facets so that it appears fragmented except when exact focus is achieved. It works best with telephoto lenses, which exaggerate the fragmented effect, but less well with wide-angle lenses. In short, it functions

where split-image rangefinder spots don't. The reverse is true as well.

In some shooting situations, however, neither of these centrally located focusing aids suffices—close-ups being one example. Then it's simple enough to use the surrounding **ground-glass screen** in the same way that one focuses a view camera. Surprisingly, quite a few SLR owners don't seem to know that the entire viewing screen is also a focusing screen, albeit a subjective one. The focusing screen's ability to "snap" the subject into focus is less marked than with the rangefinder spot and surrounding collar, but it works all the same.

ADVICE FOR THE FOCUS-WEARY

If focusing with an SLR proves difficult despite the focusing aids built into the screen, these hints may be of help:

- If you wear glasses but focus your camera without them, you may want to purchase a diopter adjustment for the viewfinder. It's a corrective lens that works just like the ones in your eyeglasses. Some cameras now come with dial-in diopter correction. You might also consider a low-power viewfinder magnifier.
- When focusing hand-held with a long lens—200 millimeters, say—it's often easier to achieve precise focus by moving the camera. Rocking back and forth on your heels lets you "focus through" your subject more easily than turning the focusing collar on the lens.
- If your lens focuses past infinity, don't worry. It's fairly common and varies with the temperature. In practice, depth-of-field will usually cover the small amount of error at infinity, but to achieve precise focus you should focus by eye rather than relying on the focusing stop.
- You're more likely to get your subject sharp if you use a smaller aperture, especially with long lenses, but don't sacrifice a hand-holdable shutter speed in the name of stopping down. You will trade one kind of unsharpness for another.

OKAY, SO WHAT'S DEPTH-OF-FIELD?

There you are, at the end of a very long Thanksgiving table, say, with your camera at the ready. You want to commemorate the occasion, and you want everyone from Uncle George in front to Grandma at the back to come out sharp. This is a classic problem of **depth-of-field,** and to solve it you need to know a little about focusing and a little about lens apertures. Let's start with focusing. Should you focus on Uncle George, Grandma, or somewhere in the middle? The answer is none of the above.

At any point of focus, whether it's 2 feet or 100, there is a broader area that will appear fairly sharp—the "fudge factor" familiarly known as depth-of-field. Part of this zone of sharpness extends in front of the focus point, and part trails off behind it. Now here's the important thing to remember: of the total depth-of-field zone, about one third lies in front of the point of focus and two thirds lie behind it.

Let's go back to the Thanksgiving table. If you focus on Uncle George, who is closest to you, you'll be "wasting" one third of the

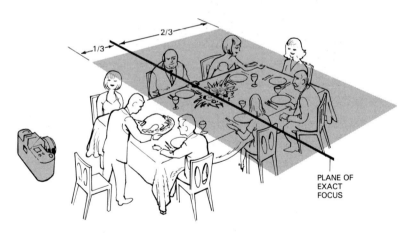

The classic depth-of-field problem: how to focus to get everybody sharp? Focusing in the middle distance doesn't work because only a third of the area of focus falls in front of the lens; the rest lies behind it. So to get all the Thanksgiving diners as sharp as they can get, focus a third of the way down the table.

depth of field that's in front of him. If you focus on Grandma at the back, you'll be giving away the two thirds behind her. If you focus exactly in the middle, Grandma may come out sharp, since she's probably within the two-thirds zone, but chances are Uncle George will look fuzzy because only a third of the depth of field is left for the front end of the table.

The correct move is to focus at a distance that's a third of the way down the length of the table. Even if it means focusing on the brother you stopped talking to twenty years ago, it's your best hope of getting everyone sharp from one end of the table to the other.

But hold on, you may say, I've got a camera that focuses automatically. Why should I have to worry about this focusing stuff? You do because most auto-focusing cameras have no knowledge of depth-of-field. There are exceptions—the Canon 650, for one—but they tend to be fairly advanced, fairly expensive cameras.

Taking care of depth-of-field with a simple auto-focusing camera is a piece of cake, however. Simply point the lens at whoever is sitting a third of the way down the table, lock in the focus by pressing the shutter release partway down, recompose the picture, and press the release the rest of the way. This works like a charm unless your camera happens to lack such a "focus lock" or "focus hold" feature.

Of course focusing a third of the way into the scene does not guarantee that Uncle George and Grandma will be sharp. To complete the solution to the problem, you have to worry about what aperture you're using. Here, many point-and-shoot photographers are out of luck since the camera doesn't let on what aperture is in use, much less let you adjust it. But if you are able to pick and choose apertures, you can consult your lens barrel to find what f-stop is needed to supply front-to-back sharpness. Engraved on most lenses is a bunch of color-coded parallel lines that indicate the "spread" of depth-of-field at several apertures. Read the distances on the focusing scale that are nearest the pair of lines for the f-stop you've chosen, and you'll know about how much of the picture will be sharp.

This way of working is pretty old-fashioned, I admit. Lately lens makers have even stopped putting depth-of-field scales on

their products, figuring that nobody knows what they are. If your lens lacks them, use the stop-down lever on the camera (if yours has one) to preview depth-of-field directly. It closes the lens from maximum aperture, needed for viewing, to the aperture at which the photograph will be taken. Remember that at any focusing distance, the zone of sharpness will be larger (or deeper) with a small aperture than with a big one. In other words, f/16 is a better bet than f/4, provided you don't end up with the shutter open for half a second.

When using a flash, you can often choose your lens aperture through the flash unit. Look on the back of the flash and see if you have a choice of several "auto flash" apertures. If you do, pick the smallest one that will still give you enough light to brighten the end of the table. If you have a "smart" camera and flash combination, the flash will tell the camera to set the correct aperture. If your camera is without any computer parts, you'll have to set the auto-flash aperture manually.

There's one last wrinkle to the depth-of-field problem. At any given aperture and focal length, the zone of sharpness will be greater when the point of focus is at 8 feet than when it is set to 3 feet. That's because the total range of depth-of-field is always greater when you are focused farther away from the camera than when focus is set closer in. In other words, stepping back from the table, thus putting more distance between the camera and your relatives, will increase the chances of getting them all sharp. They'll also be smaller, but at least you'll recognize them.

USING DEPTH-OF-FIELD: ZONE FOCUSING

To help with the depth-of-field problem, there is a rather primitive focusing "system" known generically as **zone focusing** that can be superior to automatic focusing in some situations. First of all, it is fail-safe. One doesn't have to have the main subject in the center of the frame, and there's no hesitation between pressing the button and hearing the shutter go off. Plus there are no focusing "modes" or special buttons to worry about.

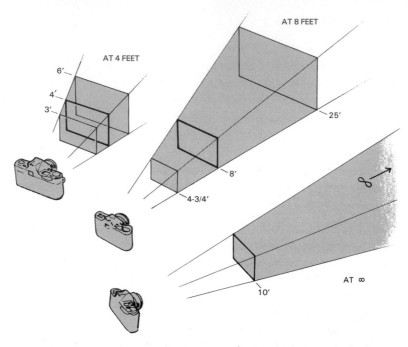

At a shooting distance of 4 feet, depth-of-field is relatively narrow compared to what it is at 8 feet. At infinity it covers an even broader range, but the two-thirds lying behind the point of focus is not utilized. To get the most depth-of-field in scenic subjects, then, you should focus slightly in front of the infinity marker on the lens.

More important, zone focusing provides more control over what is in focus and what isn't than automatic focusing does. With a little understanding of how distance, f-stops, and depth-of-field interrelate, you can decide easily what to have in focus and what to leave unsharp. It's also a simple matter to preset the lens to a focusing distance that will give you sharp pictures from up close all the way to infinity. That's what Kodak used to do on its simplest, least expensive snapshot cameras.

To master the trick of zone focusing for maximum depth-of-field, we need a camera that can focus manually and that provides depth-of-field scales on or near the lens. We also need to know about something called the **hyperfocal distance.** For practical purposes, hyperfocal distance can be defined as the point at which the lens can be focused while just managing to maintain depth-of-field all the way to infinity. Put another way, it's the place

to focus if you want to get the most front-to-back sharpness in your pictures.

An auto-focusing camera can't find the hyperfocal distance, but you can. Start by turning the lens so the infinity mark on the lens barrel lines up on the lens's depth-of-field scale with the f-stop you're using. Read the distance that the lens is focused on. Let's say your aperture is set for f/8 and that with the infinity mark on the f/8 line of the depth-of-field scale the lens is focused at 15 feet. That's the hyperfocal distance. Presto! Everything beyond 15 feet will now be in focus when you take the picture. Even better, the zone of focus also extends in front of hyperfocal distance—in this case, to about 7½ feet—so the actual range of focus is from 7½ feet to infinity.

A lens set to get the most depth-of-field for the aperture in use—in this case, f / 8. As the lens's depth-of-field scales show, sharpness will extend from about 7½ feet all the way to infinity when the point of exact focus is set to 15 feet. This is an example of zone focusing, which is possible only if you focus manually.

If you need even more of the foreground to be in focus, stop down the lens and reset the focusing distance accordingly. There's no need for complex calculations, just turn the focusing ring enough to put the infinity mark on the depth-of-field scale for your new f-stop. To know how close the near focusing distance is, look on the other side of the depth-of-field scale.

Zone focusing at the hyperfocal distance is the best way I know

to maximize your chances of a sharp photograph, but it serves certain purposes better than others. For example, it's great for landscapes, cityscapes, and other scenes in which there is great depth. It's *not* so great for portraits, however, since in a portrait you often want the subject in precise focus and the rest slightly out of focus.

If your cup of tea is candid shooting of strangers, on the street or elsewhere, zone focusing is an ideal way to capture what Henri Cartier-Bresson called "the decisive moment." But in this kind of close-in shooting, the hyperfocal distance may not suit the purpose. Instead, you might want to focus on a distance that will give you adequate depth-of-field in a range of from 5 to 15 feet. This "cushion" lets you fire away instantly in fast-breaking situations when there is no time to focus accurately.

DISADVANTAGES OF FOCUSING MANUALLY

Okay, you might well ask, if manual focusing is so great, why the current stampede to automatic-focusing cameras among single-lens-reflex users? Well, you've just backed into one of photography's less-than-well-kept secrets: for as long as conventional single-lens-reflex cameras have been built and sold, their owners have found them darned difficult to focus.

How many of us, after all, enjoy squinting into an opening the size of a dime while simultaneously turning a ring on the lens and watching a small dot in the center of a dim viewfinder screen—the procedure required for focusing a conventional SLR camera? The advantage of the SLR design, that one can look through the lens and see exactly what will be recorded on film, is also its Achilles heel. Because the view in the viewfinder comes through the lens, it is limited by the lens.

The major lens limitation that affects focusing is the lens aperture. If the maximum aperture is small, say f/4, the light that reaches the focusing screen inside the camera's pentaprism will be pretty dim—especially indoors. If it is relatively large, say f/1.4, then the focusing screen will appear relatively bright (assuming

that the lens has an automatic diaphragm, as all modern lenses do). A brighter screen, needless to say, makes for easier focusing.

This explains why in the early days of SLR development camera makers raced to develop faster lenses. The f/1.4 "normal" lens became the standard for professionals, and some carried large chunks of glass with an f/1.2 aperture. These were great for the then-popular style of "available light" photography, and they made for fast and fairly easy focusing.

Unfortunately, these speedy apertures were available only in 50-millimeter focal lengths. When a pro turned to a wide-angle or telephoto lens, the aperture squeezed down to f/2.8 or less. With wide-angle lenses the focusing situation was exacerbated because the subject seemed farther away. The opposite was true of telephotos, but they had the nasty tendency of blacking out the focusing spot in the viewfinder, rendering it useless.

Since these early days, lens designers have made tremendous strides in terms of lens speed, producing ultra-fast wide-angle and telephoto lenses that are much easier to focus than their predecessors. But just as these lenses were being gobbled up by the pros, amateurs were taking to zoom lenses like pancakes to maple syrup. Whatever great advantages zoom lenses have, however, speed is not one of them. Today their maximum apertures are usually in the range of f/3.5 to f/4.5.

Nikon's ultra-wide 20-millimeter lens has a maximum aperture of f/2.8, providing a fairly bright viewfinder image for easy focusing. Zooms with much smaller maximum apertures, such as f/4.5 or f/5.6, make the viewfinder relatively dim and focusing relatively difficult.

In a word, zoom lenses are hard to focus. This may explain why so many workshop students, carrying fancy cameras and fancy zoom lenses, have shown me pictures that are good in every respect except one: they look fuzzy. Although smaller apertures mean more depth-of-field at a given distance, they don't supply enough of a fudge factor to cover all focusing sins.

To increase the chances of getting proper focus with a zoom lens, focus at the longest focal length available and then zoom back to the precise framing you have in mind. At the longer focal length you'll have a closer, clearer view of the subject. This procedure works only with "true" zoom lenses, those that maintain a single focus throughout the zoom range. The newer breed of "varifocal" zoom designs, while improved in other respects such as lens speed, require refocusing at each and every focal length.

Another culprit in SLR focusing difficulties is the viewfinder screen itself. Because of the technicalities of viewfinder construction, the screen filters out a stop or two of the light transmitted by the lens. Thus even less light reaches the eye, and focusing is made more difficult. Within the last two years, though, several of the leading Japanese companies have introduced new, high-transmission screens as standard equipment on their current cameras. These screens can double the brightness of what one sees in the viewfinder. They also often have improved microprism and rangefinder spots. Many owners of SLR cameras with interchangeable screens can upgrade their viewing systems simply by switching to a newer screen.

Meanwhile, an aftermarket industry in focusing-screen "intensification" has arisen, designed especially to benefit those with fixed-screen cameras. Several small firms offer the service, which requires dismantling the camera to get at the screen and replacing the screen or coating it with proprietary secret ingredients. (If the idea of a brighter screen appeals to you, contact your camera repairman or repair service about the best step to take for your particular brand and model.)

The first thing to do if you have trouble focusing, however, is to have your eyes checked, alone and in conjunction with the camera. Sometimes a diopter-correction lens is needed to bring the focusing screen itself into focus. These low-power eyepieces mount onto the

back of the viewfinder and are supplied by most camera makers. An optometrist can help you select the best diopter adjustment, or you can shop for one yourself at a well-equipped camera store.

A REVIEW OF CHAPTER FOUR

1. Manual focusing in SLR cameras is done with focusing aids built into the finder screen—including a rangefinder and/or a microprism—and with the ground-glass screen itself.
2. Depth-of-field is the area of adequate sharpness in front of and behind the point of exact focus. A third of this zone lies in front of the focus point and two-thirds lies behind it.
3. Zone focusing is a way of setting the focus of the lens to produce a sharp image within a predetermined range of distances. The particular settings and the size of the depth-of-field depend on the aperture you are using.
4. Setting the focus to the lens's hyperfocal distance gives you the most depth-of-field for any given aperture, extending all the way to infinity. To set it (and to zone focus), your lens must have depth-of-field scales on its barrel.
5. Manual focusing does have disadvantages. Zoom lenses, especially, are difficult to focus because of their small maximum apertures. Focusing at the longest focal-length setting and then zooming back often helps, as can a brighter focusing screen.

FIVE

The Joys of Electronic Flash

In case you haven't figured out the origin of the bright burst of light that issues from your camera when you press the shutter, here's a flash primer covering its abilities and disabilities, sync speeds, flattering flash light, fill-in flash, and no flash.

One technological leap forward that has made its presence felt more quietly than most is the integration of electronic flash into today's cameras. Rare is the point-and-shoot camera that lacks a built-in flash somewhere within its black casing, and now auto-focusing single-lens-reflex cameras are starting to sport pop-top flashes as well.

This is quite a switch from twenty-five years ago when the only photographers to be seen carrying flash units in broad daylight were grizzled professionals. Electronic flash—the invention of Harold Edgerton in 1933—was considered an accessory for the advanced photographer. When the sun went down, casual snapshooters put their cameras away.

In the 1960s the Honeywell company pioneered the automatic electronic flash. With auto flash a photographer no longer had to get out a slide rule and an abacus to figure out what lens aperture

to set; the flash regulated its output according to feedback from its own light sensor. Today, automation is much more advanced, to the point that computer chips within the camera can sense the flash output, judge its relation to the existing ambient light, and simultaneously regulate the aperture, the shutter speed, and the duration of the flash.

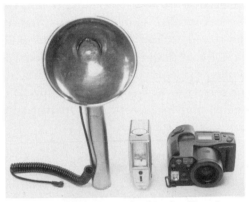

A short history of flash, from flashbulbs like those used by news photographers in the 1940s (left) to an early model of automatic flash made by Honeywell (center) to today's tiny, built-in units, which are controlled by the camera's electronic exposure system, as seen in the Olympus SuperZoom 300.

Practically all flashes are now automatic, and most are **dedicated**—meaning that they are specially designed to interact with a specific brand and model of camera. (Alas, every brand has its own, proprietary set of flash contacts.) But not all flashes are equal. Some are more powerful than others and, all things being equal, you want to get the most flash bang for your buck. But how do you compare one flash's output with another's?

COMPARING FLASH POWER

It should be easy, but it isn't. Flash power is measured in a confusing variety of ways. Large, studio-type flash units are rated according to watt seconds (WS), which is a measure of their storage

capacity. A second flash measurement is beam candle power seconds (BCPS). BCPS is an expression of how much light will reach a subject at a standard distance. While the numbers are abstract, they are ideal for comparing one flash unit's power with another's. Unfortunately, these days few manufacturers bother to give BCPS ratings.

That leaves **guide numbers**, sometimes abbreviated GN. A guide number is practical; given in feet or meters, and for a particular film speed, it can be used for calculating exposure settings. Let's say your flash has a GN of 80, your film is rated at ISO 100 (a number that tells you its sensitivity to light; see Chapter Six), and your subject is 10 feet away. Dividing 10 (the distance) into 80 (the guide number) gives 8, the aperture. Presto! Set f/8 and the picture should be perfect.

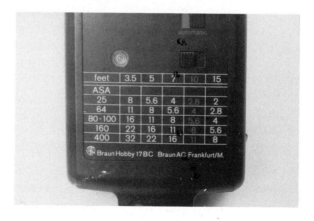

feet	3.5	5	7	10	15
ASA					
25	8	5.6	4	2.8	2
64	11	8	5.6	4	2.8
80-100	16	11	8	5.6	4
160	22	16	11	8	5.6
400	32	22	16	11	8

Braun Hobby 17 BC Braun AG Frankfurt/M.

The panel on the back of this Braun 17BC unit lets you know which aperture to use at a given distance with a particular speed of film (ASA speed ratings are the same as today's ISO ratings). For example, with ISO 100 speed film and a subject at 5 feet, you would set the lens to f / 11. That means the flash unit has a guide number (GN) for ISO 100 of 55.

To understand the basis for these calculations one needs to know that light's intensity decreases with distance exponentially, not geometrically, according to the "inverse square law." For instance, if I move my flash from being 1 foot from my subject to

being 2 feet away, I need to quadruple the light, not double it, to keep the same exposure. That's because I'm now illuminating 4 square feet, not 1. The short-form rule for adjusting the camera is that for every doubling of distance, open the lens two f-stops. (Each f-stop doubles the light; thus two of them quadruple it.)

Those of us with automatic and built-in flash units no longer have to perform these calculations, but guide numbers remain important numbers because they tell us just how far away we can be and still have our subject fully exposed. Let's go back to my example of GN 80 at ISO 100, and let's say the maximum aperture of my lens is f/4. I divide 4 into 80 and the answer is 20 feet—the farthest I can be from my subject with this combination of lens, flash, and film.

It isn't hard to figure out the limits of battery-operated flash units. Practically all of them come with a dial or a chart that, once deciphered, tells the maximum and minimum distances at which they can be used. The list of settings for manual operation are the key: first set the proper film speed, then look at the distances marked for your lens's largest and smallest apertures.

Comparing light output of competing flash units should be easy, but it isn't. Take the Pentax IQ Zoom. According to Pentax, its flash has a GN of 13 at wide-angle position and 16 at telephoto position, with ISO 100 film. These numbers are for meters, not feet. Also, the camera's zoom lens has a variable maximum aperture of f/3.5–6.7. In laymen's terms, this means a maximum range of about 12 feet at wide–angle position and 7½ feet at telephoto.

But Pentax's technical data lists the maximum flash ranges as better than 16 feet and 10 feet, respectively. What gives? Says Pentax: "These ranges are calculated by taking the latitude of current color negative films into consideration." In other words, a fudge factor for underexposure is built in. With most color-negative films the result won't be disastrous, but slide-film users should stick to the guide-number ranges, since slide films are much more sensitive to exposure errors.

Calculating realistic flash limits from manufacturer-supplied guide numbers can be difficult, as the above example suggests. (I had to convert meters into feet, at 3.27 feet to the meter.)

Nevertheless, it is the only practical way to tell in advance how useful any camera's built-in flash will be in practice. If you later find that your flash pictures consistently come out too dark and you're able to adjust your lens, use a larger aperture than suggested. If you need to reach farther than the maximum flash distance you've calculated, switch to a higher-speed film—in effect "uprating" the guide number.

Remember, however, that no matter how powerful your built-in flash, it will not light up the action in a football stadium at night.

SYNC SPEEDS

With the leaf shutters built into point-and-shoot cameras, the brief burst of light from an electronic flash unit will fully expose the film at any speed. But single-lens-reflex cameras have focal-plane shutters that can synchronize with electronic flash units only at relatively slow speeds. Back in the dark ages the top speed was $\frac{1}{30}$ second, then it grew to $\frac{1}{60}$ second. There it rested until a few years ago, when $\frac{1}{125}$ and even $\frac{1}{250}$ second **sync speeds** became possible.

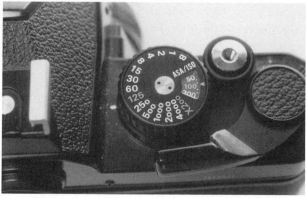

The shutter-speed dial of my Nikon FM2, a manual-exposure camera, highlights $\frac{1}{125}$ second as the highest regular speed for flash synchronization, but adds an "X200" label for flash sync at $\frac{1}{200}$ second. A flash picture taken with the shutter set to $\frac{1}{250}$ second would be missing a piece since the shutter curtain would get in the way.

The limitation on using fast shutter speeds with flash has to do with the internal workings of focal-plane shutters, which are used in SLR cameras to eliminate the chore of putting shutters in interchangeable lenses. A standard focal-plane shutter consists of two curtains, which during exposure slide across the rectangular area in front of the film, one chasing the other. At slow speeds they pause for breath; at fast speeds they zip across. When they zip across at very high speeds, the second curtain begins to follow the first curtain before the first curtain has cleared the film area, creating a slit that moves across the film.

Used with a constant light source, the small slit size is not a problem. The gap between the two curtains moves across the film plane at a constant size and speed, ensuring an even exposure. But if the light is virtually instantaneous, as it is with the light from an electronic flash, only part of the film receives the full exposure at very high shutter speeds; the speeding curtains block off the rest. If you have ever made a flash picture that turned out with a black band on one edge or the other, you now know the reason why.

This limitation of the focal-plane shutter in part accounts for the reluctance of many studio and wedding photographers to use 35-millimeter cameras. They like to have all their options available at all times, and with professional-grade leaf-shutter cameras, like the super-expensive Rolleiflex or Hasselblad, they do. The design of leaf shutters, which generally reside inside the lens, allows them to function with flash at all marked speeds—usually meaning up to $\frac{1}{500}$ second.

Makers of focal-plane shutters have long labored to end their flash inferiority complex. They've used titanium instead of fabric to lighten the weight of the curtains, and they've stood the shutter sideways so the curtains go top to bottom instead of side to side—a shorter trip by a third. These innovations account for the $\frac{1}{125}$ and $\frac{1}{250}$ second top sync speeds found on some current SLRs. But as yet no one has invented a shutter to match the leaf shutter's $\frac{1}{500}$ second.

There is, however, another way of solving this problem, as Olympus, a camera maker known for its design ingenuity, has discovered. Instead of trying to shoehorn more speed into the shutter, the Olympus designers decided to think about changing

What a difference a shutter makes: the titanium-bladed, vertical-travel shutter of my Nikon FM2, top, with a maximum sync speed of 1/200 second, is light-years more advanced than the fabric, horizontal shutter of my vintage Leica M2, which has a maximum sync speed of 1/45 second.

the nature of the electronic flash. A typical flash duration is about 1/1000 second. What, they thought, if it were even shorter, and instead of one burst there were several? From this kernel was born the Olympus F280 flash, the first flash to allow focal-plane shutter synchronization at any speed, even 1/2000 second.

The F280's flash tube is capable of putting out brief blasts of light at a rate of 20 kilohertz—twenty thousand pulses a second. The light from each burst may not be powerful, but the continual pulsing adds up at slower speeds. Moreover, the system is mated to Olympus's system, which means that with certain Olympus SLR cameras, proper exposure is taken care of by the electronics in the camera. Unfortunately, the Olympus flash works only with Olympus cameras that have off-the-film (OTF) automatic flash exposure measurement, such as the manual-focusing OM-4T or the auto-focusing OM-77AF. Other manufacturers have yet to jump on this particular bandwagon.

In the days of yore, beginning photographers—and even pros in a hurry—would forget to turn their shutter-speed dials to a speed at or below the marked maximum sync speed (often marked on the dial in red). The result was partial pictures. But modern electronic SLRs have eliminated this once-frequent slip-up; they automati-

The foreshortened look of this flash picture is the result of using too fast a shutter speed with a focal-plane shutter of the kind found in most SLRs. Happily, flubs like this are becoming rarer since automated cameras set the shutter speed to the proper "sync speed" even if the photographer forgets.

cally lower the shutter speed when either the built-in flash is turned on or an accessory unit is mounted on the "hot shoe" atop the camera.

GETTING THE LIGHT TO LOOK RIGHT

Practically speaking, few of today's modern shoe-mount flash units will let you shoot at distances greater than 50 feet unless you are using ultra-high-speed film. The AA cells on which they rely aren't capable of much more. The few units that do get over 50 feet have adjustable reflector housings that can be "zoomed," like a lens, from wide-angle to telephoto settings. At the telephoto setting they concentrate the light into a narrow beam, thus increasing its efficiency.

But even if units like these produce enough light to give an adequate exposure, its effect at such a distance is invariably harsh and unpleasant. That's because the greater the distance of the light source from the subject, the smaller it seems. Such a light source is hardly flattering, being essentially the opposite of the wraparound

umbrella lighting that portrait photographers favor. The light from the reflector of a portable flash will never seem as smooth as that bounced from an umbrella, but it's much more kind at close range. Because of this, and because of their power limitations, portable flashes are at their best when used with normal or moderately wide-angle lenses, or with zoom lenses confined to no longer than a moderate (100-millimeter) telephoto range.

To make the light even more flattering, many pros make it a habit to bounce the flash's output indirectly at the subject, using nearby walls, ceilings, reflectors or—in a pinch—the front of their shirts, preferably white. The advantage is a much broader,

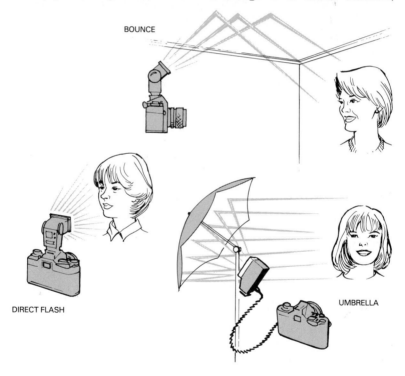

Three different ways to use flash: direct flash, the most common method, provides plenty of light but is unflattering to your subject; bouncing the flash into an umbrella, as studio portraitists do, or using a nearby wall or ceiling as a reflector produces a more diffused, flattering light at the expense of two or more stops of illumination.

smoother light; the disadvantage is that the light from the flash is dispersed, requiring an aperture two to four stops larger than for direct flash.

Calculating which aperture to use when using bounce-flash techniques is usually a matter of educated guesswork unless your camera features **through-the-lens** (TTL) or **off-the-film** (OTF) **flash** control. With TTL or OTF flash, the camera's built-in computer squelches the flash when enough light reaches the film. That's right, the film. A special light sensor inside the camera actually measures the light reflected from the emulsion during the time the shutter curtains are open. Obviously this kind of flash control is pretty sophisticated, so it's found only on SLR cameras.

To make bounce flash possible when the flash is attached to the camera, many units are designed with flip-top heads. Some also have swivel bases so that the flash light can be bounced off the ceiling in both horizontal and vertical positions. Ideally, a dedicated flash unit's head should be able to flip, swivel, and zoom.

A portrait taken with direct flash shows the harsh lighting quality typical of most snapshot photography as well as the shadows that often obscure parts of the subject.

This portrait, taken with bounce flash, displays the subject in a softer, more flattering light. By pointing the flash tube at the left-hand wall, the flash output was scattered and diffused.

FILL-IN FLASH

Back in the dark ages of photography, the most anxiety-producing technique known to camera-toting man or woman was called **fill-in flash.** It was meant to remedy a common problem of outdoor portraiture: too much contrast. Sophisticated photographers knew that just the right amount of light from a flash would eliminate unflattering deep shadows from under their subjects' noses, eyes, and chins.

The problem, of course, was figuring out just what "the right amount" was and how to deliver it. In my youthful days the complex calculations seemed to call for a slide rule. (This was before the electronic pocket calculator, I hate to admit.) Usually you aimed to get the flash exposure just a tad less than that provided by the existing daylight—henceforth to be called ambient light.

*An example of a portrait using fill-in flash technique. Here,
the ratio of the flash to the existing daylight is about
1 : 1—that is, about equally bright. The balance can be varied
to suit the situation and your taste, provided your camera
lets you choose.*

Here's an example: Let's say my meter measures the ambient light at an exposure of f/8 at ¹⁄₆₀ second. I look at the exposure dial on the back of my flash and find out that with the film I am using, the flash provides enough light for an exposure of f/8 at a distance of 6 feet from the camera. But to "fill" the shadows of my subject's face, I want one stop less flash exposure than "full," so I check the flash's recommended distance for f/5.6, which is around 8 feet. I then set the lens at 8 feet, the aperture at f/8, and the shutter speed at ¹⁄₆₀ second. Voilà! A perfect fill-in flash picture. Easy as pie, no?

But what if I didn't want to be 8 feet away from my subject? Well, I could figure it out backwards. Let's say I started out wanting to be 6 feet away, in the same light as before. Looking at my flash dial, I see that f/8 is recommended for full flash exposure. Since I want half of that for my picture, I would set the aperture to f/11. Then, to keep the ambient exposure what it was before, I'd change the shutter speed to 1/30 second. Bingo, another perfect fill-in shot.

Thank goodness for today's technology. Whatever else one thinks about modern electronic cameras, they have made fill-in flash available to all. SLR cameras such as the Canon EOS series, Minolta Maxxum series, Nikon N8008, Pentax SF-1, Olympus OM-77 AF, and Yashica 230-AF, for example, provide fill-in flash automatically as long as a compatible dedicated flash unit is used. Some call it "Synchro Sunlight," others "Daylight Sync" or "Cybernetic Sync."

Two advances are primarily responsible for taking the anxiety out of fill-in flash. One is the through-the-lens (TTL) or off-the-film (OTF) flash-metering system mentioned above. It allows all the light hitting the film to be measured by a photocell. The photocell relays the information to the camera's "brain," which in turn terminates the flash output at just the right moment. Since the camera has already measured the ambient light, it can easily tell when enough flash has been added.

The second advance enabling automatic fill-in flash is automatic focusing. Old-fashioned, manual-focusing cameras had no way to tell how far away the subject was and hence no way of knowing how much flash exposure was needed to enlighten it. A few of today's "smart" cameras with more electronic monitors than an intensive-care ward, such as the Maxxum 7000i, know exactly where the lens is focused thanks to electrical connections in the lens mounts. As a consequence, the camera can provide just enough flash light to supplement the ambient exposure without overpowering it.

Automatic fill-in flash is much more sophisticated than garden-variety automatic flash, which simply assures you that the flash output will expose the film adequately, and it is a step ahead of what is called TTL auto flash, which simply means that the flash

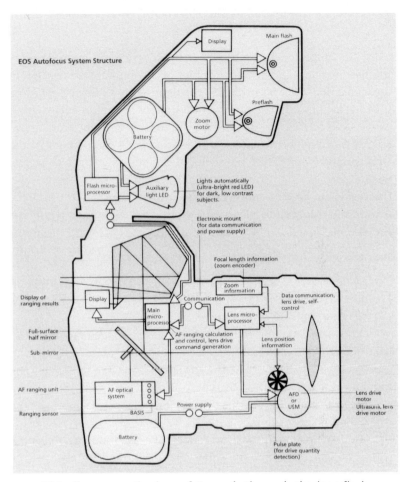

This diagrammatic view of Canon's through-the-lens flash control shows how electronic circuits connect the flash, lens, and auto-focusing system to produce accurate flash exposures automatically, even in daylight. The camera's computer measures the light hitting the film and simultaneously regulates the ambient-light exposure and the flash output, providing automatic fill-in flash.

exposure and the ambient exposure together will equal the amount of light needed by the film. The key difference between "auto fill-in flash" and "TTL auto flash" is one of proportion: for true automatic flash fill, the ratio of ambient to flash light must be controlled.

Most of the cameras capable of automatic fill-in flash let their

computer chips decide the best ratio in any given situation. Usually the flash exposure is set to about half of the ambient exposure, but it can and does vary according to the lighting conditions. That's fine if you are not particularly fussy about your results. Other cameras—such as Nikon's N8008 and F4—let you remain in control of the fill-flash ratio. By setting a switch on the back of the companion Nikon SB-24 electronic flash, you can select your own flash-to-ambient light ratio, from one stop more flash exposure to three stops more daylight exposure. It may seem like a step back toward my trusty slide rule of yore, but it's nice to know you have the option.

What about fill-in flash with point-and-shoot cameras? Many models sport a "fill flash" button that lets you fire the flash in situations when the camera, left to its own devices, wouldn't. In most cases you use one finger to press the fill-in button while another finger presses the shutter release.

The most frequent picture-taking situation calling for fill-in flash is a portrait taken outdoors in which the person's face is in shadow or in harsh, unattractive sunlight. "Fill" light will erase the wrinkles, bags, and other cosmetic unsightliness that result from noonday sun and will conquer the shadows that otherwise mask the expression you're trying to capture.

At other times a fill-flash button can be used indoors. If you're using a high-speed film in relatively bright indoor spaces, the camera may recognize that flash isn't needed, but while it isn't necessary for a good exposure, it may give you a better view of your subject. And if you are using daylight-balanced film (see Chapter Seven), it will keep your picture from turning out orange.

Let's say you're interested in recording the inside of a room but the wall in front of the camera is full of windows. If it's daytime, the camera's meter is going to expose for the light coming from outside and in the process underexpose what is in the room. One solution is to enlist the fill-in flash feature. The flash's burst of light will allow you to see details inside but won't overwhelm the light outdoors. Be careful, of course, that the camera isn't pointed straight at the windows, or else you'll get a "hot spot" in the middle of your picture.

There are other times when you will want to turn off the flash.

Case in point: your subject is standing in a hallway underneath a skylight, which is letting beautiful, diffused natural light fall inside. Since the light of a flash is enough to spoil the effect of the natural light, you should hold down the camera's "no flash" button while pressing the shutter—assuming, of course, that the camera has such a control.

You also don't want the flash to go off when you're in a museum and have just walked by a sign that says "No flash photography permitted." (Flash light may contribute to the fading of pigments in paintings. You wouldn't want to fade the Mona Lisa, would you?) Instead of being embarrassed, just hold down the no-flash button and fire away. And you should thank the museum for its trouble; most flash pictures of framed artworks turn out poorly, thanks to unanticipated and unwanted reflections.

Both add-a-flash and antiflash buttons can come in handy during an average sightseeing tour or family get-together. And as far as features go, they're simple enough so that neophyte users don't think they're using a "complicated" camera.

A REVIEW OF CHAPTER FIVE

1. If you can, use guide numbers (GN) to find out how far away you can use your electronic flash. Be wary of the promises made in your instruction book.
2. With SLR cameras using focal-plane shutters, observe the maximum sync speed (unless, of course, your camera sets the shutter speed automatically). Pictures taken at too high a speed will be truncated by a band of darkness or solid black.
3. Bounced flash light looks better than direct flash but uses up more of the flash's power. Through-the-lens flash exposure and a tilting flash head make bounce flash easy.
4. Fill-in flash is used to eliminate unflattering shadows in portrait and other situations. Some cameras control fill-flash exposures automatically, and some do it better than others.
5. For users of point-and-shoot cameras with flash units built in, fill-flash and flash-off controls allow some flexibility in lighting your pictures.

SIX

Choosing and Using Film

Decisions, decisions: color or black and white? prints or slides? fast or slow ISO? high or low contrast? to push or not to push? What film should you be using, anyway? Plus words of advice about off-shore imports, DX codes, and reciprocity failure.

Which to choose? Films come in a wide—and sometimes bewildering—variety of types and brands. Whether you shoot color or black and white, slides or prints, in bright sun or dead of night, you can bet there's a film specifically designed for your needs.

COLOR, THE KING OF THE HILL

In the beginning, photographs were black and white. It took scientists nearly one hundred years after the invention of photography to perfect the first film capable of capturing the world in natural, living color. Even today many photographers consider black and white the only format for "serious" photography. If you take a course to learn photography, chances are you will be taught to expose, develop, and print black-and-white film.

But outside the ivory tower of serious photography there is little enthusiasm left for black-and-white film. According to the *Wolfman Report,* which monitors the photographic industry, about 97 percent of the photographs taken these days in the United States are color. Of these, 90 percent are shot on **color-negative film,** for making prints. Clearly amateurs are all in favor of color, and so are the many pros who take pictures for magazines and advertisements. The latter generally use **transparency** or **slide films.**

Color used to be harder to use because it was "slow"; that is, its sensitivity to light, expressed as an **ISO number,** was lower than that of black-and-white film. (For those of you with good memories, ISO numbers are the same as ASA numbers; the only difference is the initials.) Now, however, color film is available in faster speeds than black-and-white film, and much of the competition among film manufacturers in the last five years has focused on producing faster and faster color emulsions for both slide and print films.

Why do schools continue to teach black-and-white photography despite the benefits of color? It's partly habit, but it's also because black-and-white remains the standard of quality in many minds. Only in the last dozen years has color come to be accepted as a legitimate form of expression in the world of galleries and museums, even though its use became widespread in magazines, books, and snapshots long ago.

The longstanding bias against color in the realm of "serious" photography is based on several arguments. For one, it was long felt that it was too exaggerated, that the spectrum of color incorporated into color film was gaudy and garish. When color film progressed so that this complaint no longer held water, another

objection surfaced—color photography was too literal. Roughly translated, this means that black-and-white pictures, being more divorced from reality, were better at expressing an individual's point of view or a mood. Black-and-white picture-making was seen as an honorable craft, each print being made by hand, whereas color photography smacked of the processing lab and mass production.

YOUR CHOICE: SLIDES OR PRINTS

The rivalry between color prints and slides is an ancient one (forty years old, anyway). It used to be that slides were a sign of seriousness, used by that most elusive of breeds, the "serious amateurs." Prints were for casual snapshooters, the folks with Kodak Instamatics whose first pictures usually were taken at Disneyland.

Twenty years ago the two camps were neck and neck in terms of the number of exposures clicked per year. Today, however, the print-film users shoot more than ten times as much film. There are several explanations for the change. One of the most salient is that color-print film is inherently more forgiving of exposure errors. Overexpose transparency film a stop and you get a slide that looks as though it was bleached in Clorox. Overexpose print film to the same degree and all you get is a denser negative.

Camera and film manufacturers together have realized that their customers are happier when their pictures come out—the more successes per roll, the merrier the photographer—so as consumers we have been encouraged to think of photographs as small pieces of paper coated with a memory-holding emulsion.

Until recently the widely advertised idea that memories should be entrusted to color prints clashed with scientific reality: color prints tended to fade relatively rapidly, as did the negatives from which they were made. It may not have been obvious in ten years or even in fifteen, but the gradual disappearance of color was inevitable. Trust your memories to color-print film? Only if you wanted to forget.

Color slides fade, too, but in most cases the process is much slower. The most permanent, fade-free color film family has always been Kodachrome. Kodachrome films from the forties still look terrific. Unfortunately, one can't say the same for vintage Ektachrome slides from the fifties, which now look a ghastly purple.

Film technology has improved lately, however, so that most color slides and color negatives around today will probably last a human lifetime. For those of us with stubborn streaks, slide films still seem to be safer bets in terms of longevity. For those of us with penurious streaks, slides have an even bigger advantage: they're cheaper to shoot.

With color-print films the developing lab usually develops the film and then exposes and processes a print for every negative on the roll. With color-slide film the lab just develops the film, cuts it up into frame-size pieces, and puts each slide into a mount. Obviously the processing bill is going to be higher for the prints.

Of course you can always ask for a color **contact sheet** instead of getting a print of each negative. It's simply a negative-sized record of every frame on your roll, all on one 8½-by-11-inch sheet of paper. But have you ever tried to explain to a drugstore clerk what a contact sheet is? Good luck.

Okay, cheapskates like me go for slides because the per-image cost is less, but quality-minded cheapskates also like the less apparent grain of transparency emulsions and the cleanness of their color. Properly processed, a slide reproduces the world with remarkable accuracy. There's none of the decision-making that goes on in the printing process. In terms of image quality, transparencies have it all over prints.

Slide films also come in various types intended for use with different kinds of lighting. **Daylight films,** the most common, are color balanced for use outdoors or with electronic flash units. **Tungsten films** are balanced for special photo floodlights and serve well enough under normal household illumination. Shoot daylight film indoors, and your slide will look too orange. Shoot tungsten film outdoors, and you'll see blue. Used with the proper lighting, slide films can reproduce colors with great exactitude.

For all their technical and economic advantages, slides lack one essential real-world quality: they can't be passed around a table

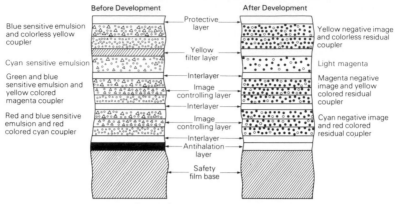

Before Development After Development

Blue sensitive emulsion and colorless yellow coupler — Protective layer — Yellow negative image and colorless residual coupler

Cyan sensitive emulsion — Yellow filter layer — Light magenta

Green and blue sensitive emulsion and yellow colored magenta coupler — Interlayer — Image controlling layer — Interlayer — Magenta negative image and yellow colored residual coupler

Red and blue sensitive emulsion and red colored cyan coupler — Image controlling layer — Interlayer — Antihalation layer — Cyan negative image and red colored residual coupler

Safety film base

A typical color film, seen in a greatly enlarged cross-section, consists of a multitude of microscopic layers. The color part of the emulsion is usually contained in three layers; in the case of Fuji's Reala film, however, a fourth layer is added to produce more lifelike colors. Obviously, making color film is a complex and costly art.

from hand to hand while people point out their second cousins and in-laws lurking in the background. To look at slides requires a projector or a lightbox. The projector sets up a public dynamic that's like going to the movies. You sit there, usually with friends and family, while pictures parade past your eyes. You can't touch them, you can't examine them, and unless your finger is on the projector button, you can't control how long the experience will last.

Conversely, a lightbox is a solitary business. It's just one person, a magnifier, and one slide at a time. That's great if you want to commune with the experience of each image, but in social terms it's like playing solitaire.

Prints are much simpler. We pass them around, holding on to some longer than others, pointing out where we saw the hummingbird before it flew off, exclaiming at baby's expression. If photography is a means of sharing our experiences of the world in a convivial spirit, then prints have it all over slides. It's no wonder we shoot ten times as many.

PICKING A FILM SPEED

Here's a scene I see almost every time I go into a camera store: Harry the hapless customer walks up to the counter and asks for a roll of film.

"What kind?" the clerk queries.

"I dunno, the kind that makes color prints," Harry replies, acting as if he's on an errand for his wife.

"What speed—100, 200, 400?" the clerk asks, trying to be helpful.

Harry shrugs.

"Well," says the clerk, "what are you going to shoot?"

"You know, family things, indoors with flash, and then some outdoor stuff as well."

"Okay, you want 200 speed; it's good outdoors and with flash," the clerk advises with a flourish, sending Harry off with a roll of film he knows nothing about.

Such conversations always cause me to cringe. The truth of the matter is that a film rated with an ISO speed of 200 is not necessarily the right film for our hypothetical Harry. What is? To know the answer we'd have to ask him a lot more questions: what size he wants the prints to be, whether his subject has bright colors, what the lighting is going to be, and how fast things are going to be moving past his lens.

Film speed, which is basically a measure of an emulsion's sensitivity to light, is not an unmixed blessing. If it was, we all would be shooting Konica's 3200-speed print film. But as sensitivity goes up, other things happen. The size of the grains in the film's silver-laden emulsion tend to get bigger, sometimes masking fine details in the subject. The purity and strength of the colors tend to diminish, and contrast, which gives our images their "snap," decreases.

When we choose a film for its film speed, we are making a compromise. On the one hand, we want to get the kind of sharp pictures that fast shutter speeds and small apertures guarantee. On the other, we want the brightest, clearest, most lifelike color images we can get. The trick is to strike a balance between the two.

In the case of our hypothetical Harry, a 100-speed color-print

Seen by an electron microscope, film grain reveals itself as an array of platelike silver clumps. These are special tabular grains designed by film manufacturers to produce a less apparent grain structure than the irregular, round grains of yore. The development of tabular grains has improved all of today's films.

film would be fine outdoors in sunlight and indoors within the limits of his flash. A 200-speed film is "twice as fast"; that is, it provides a one-stop advantage over the 100-speed variety. In dim or overcast light, the one extra stop provides the luxury of doubling the shutter speed or narrowing the aperture one stop.

With flash, the one-stop difference means an increase in the maximum distance between the subject and the camera. For Harry, this might be a major plus, especially if his flash is a tiny, built-in type. Instead of being limited to a distance of 8 feet, for example, he could take pictures from 11 feet away.

What if we want to photograph future Olympians at a skating rink without using flash? Because skating rinks are relatively dim and skaters relatively fleet, we need all the action-stopping help we can get. A high-speed film of ISO 400 or higher can save the day.

But you'll also notice, if you look carefully at the results, that a kind of sandy texture has crept into your pictures. This is a consequence of the faster film's bigger grain size, and it gets more noticeable the larger you make the picture.

What should you do if your camera is loaded with a fairly slow film and you really need a fast one? If it's color-print film and you can manually adjust the exposure or the film-speed rating, you can get away with underexposing the film up to a stop. In essence, this makes a 100-speed film do the duty of a 200-speed film. What gets sacrificed is something called **D-Max,** which is a measure for deep, rich blacks.

It should be common knowledge that higher-speed films aren't as adept as slower ones at reproducing detail, color, and contrast. But what film manufacturer is going to come right out and tell us that its 400-speed entry can't hold a candle to its slower brethren? In a booklet called "Guide to Kodak Films," for example, Kodak describes its Kodacolor Gold 100 film as "ultra sharp" and "super saturated," great for "close-ups, still lifes, and portraits." Kodacolor Gold 200, by way of contrast, has "all the speed you need to shoot in a broader range of lighting situations" and is ideal for "candids, the action shots, group portraits, and scenics."

What Kodak doesn't tell us, except by implication, is that its 200-speed film is less saturated, has less contrast, and is more grainy than its slower mate. That's not bad-mouthing it; it's just stating the facts. Compare the 200 to Kodak's 1600-speed Kodacolor Gold, and it will look fantastic.

It boils down to this: if you need the speed, then use a fast film. If you don't, don't. You'll even save money, since high-speed films sell for more than low-speed ones.

SETTING THE FILM SPEED: DX CODING

Over the past several years mysterious checkerboard-style squares have found their way onto the cylindrical cartridges of 35-millimeter film. These silver-and-black patterns are not merely decorative, they are the most obvious manifestations of a new

method of automatic film identification known as the **DX coding system.**

The DX code was developed by Kodak to meet the challenges of increasingly electronic camera design, automated film processing, and the demands of a public unwilling to deal with putatively complicated camera settings. Why anyone should feel that turning an aperture or shutter-speed ring is too complicated escapes me, but there's no doubt that a fail-safe system for setting ISO/ASA film speeds is a boon to carefree photography.

Checkerboard squares on the sides of 35-millimeter film cartridges comprise the DX coding system. Squares 2 to 6 tell the camera what the film's speed is; 8 to 10 the film's length, and 11 to 12 cue in the film type. Squares 1 and 7 are silver electrical contacts.

This is just what the DX system does: it automatically signals to the camera, by means of those checkerboard squares, the sensitivity of the film in use. It also can tell the camera how long a roll of film it is (36 or 24 exposures) and how particular the film is about receiving the exactly correct exposure (what is called, in photo jargon, the **exposure latitude** of the film).

The DX system can only function, of course, if the camera is intelligent enough to recognize its messages. All of the latest models of point-and-shoot and SLR cameras can. Open up the back of any of these machines and examine the chamber that holds the film cartridge; if a row of metal contacts is visible (usually they're

gold plated), the camera is equipped to make use of the cartridge's coded information.

Older cameras don't have the contacts the DX system needs. Does this mean they are outdated? Not by a long shot. It simply means that the photographer remains responsible for setting the film speed and knowing the length and exposure latitude of the film.

Part of the DX system does function with all cameras, contacts or not. Besides providing cameras with information, the system can also tell automated processing labs just what kind of film is inside the cartridge and, if it is negative film, how to print it.

These features are accomplished not with the silver-and-black checkerboard markings but with the bar codes that appear both on the cartridge and on the edges of the processed film. Resembling the checkout-counter hash marks found on cereal boxes that tell the cash register how much you owe, these bar codes reveal their secrets to laboratory processing and printing machines equipped to interpret them.

As mentioned above, it doesn't matter if your camera is *not* equipped to use the DX code; the film will still perform as advertised. The contrary is not necessarily the case. That is, *a non-DX roll of film in a DX-designed camera may wreak havoc on the exposure system,* giving film-speed readings that are way off base. Most systems will default to ISO 100, no matter what the actual film speed.

If you have acquired a camera in the relatively recent past, peek inside the next time you take the film out and see if it has DX contacts. (It may have as many as ten contacts or as few as three.) If it does, you should use DX-coded films. Fortunately, the DX system has been adopted by all the major film manufacturers, so you don't need to abandon your favorite brand.

THE ELEMENTS OF FILM: CONTRAST, GRAIN, SATURATION

Just what is it that puts zip into our photographs? To some minds the magic ingredient is **contrast.** What is meant by contrast in

photography is the amount of tonal separation in a picture, ranging from the brightest tones to the darkest. High contrast means a steep transition from light to dark, with few stops in between. Low contrast means a slow, long amble across the tonal scale.

Contrast is referred to in two ways. Normally, we call a scene contrasty if the light is a mixture of bright highlights and deep shadows, as it often is on sunny days in summer. Low-contrast lighting is found on overcast days or when the sun is behind a cloud. We also can talk about *film* being contrasty or low in contrast. This refers to its built-in ability to span the range of tones out in the real world.

All things being equal, a photograph with high contrast will seem more dramatic and will attract our eyes more insistently than an image in which most of the tones are middling. This is simple to see in black-and-white pictures, but it applies equally to color.

In terms of color films, slides have an inherent ability to reproduce more contrast—or a greater contrast range—than prints. This is part of the reason that slide shows look so much more impressive than passing around an album. Sure, slides have the advantage of size and a darkened room, but anyone who has seen a transparency and a print of the same subject side by side knows that slides seem more punchy.

Contrast isn't always beneficial to our pictures, however. Too much contrast can "burn out" the highlights and render the dark areas pitch black. The problem is the same in black and white and color. The contrast range of the film has to be matched to the contrast of the subject or vice versa. In other words, either you change the lighting or you change the film.

Scientifically speaking, the slower the film, the higher its contrast and vice versa. A 400-speed emulsion such as Kodacolor 400 is by nature less contrasty than a 100-speed film such as Kodacolor 100. However, since photographers often use high-speed films in situations in which the light is drastically uneven—as it usually is indoors and at night—the results can seem the reverse: pictures taken with high-speed films can *look* more harsh even if they are technically less contrasty.

Unfortunately, there's more to choosing a film than contrast, especially when it comes to color. First, there's that dreaded *bête*

*A high-contrast scene showing a wide range of light levels
from bright highlights to dark shadows. If your film is
inherently high in its contrast—as slow-speed films usually
are—then the range of illumination levels in the scene may
exceed the film's ability to record them. The result: "empty"
highlights and "solid" shadows.*

noire called **grain.** Grain is the visible sign of the sensitive silver particles that make photography possible. Fast films are generally more grainy because they need more silver, which makes for bigger clumps. A film that can be exposed at a speed of 1600 or 3200 is likely to give you a picture surface that looks as though it has been sandblasted—with pebbles instead of sand. Of course it all depends on how large a print you make and how closely you look at it.

Just as important an element is **saturation.** Based on my experience, I'd be willing to bet that in most photographers' minds saturation and contrast are hopelessly confused. Color saturation refers to the amount of color dyes deposited on the surface of the slide or print after it has been processed. Contrast refers to the density range recorded on the film. Needless to say, the two don't necessarily go hand in hand.

One of the most eye-boggling, colorific films on the market is Kodachrome 25. It's a fairly high-contrast slide emulsion, which makes it tough to use in full sunlight if you want detail in both the

A low-contrast scene in which the range of tones is relatively compressed. A film that is itself inherently low in contrast would make the scene seem dull and flat; a high-contrast film would give it more sparkle and "punch."

shadows and the bright areas of the scene. Yet it is also highly saturated, meaning that the scenes it records seem to pop off the screen. What makes Kodachrome images dramatic isn't so much their contrast as their saturation.

Higher-speed color films, of both slide and print varieties, tend to be less saturated. But in recent years Kodak, Fuji, Konica, and other film manufacturers have managed to narrow the disparity of saturation levels. So-called Process E-6 slide films, including the slower-speed Fujichromes, Ektachromes, and Agfachromes, have progressed to a point at which their saturation almost rivals the Kodachrome standard.

To make a long story short, if you want to maximize the chromatic drama of your color pictures, pick a highly saturated film—usually, if not always, a slow-speed one. If on the other hand you want the scene to have a misty, moody air, try a faster film, which is likely to have less contrast and less saturation built into it.

PUSHING FILM TO THE LIMIT

There is a time-honored technique for increasing the effective speed of black-and-white films called **pushing** or **pushed development.** Basically it consists of lengthening the time that the film is developed. If you expose a black-and-white film such as Tri-X at ISO 800 or twice its rated speed, for example, you need to increase the developing time about 50 percent—fifteen minutes, say, instead of ten minutes. The longer development increases the density of the highlights and midtones, though not of the shadows.

"Pushing" black-and-white film is simple enough if you do your own processing. It's usually equally simple to tell your camera store or lab that you've exposed the film for twice its rated speed and need extra development—a 1-stop push, in photo jargon. Any black-and-white lab worth its salt can accommodate your wishes, up to and including a 2-stop push, although it is likely to charge you more for the special handling.

But many photographers are unaware that color films can be push-processed as well. This is usually done to slide films, which are much more particular about precise exposure than negative

color films that produce prints. The process is the same as with black and white: you give the film one or two stops less exposure than would normally be called for and extend the time that the film is in the first developer (unlike black-and-white films, color films such as Ektachrome are developed twice).

The hitch here is that very few photographers process their own color films; most of us have to rely on the good graces of the people who do. Kodak's former processing services (now called Kodalux) and a number of professional labs can push-process certain color films on request; you just have to pay extra for it. (In Kodalux's case, you can buy a push-processing envelope for inclusion in its mailers.) Neighborhood labs that offer one-hour turnaround times, on the other hand, are not good bets for such individualized service since their profit margins depend on mass production and mass processing.

Which films take best to push processing as a speed booster? Those that are fast to start with, of course. There is no need to pay extra to speed up Ektachrome 100, say, when you can easily buy a roll of Ektachrome 400 off the shelf. The only reason for changing the development of a slow film is if you've mistakenly exposed it at the wrong ISO setting—in which case pushing can save the day.

Almost any film processed in E-6 chemistry (Kodak's name for its Ektachrome slide-film developing system) can be push-processed a stop or two to boost its speed. These include not only all the films in Kodak's Ektachrome family but also E-6 compatible films made by Agfa, Fuji, 3M, and others. The Kodachrome family of films can be push-processed, too, but only at labs catering to pros.

The prime candidates for push processing available today are Kodak's Ektachrome P 800/1600 and Fuji's Fujichrome 1600 D. Both are basically 400-speed slide emulsions designed to be pushed to greater heights through extended first-developer times. Both are professional films, meaning that they need to be refrigerated until use and that only full-fledged camera stores are likely to stock them. What's amazing about these high-speed competitors is that their grain is actually less obvious than that of 400-speed black-and-white film pushed to the same degree.

Are there losses that offset the gains of push processing? Is there such a thing as a free lunch? Speed-hungry photographers have to put up with increases in grain size and contrast and a decrease in the deepness of the black tone the film is capable of recording. This maximum black—our friend D-Max, short for maximum density—shades off into a weak gray when a film is pushed too far. How far is far? Currently, no film can survive with honors much above 3200 ISO.

One can, of course, take pictorial advantage of big grain, high contrast, and lowered D-Max, but unless you plan to cultivate a romantic, misty look, you'd be better off using a tripod or a flash unit and sticking to a high-quality medium-speed film in the ASA / ISO range of 100 to 200.

RECIPROCITY FAILURE

Have you ever taken pictures just after sunset and found later that they come out underexposed and in an unattractive shade of green? Have you ever had some of your flash pictures come out darker than they should? If so, you may have been a victim of what's known as **reciprocity failure.** What's reciprocity failure? Let's backtrack to some basics of exposure.

We all know (or we should) that the amount of light reaching the film and the film's density after development have a mutual relationship; that is, if we open our lens a stop, the on-film exposure should double. The same goes if we use the next slower shutter speed. Double the exposure, double the density. This one-to-one, reciprocal relationship is the base on which exposure measurement is built. But the relationship breaks down at the extreme ends of the speed spectrum. Instead of 30 seconds giving twice the on-film exposure as 15 seconds, it may produce only a third more density. This is reciprocity failure.

Every film reacts differently to short and long exposure times, but in general, here is what happens:

• With long exposure times (usually a second or longer), the film slows down, producing underexposure. Color film also changes

colors in weird and unsightly ways, producing overall color casts.

• With short exposure times (faster than $\frac{1}{1000}$ second), the film also loses sensitivity and underexposes. Color shifts are involved, too, although they aren't usually as noticeable as in long exposures.

Who shoots pictures at speeds shorter than a thousandth of a second? You do, if your automatic flash unit quenches its output based on exposure feedback. Automatic flashes of this sort can cut off in as little time as $\frac{1}{100,000}$ second—short enough to cause reciprocity failure in most films.

If you shoot color-negative film, you may not have noticed any of these so-called reciprocity effects. That's because color negatives have a built-in cushion, tolerating underexposure of a stop and sometimes more. Since most reciprocity effects are within this cushion, you don't see the underexposure in your prints. And unless you have a sharp eye you won't see any color shifts since the printing process tends to mask them.

Slides are another matter. Being sensitive to exposure variations of even a third of a stop, they readily show the effects of reciprocity.

To avoid reciprocity failure's unwanted effects, you need to consult the film manufacturer's recommendations. When data sheets came as separate pieces of paper inside every box of film, this was a piece of cake, but today we have to search for the information in places such as the publication *Kodak Color Films* (Publication E-77 from Kodak) or *Modern Photography's Photo Information Almanac* (no longer published), which reproduces both the Kodak chart and one for Fuji films. The only fly in the ointment is that both manufacturers keep upgrading their emulsions, and therefore these charts get out of date fairly rapidly.

What if you're stuck in Afghanistan on a moonlit evening and you don't have your reference library with you? As a rule of thumb, most slide films need about a half stop more exposure at 1 second times, one to one and a half more stops at 10 seconds, and at least two more stops at a minute or more. Since these shutter speeds are likely to be outside the range of your meter anyway, I'd

advise **bracketing**—taking shots with both less and more exposure than the meter calls for—like crazy.

On the short end of the scale, try increasing flash exposures by half a stop to a stop when you're focusing on a subject closer than 4 feet. The nearer you are to your subject, the shorter the auto-flash exposure will be and the greater the reciprocity effect.

Remember to always make your exposure compensations by opening the lens aperture. If you change the time the shutter is open, you'll also change the reciprocity effect!

In terms of color shifts, the possibilities are endless. Kodak films can go anywhere from too yellow to too red. If you are shooting under streetlights at night, these shifts may not be a problem; the colors are going to be strange anyway. If you want accurate colors, experiment with a roll beforehand. As long as you stay with the same film, its results will be consistent and therefore predictable.

GRAY-MARKET FILM

Recently, when buying two rolls of tungsten film at my local camera store, I noticed that the ends of the packages were ever so slightly different. Both said Ektachrome in big letters, and both had 160 (the film speed) printed on a band of blue. However, one package said Tungsten indicating that the film is balanced for artificial light, while the other package had two words in the same spot: Tungsten and Tungstene.

What I was getting, a close look at the fine print told me, was one roll of Ektachrome made in England and one made in Rochester, New York. The multiple languages were there because English-made films are commonly distributed throughout Europe, but they are not distributed, at least officially, in the United States.

In short, I had just bought a roll of **gray-market** film. The gray market involves the importation of goods that were not meant to reach these particular shores. Thanks to currency fluctuations, importers in this line of business can make handsome profits while still selling the goods at a better price than "official" distributors or importers. These distributors and importers may suffer (and they do), but the buying public apparently gets some great deals.

But the gray market is tricky. Film is sold, here and abroad, with an expiration date stamped on the box. The reason is simple: film "ages," and as it gets older the color balance changes and the speed often slows. Age is not the only thing that can change the characteristics of film stock; high temperatures and moisture are equal and quicker-acting agents. In short, film is not like a camera; it needs to be pampered and coddled during its relatively brief life span.

When Kodak releases a film from its Rochester factory, it knows just how long it will take, statistically, for it to get onto the camera-store shelf and from there into a customer's hands. It arranges for the film to "mature" to its proper color balance just before it is bought, giving colors the customer expects to see.

The English factory does the same bit of timing for its European customers, but what it doesn't figure on is that someone is going to put the film into the hold of a cargo ship and send it across the Atlantic. For weeks if not months the film sits there, without air conditioning and without a dehumidifier, a prisoner of modern economics. Sometimes it emerges without visible damage, but sometimes it's a shadow of its former shelf. And the expiration date may be getting perilously near by the time we see it.

Buying gray-market film, then, is a definite gamble—a gamble that some photographers figure is worth it because of the price advantages. Much of the gray-market film is sold by mail-order stores that specialize in having the lowest prices, and their customers appreciate getting the break. But in my case, I was patronizing a garden-variety, walk-in store, and gray-market film was being sold alongside the Rochester-made variety. To add insult to injury, I was paying the same price for the import as for the native product.

This isn't to say that film made in England or France is inferior to the made-in-America sort or that foreign companies such as Agfa, Fuji, or Ilford are at a competitive disadvantage selling their films here. When Ilford makes a film in England intended for the United States, it ships it so that it arrives in peak condition.

There are differences among Kodak films made in different countries, though. Some professionals, for example, used to swear that English Kodachrome had it all over the American version,

while others preferred theirs with a French accent. The distinctions are subtle, but they are there, and anyone trying out a batch from overseas would do well to test a roll in the beginning to assess the batch's overall characteristics. It might need filtration or a change in the exposure index before it suits your taste. If you're the experimental type, you may have a great time with gray-market film. If you're not, insist on the fresh-dated, United States–produced article.

A REVIEW OF CHAPTER SIX

1. Color film comes in two basic types: transparency film for slides and negative film for prints. Both types come in a variety of speeds, expressed in ISO numbers, ranging from very slow (25) to very fast (3200). Each doubling of an ISO number amounts to one stop more sensitivity to light.
2. The colors a film renders depend on the quality of the light reaching it. Daylight is more blue than tungsten light from a house lamp, so film makers manufacture both daylight and tungsten slide films. (Print films can be filtered when prints are made.)
3. Slide films have less margin for exposure error, also known as exposure latitude, than print films. They must be exposed more carefully, since even half a stop more or less exposure makes a visible difference in the result. For this reason many slide-film users bracket their exposures.
4. Slow films are inherently more contrasty than fast films, and also more saturated. Fast films are inherently more grainy. Which speed you choose depends not only on how much light there is but also on the nature of the scene you are photographing.
5. Color films are subject to reciprocity failure at very fast and very slow exposure times. When shooting at one second or longer, or when using automatic flash at close range, you need to increase exposure and, in some cases, add filters.
6. Gray-market films arrive here from overseas markets in ways

not intended by the film manufacturers. Unless you delight in the unexpected, stick to packages without foreign languages on them.

SEVEN

A Film-Buying Guide

An admittedly subjective survey of films
now on the market.

COLOR FILMS

Compromise is as much a part of the color film buying process as it
is of life. We'd all like to have an ultra-fast, ultra-sharp, ultra-vivid
emulsion residing in our camera bodies—preferably one that would
also countenance underexposure and overexposure without com-
plaint. We could then shoot away in all manner of conditions
without a care in the world. But such is the stuff of pipe dreams.

As the people who make color film like to point out, every color
film is a balancing act. There are five balls in the air: speed, grain,
sharpness, color, and latitude. If you increase the speed, sharpness
and color are likely to suffer. If you go for fine grain, the film's
sensitivity to light will decline. Film makers therefore have to
guess what will make you and the rest of the world's film consumers
happy. How close do they get to that goal? Remarkably close, if
you judge today's emulsions as a whole. In fact, film technology has
made great strides in just the last few years.

What's a "Pro" Film?

Ordinary color film is shipped "green," or immature, with the idea
that it will reach its peak of color balance and speed just at the
moment you take it off the dealer's shelf and start using it. Usually

this is just what happens. But professionals don't like to play the odds, so film manufacturers such as Fuji, Kodak, and Agfa have obliged by making special batches for them.

These **professional films** are shipped at their peak and are kept refrigerated to inhibit naturally occurring changes in the color balance of the emulsion. You should expose them the same day that you take them out of the refrigerator and ideally have them processed within twenty-four hours. If you shoot half a roll at Christmas and finish it on summer vacation, pro films are not for you. In addition, buying pro films by mail order doesn't make much sense.

What's the difference between professional film and its nonprofessional equivalent? Price, for one. A roll of 36-exposure Pro Fujichrome costs about 25 percent more than the regular emulsion.

The designation "professional film" does not mean that one must be a card-carrying pro to use it; its attractions are consistency of coloration and an accurately rated film speed. Film makers mark on each box the precise speed and the needed filtration, if any, of the particular emulsion batch that is found inside. This is the main reason pros use pro film: they need to get things right every time, without variation.

The rest of this chapter is devoted to an analysis of the films that are readily available at film counters in camera shops and elsewhere across the United States. My comments on their virtues and faults are based on my own experience shooting with them in real-world situations. I haven't done controlled tests, so my remarks are not scientific, but I have taken pictures that duplicate the kind that average photographers are likely to take themselves. And I haven't included every film on the market, just those that are widely available and highly regarded.

Print Films

Color-negative films, which produce color prints, traditionally have been formulated to meet the needs of photographers who like to take snapshots of their family, travels, and recreation. Because the print size of snapshots is less than 5-by-7 inches, film makers can

compromise on sharpness and grain in an effort to maximize film speed and provide a good cushion for exposure errors.

Most 35-millimeter amateur print films are moderately fast (typically 100 to 400 ISO) and fairly tolerant of under- and overexposure. The slower emulsions are very good in the grain and color departments, and even the faster ones do most subjects justice. Kodak, Fuji, Agfa, and other makers of the world's film have refined their recipes well over the years.

Kodacolor Gold 100, 200, 400, 1600

These are the latest iterations of Kodak's mainstay amateur films, which have long set the standards for their respective speed ranges. Compared to earlier versions of the Kodacolor emulsions, the Golds have an improved grain structure and more precise coloration—benefits of the latest technology in film making. Gold 100 is the best-looking of the bunch, Gold 200 gives you an extra stop of speed without any serious compromise in quality, and Gold 400 and 1600 are handy for times when stopping action or low light is a more important consideration than maximum saturation and tightest grain.

Ektar 25

Most of the photographers who exhibit color prints in museums and galleries switched long ago from the 35-millimeter format to something bigger. Some carry around custom-built cameras that act like 35-millimeter rangefinders but take 120-size film. Some have made the jump to 4-by-5-inch and 8-by-10-inch view cameras. Their reason: at a size of 16 by 20 inches or even 11 by 14, the grain of all 35-millimeter amateur color-negative films becomes objectionably visible, and sharpness and detail fall off noticeably.

Kodak has catered to this special audience of fussbudget image makers with Ektar 25, a high-quality color-negative film balanced for optimum grain, sharpness, and color. It is one of three entries in the new line of "premium" (that is, more expensive) color-negative films from the Rochester firm.

Ektar 25 is not for everyone. Its ability to produce good-looking

enlargements is offset by its slow speed and whisker-thin exposure latitude. Because of this, Kodak recommends that it be used only in single-lens-reflex cameras, not in point-and-shoots. (One reason is that most point-and-shoot cameras are equipped to "read" ISO speeds only as slow as 100.) Still, for serious photographers, it's a dream come true. Even in snapshot form, my Ektar prints look a great deal sharper than my results with Kodacolor Gold 100, the closest comparison film. Plus, the colors are about as lifelike as I can imagine them getting.

The virtues of Ektar 25 are such that they test one's technical prowess. Because the film's sharpness is so great, it tends to reveal even the least amount of camera shake, and as the enlargement of the negative increases, so does the evidence of any camera or subject movement. Besides using a tripod you also might want to stop down the lens to increase its performance and to change from a zoom to a single-focal-length lens. If all this seems too much, try the medium-speed version, Ektar 125.

Fujicolor Super HR II 100, Super HG 200, Super HG 400

Fuji is the largest film maker in Japan and Kodak's biggest competitor worldwide. To grab a share of the American marketplace, it has had to do two things: make films that equal or better Kodak's, and sell them for slightly less money.

The current Fujicolors succeed on both counts, although the devaluation of the dollar versus the yen has caused Fuji to raise its prices recently. The newest versions of its Super HR and Super HG films incorporate the same kind of tablet-shaped grain structure found in Kodak's Kodacolor Gold line. In addition, they have what Fuji calls a "reactivated inhibitor releaser"—that's shop talk for the chemical compounds that prevent the exposed silver grains from coagulating into big and unsightly clumps.

Fuji claims that these films offer improved sharpness and color compared to earlier versions and that they have a long storage life both before and after exposure. Unlike Fujicolors of yore, they deliver fairly neutral colors and natural skin tones. The 400-speed version is good for point-and-shoot photographers who find their built-in flashes firing all the time. It and the 100- and 200-speed

Fujicolors are real competitors with the equivalently rated Koda-color Golds.

Fuji Reala 100

Fuji's Reala 100 color-print film may give Kodak's Ektar 125 a run for the premium film buyer's dollar. Reala is said by Fuji to be "the first film to reproduce colors as they are seen by the human eye." Hype aside, Reala's emulsion has an extra blue-green layer that is said to control excess reds in a manner that mimics human physiology. Plus, according to Fuji, the film has great sharpness and color purity. Fuji is the only film maker confident enough to go head to head with Kodak.

Polaroid OneFilm

Polaroid's OneFilm is the instant-picture company's first venture into the conventional print-film business. OneFilm is cleverly marketed as the cure-all to the "which film speed to use?" blues. Never mind dithering over 100 speed, 200, 400, or even 1,000 ISO, Polaroid's ad campaign suggests, just pick up a roll of "universal" OneFilm.

In truth, however, OneFilm is not the film-speed panacea its ads proclaim. It is a quite mundane, single-speed color film with an ISO of 200. That places it right in the middle of the highly competitive ranks of 35-millimeter color-print film but hardly makes it unique. Even the existence of what Polaroid refers to as "excellent exposure latitude" doesn't make OneFilm unique. Practically all 200-speed negative color films have an exposure latitude of three stops on the side of overexposure and one stop on the underexposure side.

The results of my first roll, developed in standard C-41 chemistry by my local one-hour lab, were respectable for a 200-speed emulsion. Colors along the blue-yellow axis were especially strong, with bright blue skies predominating when the sun was out. But greens seemed a tad wimpy, and the blues seemed to get into shadow areas when the day was overcast. (I didn't use a UV filter, though, and the mini-lab doing the processing could have corrected the excess.)

Agfacolor XRC 100, 200

Agfa's negative (print) and transparency (slide) films have long had a reputation for providing "European color." Much as I like German cars, French wines, and Italian clothes, European color was never my cup of tea. It seemed too muted and brown, as if the antique flavor of the old world had leaked into the emulsion. Lots of European photographers loved it, but many Americans were lukewarm.

But with its Agfacolor XRC 100 and 200 films, Afga has made a quantum leap into the arena of modern color film. As the numbers suggest, these are medium-speed, general-purpose emulsions, and they are designed for daylight. My results with the films were impressive enough to suggest that Agfa has finally shed its European-color image. My prints were vivid, with bright blue skies, warm reds, and deep saturation of all colors. Sometimes friends' faces looked a little pinkish, but that may have been from too much sunbathing, not the film.

Agfacolor XRC 100 and 200 join competitors such as the Kodacolor Golds from Kodak and Fuji's Super HR and HG films on a new plateau of color-print quality for amateur photography. The advances in these emulsions are due to technological breakthroughs in the recipes for making color-print films. Again, those tabular-shaped silver grains and new developing agents that minimize grain clumping are mainly responsible.

Kodak Ektar 1000

Ektar 25's mate goes to the other extreme in terms of speed. Called Ektar 1000, it is intended for use in low-light and high-activity situations. Kodak also says it gives better color reproduction than Kodacolor Gold 1600 in tungsten light, although it is designed and marketed as a daylight film.

In my judgment, Ektar 1000 is the first 1000-speed film that manages to retain color in the shadow areas of the print. Admittedly, my shooting with the film was of a casual sort, but the prints tell the story. Instead of the washed-out, brownish shadows familiar to users of high-speed color film, Ektar 1000 manages to provide

color throughout the print. Its grain seems less noticeable than that of other 1000-speed film, although it remains obvious even in snapshot size.

Konica SR-V 3200

Konica SR-V 3200, as the name suggests, has an ISO/ASA rating of 3200, making it king of the speed hill as of this writing. To put that speed in meaningful terms, it is a full five stops faster than garden-variety 100-speed film. While that doesn't place it in the fine-grain category, it does mean the film is worth looking into for low-light and other specialized situations.

There are times when the film's advantages outweigh the disadvantages of huge globules of grain. The most obvious, of course, is shooting in the evening, just before and after the sun goes down. The film's high speed means that one can shoot hand-held as well as capturing subjects that otherwise would turn into swirling blurs. Indeed, stopping motion is the category of shooting in which high-speed films clearly shine.

There are other times when depth-of-field, not motion, is the most important consideration. This is an especially important factor when shooting in close-up or "macro" range. At distances of about a foot or closer to a subject, such as a flower or a butterfly, depth-of-field at large apertures is practically nonexistent. This is why macro lenses, unlike so-called normal lenses, stop down to f/22 or f/32, thus increasing the area in which the subject will be sharp, front to back.

One place where you might think fast color films would shine is indoors, since light there is often dim. But you should think again if you're using Konica's (or anyone else's) color-negative speed demons. They're all balanced for daylight, and the most common illumination found indoors is incandescent or fluorescent. Incandescent lighting turns daylight-film pictures orange, while fluorescents usually produce a sickly green.

SLIDE FILMS

The Kodachromes: 25 and 64

When Kodachrome film was introduced fifty years ago in 35-millimeter size, "the miniature format," as it was then called, it was not as popular as it is today. In effect, the two grew up together, 35-millimeter becoming by far the most popular format and Kodachrome becoming the most popular slide film.

In its first version, though, Kodachrome was hardly the ideal film for 35-millimeter cameras since its sensitivity was relatively low—about ASA 10. This made it less than perfect for spontaneous, hand-held shooting for which 35-millimeter cameras were made. It was only in 1961, with the introduction of Kodachrome II, which had a speed of ASA 25, that the film picked up enough quickness to be practical for everyday shooting.

Even in today's multihued marketplace where color films with speeds three to four times faster than the fastest Kodachrome are commonplace, the venerable film remains the standard for serious photographers. Kodachrome 25 is beloved by meticulous pros, and Kodachrome 64 is popular as a slightly speedier alternative.

Why would advanced-level photographers use Kodachromes, which have to be sent to a lab specially set up to process them, when Ektachromes and their cousins from other manufacturers can be processed by street-corner labs in a matter of hours? One reason is that the Kodachrome family is a unique kind of color film. Unlike the Ektachromes, which have their color built in, Kodachrome is essentially composed of black and white layers. The color dyes that correspond to these layers are added during processing. As a result the emulsion is relatively thin and the development relatively consistent. The thinness of the emulsion translates into more sharpness and less apparent grain, and the consistency in processing means consistent color in the image.

There also are differences in the ways colors are reproduced in Ektachrome and Kodachrome films. Many photographers swear by the graphic boldness of Kodachrome colors, while others prefer Ektachrome's less dramatic rendition. Those who like their reds redder than red use nothing but Kodachrome. Kodachrome's

palette may be an acquired taste, but it is a taste a great many photographers have acquired. In addition, because of the chemistry of their color dyes, Kodachromes have proven to be remarkably resistant to fading.

Kodachrome 200

In absolute terms, Kodachrome 200 isn't a wildly fast film, but within the Kodachrome family it's the tops. It has a full three-stop advantage over venerable Kodachrome 25, and a 1⅔ (one and two-thirds) stop leg up on Kodachrome 64, which used to be the fastest Kodachrome available. There are the inevitable trade-offs, of course. Grain is much more apparent here than in the slower emulsions, and the color saturation, while nothing to sneeze at, seems not quite up to the vaunted levels of its family partners.

What is it good for? I keep a few rolls of Kodachrome 200 on hand for shooting moving subjects on mildly overcast days, when the Kodachrome 64 I use as my standard slide film doesn't give me a high enough shutter speed. By keeping within the Kodachrome family rather than switching to an E-6-type film like Ektachrome or Fujichrome, I can keep my entire "take" consistent. Overall, Kodachrome 200 resembles the other two Kodachromes more than anything else.

K200 comes in two versions: a standard, amateur type and a professional one. It costs slightly more than its slower, older siblings.

The Ektachromes

Kodak's Ektachrome family of films was first introduced to please photo hobbyists who wanted to be able to develop their own color films. In their latest incarnation, generically known as Process E-6 films, Ektachromes can be processed by almost anyone. As a result, color slide processing labs have sprung up in practically every town and city, and professional photographers can have their exposed film processed and delivered in under two hours. The E-6 process has proven so popular that it is practically universal: Fujichrome and Agfachrome slide films can be "souped" in the same chemicals.

Until recently the Ektachrome family also had been known for another characteristic, known as the Ektachrome blues. On a cloudy day or in shade, Ektachrome slides generally exhibited an overall cast of azure. Even studio pros using electronic flash found these emulsions too blue, and many took to using light-yellow filters to "warm" their results. But the latest entries now on the market have largely eliminated this adverse characteristic.

Ektachrome 100 HC, 100 Plus Professional

One of the latest and most useful members of the Kodak family is Ektachrome 100 HC. It's a general-purpose, amateur version of an emulsion first introduced in so-called professional form, Ektachrome 100 Plus Professional, which is no mean film itself.

I expected the initials "HC" would stand for "high contrast," but in reality they mean "high color." My shots of landscapes on rainy days are no more contrasty than those I took with Kodachrome 200, but they are nearly as rich and saturated. They are also admirably neutral in terms of hue, just like Ektachrome 100 Plus Professional, in fact, but without the need to keep the boxes in the refrigerator.

Ektachrome 100 HC takes over the throne as Kodak's medium-speed, all-purpose slide film in the E-6 arena. It's important to remember, however, that it is not alone: Fuji's fine Fujichrome 100 has a foot on that base, too. Indeed, part of the reason Kodak has been showering the photography world with new films of late is that Fuji has made a dent in its American market. Fuji's film sales are only a fraction of Kodak's, but the Japanese company's piece of the pie is enough to make the home team worry.

As for the 100-speed pro Ektachrome, it's a dream come true. In pictures I took of snow scenes, the shadows are as gray as steel plate, no matter if my exposure was on the button or half a stop under. Moreover, the reds, greens, and yellows on the slides were as clean and shiny as a freshly mopped floor. When something actually was blue to start with, the film rendered it accurately and without undertones.

As is the case with Kodachrome 64, Ektachrome 100 Plus seems to perk up with slight underexposure. That's because the

saturation, or intensity, of the color deepens with the density of the emulsion. My results suggest a third of a stop less exposure is good for certain subjects but not necessarily for snow scenes, which get a bit dirty looking when underexposed. In sunlight it seems as pleasantly warm as Kodachrome 64 can be, but not to a fault.

Being a full stop faster than ISO 50 films such as Fujichrome 50 and two stops faster than Kodachrome 25, it's no surprise that neither 100 Plus nor HC 100 is the fine-grain champion of slide films. By all appearances its grain structure is admirably tight and inconspicuous, but I've always felt that what really matters in terms of grain isn't its size but whether it is clumped or smooth looking. This film looks as if Kodak pureed the grain in a Cuisinart.

Fujichrome 50 and 100, Amateur and Professional

Before I ever tried Fujichrome Professional 100 film I heard good reports about it, and with good reason. It produces clear, snappy colors with good saturation and contrast. The purity of the color is surprising since Fuji films were once as overly green as Ekta-chromes were overly blue. But the Fuji Pro 100 seems to represent an almost ideal color balance for an E-6 process film. Fujichrome 100's "non-pro" amateur version is also quite an improvement on previous Fuji emulsions.

Fujichrome 50 gives equally neutral and vivid colors in its professional incarnation, and the amateur version is not far behind. Recently Fuji has tinkered with the color balance to get the "pinks" out of shadow areas and clouds, a color cast that affected early versions of the film. Fuji also claims improvements in grain structure and sharpness. As always, I'd recommend the slower film unless you need the extra stop of the 100-speed version.

Agfachrome CT 100, CT 200

With these fairly recent introductions the German film maker hopes to up its share of the slide-film market. They're good, producing results in the neighborhood of their Kodak and Fuji competitors in terms of saturation, tonal fidelity, and grain. But let me be frank: if Agfa hopes to capture the hearts and minds of

American photographers, it's going to have to beat the competition, not just match it. Maybe if the price is right, Agfachrome will once again become a household word.

OKAY, NOW WHAT ABOUT BLACK-AND-WHITE FILM?

There are those who feel that black-and-white film has been rendered vestigial by the improvements in color photography, but before we pronounce the death of black and white we should heed these words by Edward Weston, written in 1953: "Those who say that color will eventually replace black and white are talking nonsense. The two do not compete with each other. They are different means to different ends."

Despite color's near-universal appeal, there remain a few diehards to whom the tones of black and white are as beautiful as any colors. I have to admit that I'm one of them since I shoot as much black-and-white film as color. So let's take a second to look at what's available for us monochromists.

Despite the fears of the faithful, the photographic firms that make film and printing paper remain committed to supplying black-and-white materials. Indeed, in the last several years a number of new and improved products in the black-and-white category have appeared. Most have been designed to appeal to the artistic, fine-print market where qualities such as fine grain, extra-blackness, and near-eternal life are important.

Ilford's premium printing paper, Galerie, was the first shot of the latest black-and-white revolution. The silver-rich paper was introduced together with a new processing recipe for achieving print permanence quickly. Kodak followed suit with a high-quality, high-priced paper of its own called Elite. Meanwhile, Japanese companies such as Seagull have entered the U.S. paper fray in a big way. One result was an increased interest in black-and-white printing, despite the long-term, mass-market trend toward color.

The new silver-laden papers have become regular fixtures in many darkrooms, delivering the wide range of tonalities and deep

black tones printers crave. And Ilford's new quick-fix, quick-wash processing cycle has won adherents among those, like myself, who want prints that last for years without having to stand for hours over a darkroom sink. But printing paper can only respond to what's on film, and new emulsion technology has led to a new breed of black-and-white film. Ilford's XP-1 was the first black-and-white film based on color-print film. It is developed in the same color chemistry as Kodacolor and Fujicolor, and it features a remarkable exposure latitude unknown in conventional emulsions.

Kodak chose to use color-film technology in less dramatic fashion in its T-Max line of professional films. These black-and-white emulsions consist of a layer of tabular-shaped grains of silver, as in Kodacolor Gold films. Because of the shape of the silver particles, these emulsions are thinner and thus appear less "grainy" than their conventional brethren, which have their silver distributed in random clumps.

Kodak's new films are christened T-Max 400 and T-Max 100. T-Max 400 maintains the speed of its predecessor—Tri-X, at ISO 400—while T-Max 100 is slower by a hair than its elder, ISO 125 Plus-X. Both, however, offer something other than speed: a dramatic improvement in image quality. That infernally persistent grain that led me into large-format photography has been greatly reduced thanks to controlled engineering of the grain "clumps," leading to smoother and sharper appearing prints. According to camera magazine tests, the new T-Max 400 has the small-grained look of Plus-X while the new T-Max 100 approaches the quality of Panatomic-X, Kodak's former (and now phased out) fine-grain champ at ISO 32.

Word on the street has been mixed about the performance of Ilford's and Kodak's new films. Photographers of my acquaintance have had trouble adjusting to the look of prints made from Ilford's XP-1. Instead of showing a tight, crisp grain pattern, the prints have the almost soapy appearance found in prints from color negatives. That's to be expected, of course, and it's not bad by definition, it's just not what old-fashioned printers are used to seeing.

In Kodak's corner, the T-Max films have been diagnosed as having a contrast gremlin. Photographers are able to achieve sweet

and dulcet tones in the shadows or in the highlights but rarely in both shadows and highlights at the same time. This would be tolerable if one could choose one or the other by visually inspecting the film during development, but unlike other Kodak films, the T-Max films cannot be developed by inspection due to a masking layer in the emulsion. Both T-Max films would serve darkroom-oriented photographers better if the progress of their development could be assessed in the dark. Then the contrast characteristics of the films would be less of a problem.

Meanwhile, Tri-X and Plus-X, the old black-and-white standbys, remain on photo store shelves, as does Fuji's Neopan line of conventional black-and-white emulsions. It's good for us old diehards to have some things remain the same.

EIGHT

Extending Your Range with Accessories

Unhappy with the pictures your camera is taking? Chances are you don't need a new camera—just something new for it. In this chapter we survey all sorts of lenses, filters, and other add-ons for photographers who are stretching their wings.

LENSES

At one time or another all photographers who take their work seriously ask themselves: what can I do to make my pictures better? This is especially a quandary for those who are just starting out with a single-lens-reflex camera and have never experienced the joys of interchangeable lenses. For them, going beyond the 50-millimeter **normal lens** that comes with most cameras is a momentous step.

That a new lens will actually lead to better pictures is a debatable notion since human beings, not chunks of glass, are ultimately responsible for what finds its way onto film. But there is no disputing that the addition of a new focal length can increase one's visual versatility, lead in new directions, and frequently renew one's interest in photography.

I once had the temerity to ask Garry Winogrand, the abrasively inventive street photographer who died in 1984, if anything new

One of the advantages of single-lens-reflex cameras is their ability to accept a variety of interchangeable lenses, from ultra-wide angle to long telephoto, like the ones shown here. Camera manufacturers produce lenses that fit their own cameras and no others; since lens mounts vary from brand to brand, independent lens producers offer their wares in different mounts.

was happening in his picture-taking. He replied that he was in the midst of a radical stylistic change. Asked what that radical change might be, he said that he had recently switched from his tried-and-true 28-millimeter lens to a 35-millimeter lens.

Both 28-millimeter and 35-millimeter focal lengths are known as **wide-angle lenses,** and a mere 7 millimeters separates them. Nevertheless, the differences in the way they render the world were enough to cause Winogrand to see in new ways. For the neophyte, these subtle differences will be equally apparent, although the natural tendency is to choose to buy lenses of widely varied focal lengths.

Choosing a Zoom Lens

Which to pick? Today, that question is often made moot by the existence of the highly popular zoom lens, which provides a multitude of focal-length choices in a single barrel. One simply pushes, pulls, or turns a rubberized ring and the world in front of the lens expands and contracts effortlessly. Such are the pleasures of looking through a zoom that one can become addicted, but while zoom lenses may be omnipresent, they don't eliminate the need to make decisions.

Essentially, zoom lenses come in three ranges: from ultra-wide to wide angle (20 to 35 millimeters, say), from short to long telephoto (80–210 millimeters), and from moderately wide to moderately telephoto (35–90 millimeters). You can also find zooms as wide-ranging as 35–210 millimeters. Some have a constant maximum aperture and some a **variable aperture** that changes with the focal length. Some are faster, with a wider maximum aperture than others, just like single-focal-length lenses. So there are choices and more choices to be made.

In choosing a new lens, zoom or not, it pays to consider first and foremost the kind of photographs you take and the kind you would like to take. You should be dissatisfied with the lens you are using—otherwise, why buy a new one?—but the pictures you are taking with it now should provide the clues to your next direction.

My own first deviation from a normal lens came about because I wanted to photograph people more spontaneously and candidly. Friends came out fine with the normal lens, but strangers appeared too small and distant. My first additional lens, then, was a 135-millimeter telephoto, with more than double the image magnification of my 50-millimeter lens. It was, I soon learned, a big mistake. Not only was the 135 a vast jump in magnification from the 50-millimeter lens, but it also made the quest to capture people on the street nearly impossible. They were gone from the frame as soon as they appeared, and I seemed to be always standing too far away or too close. It focused to only 5 feet, while the normal lens got as close as a 1½ feet, and what was in focus in my pictures was just a sliver compared to what it had been.

What I really needed, I soon learned, was a 35-millimeter

focal-length lens. It allowed me to get close to people and engage them visually if not verbally, and it kept much more of what I was seeing in focus. While the old saw says that a wide-angle lens renders the human face in unpleasant fashion, in rapid-fire "street" photography it is about the only way to go.

This isn't to say that long focal-length or **telephoto lenses** are useless, but anyone wanting the somewhat flattened perspective and greater subject-to-camera distance telephotos provide should think first about a 90- or 100-millimeter lens. These focal lengths, which magnify less than a 135-millimeter lens, are much more manageable and useful.

It follows that if zoom lenses are your desire, a good first choice would be in a range of 35 to 90 millimeters. This selection of focal lengths probably accounts for 90 percent of all the pictures taken with single-lens-reflex cameras. Once you are experienced with moderate wide-angle and moderate telephoto focal lengths, you can better decide if your next zoom should be in the ultra-wide (20–35-millimeter) or ultra-long (80–210-millimeter) bracket.

Pros once considered zoom lenses the essence of amateur photography. Despite years of groans and grunts induced by heavy camera bags filled with single-focal-length "prime" lenses, these expert photographers claimed that zooms had no attractions for them. They were wrong, of course, and today nearly every pro packs at least one zoom in his or her kit.

If pros once faulted zooms for things such as barrel distortion, resolution, and color rendition, amateurs loved them for their portability, flexibility, and economy. Although zooms continue to cost more than many single-focal-length lenses, they cost considerably less than the sum total of the prime lenses one would have to buy to cover the same range of focal lengths, and they also provide all the "in-between" focal lengths for which there are no prime-lens equivalents—such as 113 millimeters.

These days many zooms are about the same as run-of-the-mill prime lenses in terms of resolution and coloration. Barrel and pincushion distortions (in which straight lines either bow out or sag in at the edges of the frame) have been reduced and are often no greater than with wide-angle lenses. But what's really behind the popularity of zoom lenses is their convenience. Instead of having to

What focal lengths do: I took these photos with a zoom lens while standing in one spot; all that I changed was the focal length—top at 28, center at 50 and bottom at 85 millimeters. Notice that as the focal length increases, the apparent distance between my subject and the house decreases.

carry a case full of heavy lenses and stopping every few minutes to remove one and mount another, a photographer can travel light and be ready for almost any situation.

Still, some persnickety photographers prefer single-focal-length lenses. The reasons? Less apparent distortion, somewhat higher performance in terms of resolution and contrast, wider maximum apertures and, for some, tradition. As a general rule, zooms with modest focal-length ranges come closest to single-focal-length lens quality.

What's Tele, What's Wide?

Camera and lens manufacturers make a big fuss in their advertising about the range of their zoom lenses. No sooner has one "wide-angle-to-tele" lens appeared than another one—wider and longer—is announced. The question is: should one buy a lens or the camera to which it is attached simply because of the breadth of its focal lengths?

It's a question that takes some looking into. For starters, just what do the ad creators mean when they toss around the terms "wide-angle" and "tele"? Oftentimes, considerable artistic license is involved. For example, one new point-and-shoot's "tele" lens is all of 60 millimeters. Considering that the so-called normal focal lengths for 35-millimeter cameras range from 45 to 55 millimeters, 60 millimeters is no great shakes, tele-wise.

Moreover, "tele" is a contraction of "telephoto," which is a term for the design of the lens, not for its focal length. There are plenty of long focal-length lenses on the order of 300 millimeters or more that are not telephotos; they're simply "normal" designs intended for large-format cameras. "Wide–angle" is also a lens designer's term, not merely shorthand for small focal lengths. Yet some cameras' supposedly wide-angle lenses are constructed optically like normal lenses. What's important when lens shopping, therefore, is the length, in millimeters, not the phraseology.

It's important as well to understand that variations among short focal lengths are greater than variations in the longer ranges, numerically speaking. Let's say you have a choice between a 35-millimeter and a 28-millimeter wide-angle lens. There's only a

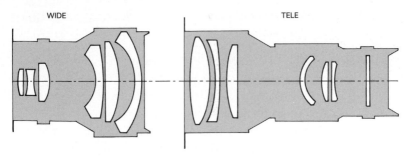

An inside, cutaway view showing how telephoto and wide-angle lenses are typically constructed. Wide-angle lenses for 35-millimeter cameras, left, are of retrofocus design, so called because of added elements near the camera that prevent the light from focusing in front of the film plane. A true telephoto, right, is characterized by a strong convex element behind the front group of elements; the elements near the camera are used for focusing.

paltry 7-millimeter difference between them, but the difference in what they do is substantial because of percentages: those extra 7 millimeters give the 28 a field of view 20 percent greater than that of the 35-millimeter lens.

At the other end of the spectrum, consider the difference between a 180- and a 200-millimeter lens. There are all of 20 millimeters between them, but in terms of performance, the difference is more like 10 percent. If I were choosing to buy one or the other of these, I might make a decision based on price rather than "reach."

In terms of zoom lenses for SLRs, there's a trade-off. Large-ratio zoom lenses—50 to 250 millimeters, say—are longer, heavier, and more expensive than their less ambitious cousins. Hence many photographers decide to carry two zooms instead of trying to make one lens cover everything they shoot. One lens takes care of the range from wide-angle to normal (21 to 50 millimeters, for example) and the other goes from normal to tele range (often 50 to 210 millimeters).

Using a Zoom

It's easy to use a zoom lens as if it (and you) were an immovable movie camera. You start out at the wide-angle setting and then "zoom in" until the scene is framed. It's easy, but it's not necessarily

the way to get the best picture. That's because when you change focal lengths you are doing more than changing the angle of view; you're also changing the relationship of objects in the frame and what's going to be in focus and what's not.

Unfortunately, few photographers weaned on zoom lenses are aware of the different impact a wide-angle shot taken at a distance of 3 feet from the subject has compared to a tele shot taken from 12 feet. Those of us brought up on interchangeable lenses had to learn because we had no choice. We moved back and forth until we found the most comfortable working distance and best perspective for each lens in our bulging camera bag. That's how we found out that the lens we thought was the solution to our problems wasn't, as I did with the 135. But that's also how we discovered that every focal length imposes its own pictorial will.

Zoom-lens users should try to learn the same lesson by doing the following exercise: set the lens to one focal length and leave it there for an entire roll of film. Shoot different situations using different working distances, shutter speeds, and apertures, then shift to another focal length, load another roll, and repeat the process. At minimum you'll find that what appears on the lens barrel to be a seamless strand of focal lengths actually presents a treasure trove of disparate pictorial personalities.

It should be pointed out, however, that zooms are not instant cures for the picture-taking blues. There is no guarantee that by using a zoom lens you will suddenly improve your pictures any more than buying a new tennis racket will automatically improve your tennis game. It may inspire you to practice more, which will hone your skills, but you will still face the same problems of technique you faced before you got it.

One of the novice photographer's biggest problems is getting close to people. Instead of focusing on them from a conversational distance, the novice will stand 20 feet away. Many claim this stems from a fear of strangers, but I've seen hundreds of amateurs photographing family and friends from an equally hands-off distance. In any case, the novice often believes (or is led to believe)

The difference between focal lengths is most apparent when you move your feet as well as the lens. Here, the foreground subject stays the same size in the frame, but what is included in the background changes dramatically. The picture opposite was taken up close with a zoom at 28 millimeters, the one below from farther away with the lens set at 85 millimeters.

that the cure for the problem is a telephoto-range zoom lens, which lets one zoom in on faces from far away.

Unfortunately, while the zoom is changing the magnification of the subject it also is changing its appearance—the relationship of far and near objects—and the depth-of-field. As one heads toward 200 millimeters, the depth-of-field decreases, the perspective gets "compressed," and the chance of fuzziness due to camera shake increases. It's not surprising to find that pros almost always use tripods at the 200-millimeter and above range.

It's also not surprising that pros photograph "on the street" with short focal-length lenses—35 millimeters at most. Because the scene is always shifting, the more depth-of-field the better. More-over, the perspective tends to accentuate the feeling of spatial depth in the picture. Instead of being "flattened," people look three-dimensional. There is another practical reason for wading in with a wide angle: up close, the photographer can see his subject much more clearly than he can from across the street.

To make a long story short, if you want a zoom lens to do the work that your legs should be doing, you're going to be disap-pointed. With most pictures that prove disappointing, the problem isn't one of focal length but of where the photographer stood. Getting closer may be the answer to your problems, and so might getting lower or getting higher or moving to the side.

To use a zoom to best advantage, it pays to think about its effect on perspective rather than its effect on the size of the subject. If you want the immediacy of wide-angle perspective, then you'll need to get close. If you want to make two people seem closer together than they are, switch to a tele setting and simultaneously back away. Though it may seem at first like chewing gum and thinking at the same time, coordinating footwork and zoom work should get you better pictures.

Pointers for Point-and-Shooters

When it comes to upscale point-and-shoot cameras, one doesn't have the luxury of interchanging lenses. The lens or lenses built into the camera are what you're stuck with, barring any supple-mentary add-ons. Those that offer a choice of two built-in focal

lengths tend to moderation. The shorter length is usually what I'd call "semi-wide," it takes in just a little more than what a normal lens would. And the longer length is "semi-tele," giving you just enough magnification to eke out a passable head-and-shoulders portrait.

Cameras with noninterchangeable zoom lenses try harder to offer picture takers some variety although none go hog wild. The breakthrough Pentax IQ Zoom, the first of its breed, has a lens that spans 35 to 70 millimeters. That's impressively wide, if a bit low on the tele side. Chinon's Genesis camera goes Pentax one better with a lens stretching from 35 to 80 millimeters. Olympus's Infinity Super Zoom beats Chinon on the long end with a 38 to 105 zoom lens but loses to the Ricoh Murai's 35–135-millimeter cannon.

Does it pay to go for the longest reach on a fixed-zoom camera? All things being equal it would, but all things are never equal. The extra reach you may be paying extra for may not add up to much in terms of your picture-taking needs. What good is an extra-long focal length if your shooting is done in the wide-to-normal range? Look through the camera's viewfinder before deciding whether the focal-length difference is important enough to influence your purchase. Besides, the four cameras just mentioned are vastly different in features and handling.

Indeed, I recommend a thorough self-examination for all prospective camera or lens purchases. Then instead of being carried away by advertising hype, you can decide on the focal lengths you need based on your own habits and desires. If it turns out that you are perfectly happy with a plain normal lens, you can get a very capable camera for less than your zoom-crazy cohorts.

Macro Lenses: The Joy of Being Close

One of the amazing things a camera can do is show you the world in greater detail than your naked eye can perceive. The effect is especially dramatic when a tiny subject is larger in the print than it is in real life. To do this you need to photograph at close range, and to photograph at close range you need a **macro lens** or at least a lens that has close-focusing abilities.

What does it mean when a lens carries the designation "macro"?

If you don't know the answer to the question, don't feel bad—most camera and lens makers don't know what "macro" means either. This is especially true when it comes to point-and-shoot cameras with "macro" written across their lenses. Unfortunately, point-and-shoots don't make good close-up cameras because the disparity between what their viewfinders show and what their lenses actually record increases the closer the subject is to the camera. Close-up photography is really the domain of the single-lens-reflex camera.

According to the textbooks of optics, taking pictures in which the image recorded on the film is the same size or larger than the subject before the lens is called photomacrography (as opposed to macrophotography, which means the making of large photos). From photomacrography comes the term macro, which is applied not only to lenses specifically designed for close-ups but also to zoom lenses that focus closer than conventional distances.

You might think from this that macro lenses and zoom lenses with macro features will allow you to take same-size pictures of

Getting close to small objects is the province of the macro lens, another variant of the interchangeable lenses made for SLRs. To focus on a slice of meteorite, the 50-millimeter macro shown here needs to be quite close; a small aperture is used for good depth-of-field, which means a slow shutter speed, which in turn explains the need for a tabletop tripod.

small subjects such as flowers, insects, coins, and postage stamps without much fuss. That's true in theory, but in practice, no dice. For marketing reasons the word macro is now applied to any lens that lets you focus closely, never mind if the on-film image is four or five times smaller than the subject.

The relation of image to subject is called the **reproduction ratio.** If it is 1:1, the film image and the real-life subject are the same size. If it is 1:2, then the subject is exactly half the size of the image. Most zoom lenses that claim to have macro capabilities do well to achieve a reproduction ratio of much more than 1:5. That's not really macro, but it is close enough to let photographers home in on details in the natural world such as wildflowers and maple leaves.

The problem with using zoom lenses for close-ups is that, like the vast majority of lenses, they are designed primarily for other tasks, such as making portraits of Aunt Harriet. As a rule they have what is called a curved-field design, meaning that the plane of absolute sharpness in front of the lens is shaped more like a parabola than a straight line. This kind of design has a great many advantages with normal subjects at normal focusing distances, but it doesn't cope well with flat subjects at short distances.

Hence the need for a specialized breed of lenses known as macro lenses. These are designed for close-up photography and have a flat field, meaning that the plane of sharpness in front of the lens is perfectly perpendicular to the axis of the lens. Thus the center and corners of close-up pictures taken with macro lenses are sharp at the same time.

Practically all macro lenses made today for 35-millimeter single-lens-reflex cameras focus to 1:2 or half life size. To make them conform to the true 1:1 definition of macro, most lens makers supply each lens with an extension tube. In Nikon's case the extension tube is a separate purchase, which may explain why Nikon calls its macro lenses Micro-Nikkors, not Macro-Nikkors.

The added bonus of macro lenses is that they also focus to infinity. This means they make excellent general-purpose lenses, ready to take anything from a distant landscape scene to a spider in its web. The demerits of curved-field lenses when used close up do not apply in reverse to flat-field macro lenses when used at a

distance. There is no discernible difference between a landscape taken with a normal 50-millimeter lens and one taken with a 50-millimeter macro lens.

One limitation the typical macro lens used to have was speed; until recently its maximum aperture was three or more stops smaller than that of its normal-lens counterparts. But in recent years macro lenses have been redesigned to reach f/2.8. While still not as large as that of a fast normal lens, such a maximum aperture is entirely adequate for day in, day out picture taking. It even beats the biggest aperture of many zooms.

Another limitation recently overcome concerns focal length. Traditionally, small-format macro lenses were available only in so-called normal focal lengths—50 to 55 millimeter. Today, there are several companies making 100-millimeter macro lenses and even a few making 200-millimeter macros.

The main advantage of the longer focal length in a macro lens is not a matter of perspective, as might be expected, but of working distance. At 1:1, the front of a 50-millimeter macro lens is right up against its subject. At the same magnification, a 100-millimeter macro allows for much more room between lens and subject. The farther away the lens, the less chance it will intrude its shadow on the scene.

There are, of course, alternatives to macro lenses when it comes to close-up photography. Supplementary lenses, extension tubes, and bellows can all be used to achieve similar results and to get beyond the 1:1 reproduction barrier. Of these, only a bellows allows the continuous adjustment of magnification that is a feature of macro lenses. In terms of all-around usefulness and convenience, though, the macro lens wins hands down.

Convenience is a big issue in close-up photography since it is more complex than other kinds of picture taking. For one, depth-of-field at very close distances is practically nil so it pays to stop down the lens aperture as far as possible. (Macro lenses usually provide smaller apertures than conventional lenses for this reason.) For another, focusing is controlled by moving the camera body, not just the lens.

And to top it all off, exposures must be lengthened to compensate for the distance light has to travel between the front of the lens

and the film plane. Fortunately, with any macro lens that is coupled to the camera's built-in meter, such exposure corrections are taken care of automatically.

Add-on Lenses for Point-and-Shoots

Do owners of point-and-shoot cameras want to be creative photographers? That's a tantalizing, seemingly contradictory question since their cameras were designed for people who want pictures without having to think about photography at all. But from what I've seen, all camera owners like to add frills to their repertory from time to time. They don't call camera cases "gadget bags" for nothing.

Since point-and-shoots don't have interchangeable lenses, one extra-cost accessory made available by some manufacturers is a **supplementary lens.** This is basically an additional lens element—most often a magnifying one—that fits over the built-in lens to provide a new focal length. A corresponding magnifying lens fits over the viewfinder optics to provide a sense of the new frame. The change isn't dramatic; a 38-millimeter lens may become a 65-millimeter, for instance. But it loosens the straight-jacket of a single focal length somewhat.

FILTERS

Filters change the quality and quantity of light entering the lens. In the SLR world, the choice of filters is prodigious. There are **skylight** and **UV** (ultraviolet) **filters**—also known as transparent lens caps—that remove excess blue from scenics. There are **color-compensation filters** that let you use daylight film indoors and tungsten film in sunlight. There are dark-colored filters for changing the tones of black-and-white film, and subtle **color-correction filters** for shifting the overall rendition of color films. And there is every calendar photographer's favorite, the **polarizing filter,** which in certain sunlit conditions darkens blue

skies and eliminates spectral reflections (more about polarizing filters below).

That's not all. There are literally hundreds of different **special-effects filters,** which turn humdrum scenes into kaleidoscopic fantasies or into the shapes of hearts and flowers.

What about point-and-shoot photographers? Their choice of filters is much more limited, but point-and-shoot owners with a creative bent can take advantage of a line of special-effects filters called the Cokin Creative Filter System that is engineered to work with both types of camera.

Developed several years ago by French photographer Jean Coquin, Cokin filters produce such adrenaline-pumping effects as prismatic highlights, rusty-colored skies, and "romantic" mists. Besides these flashy effects, two things make the Cokin line different from old-style filters: the filters are made of a sturdy optical resin (instead of fragile glass or flimsy acetate), and they fit neatly into Cokin's unique compact filter holder.

The original Cokin system—consisting of a filter holder and filters, of which there are now 125 types—was strictly a single-lens-reflex affair. Owners of SLR cameras, after all, are purportedly the "serious" photographers, interested in managing their pictures and in creating unusual effects. They're the ones who are confident enough to try dabbling with the extraordinary.

But as more and more knowledgeable photographers jumped on the point-and-shoot bandwagon, Cokin saw a marketplace for a point-and-shoot filter set. And why not? Some of the newest point-and-shoot models sport controls for fill-in flash, self-timers and—the newest of the new—soft-focus filters for portraits. Given this tendency to elaborate on simplicity, the idea of using fancy filters doesn't seem so strange.

In practice, using effects filters on non-SLR cameras is a bit like flying blind. For example, a filter like Cokin's Graduated Tobacco (T2) introduces different intensities of color into different parts of the frame. How much of the picture area is covered by strong color and where the dividing line occurs are controlled by adjusting the filter's position in the filter holder. With an SLR, the effect is instantly visible through the viewfinder; you see what the lens sees.

A photograph taken with a special-effects filter—in this case the Cokin Star 8 filter, which produces an eight-rayed "star" around any strong point of light. The source can be the sun, its reflection, or any kind of illumination at night. Other Cokin filters soften wrinkles, create rainbows, and color the sky tobacco.

But with a non-SLR camera, you have to make an educated guess as to the result.

Not all of the Cokin filters are position-dependent, however, so using the system is not totally a matter of guesswork. And since the filters are the same as those used in the standard Cokin "A" series, you can always trade up to a lens-mounted SLR filter holder at the same time that you trade up to an SLR.

Polarizing Filters

Like a UV filter, a polarizing filter under the right conditions can make atmospheric haze practically vanish. It does this not only by cutting down on ultraviolet light reaching the film but also by eliminating glare created by particles in the air. Moreover, it has

the unique capability of increasing color contrast and saturation. I'd even go so far as to say that no serious color photographer should be without one.

How a polarizing filter works is a long and complicated subject, so suffice it to say that it filters out reflections large and small— from store windows to microscopic droplets of water. One consequence is that pictures taken with a polarizer in place often have a vividness and depth of color that puts other pictures to rout. This is especially true in the sky areas, which characteristically become an intense azure.

Polarizing filters don't always have this particular effect because they only work under certain conditions, the foremost of which is that polarized light needs to be present. For the landscape photographer this means that the sun needs to be out. Additionally, the position of the sun in the sky determines the effectiveness of the filter. To get the maximum intensity of azure in the sky, you need the sun low and behind or beside you.

All polarizing filters can be turned in relation to the lens because turning them increases or decreases their effectiveness. With a single-lens-reflex (SLR) camera, you can see it work by looking through the lens while rotating the filter. Besides noticing the sky darken and reflections disappear, you'll see the light reading of your built-in exposure meter change. This is because the filter cuts out different amounts of light depending on its position, generally from one to two f-stops.

Built-in meters in almost all SLR cameras automatically adjust to these changes, and automatic exposure cameras eliminate the task of resetting the aperture and shutter-speed settings. Be warned, though: a few cameras with unusual metering systems don't read exposures accurately when a polarizer is in front of the lens. A more expensive type of polarizing filter, called a **circular polarizer,** can cure this design glitch, however.

A polarizing filter can eliminate reflections in glass, such as those seen in the window of the car (top), allowing you to see inside (bottom). It can also darken skies and increase overall color saturation by eliminating myriad tiny reflections; but its effectiveness is dependent on the position of the sun.

POLARIZED
BAND OF LIGHT

90°

EARTH

For a polarizing filter to work, the sun has to be out and the camera must be pointed at the band of polarized light in the sky. This band can be located by imagining an arc lying at a 90 degree angle to the sun's position. If you point your index finger at the sun and sweep your thumb across the sky, you've found it!

TRIPODS

In the nearly 150 years that photography has existed, photography equipment has undergone enormous changes. Cameras, originally wooden boxes of considerable bulk, now are sleek, battery-operated marvels of metal and plastic. Lenses have gone from simple and slow to speedy and compact. Flexible film has replaced glass plates.

The exception to this tale of technological progress is the tripod. It still sits beneath the camera, steady and subservient, performing its task of ensuring sharp pictures. As its name suggests, it has three legs, and no one has ever figured a way to get the job done better with two or four.

In its construction, a tripod is like a greatly foreshortened body—its head is directly connected to its legs. The head provides a platform for the camera and allows it to maneuver, while the legs,

hinged at the top, can be spread wide to provide a steady base. Joining them, like a neck, is a column that goes up and down, either by friction or geared elevator. In these respects, all tripods are pretty much alike.

Tripods differ in the details, though, which is what makes choosing from among the scores of available models such a task. Some have pencil-thin legs that collapse to the length of a camera bag; others have thick braced legs that look like crutches. Some legs are U-shaped, others are round. Some tripods cost $250, while others may sell for $25.

In choosing a tripod, a photographer should start by considering its mission. Tripods are primarily necessary when shutter speeds grow too slow for sharp hand-held pictures—when the light is low, when long telephoto lenses are used, or when small apertures are needed, as in close-ups. At what speeds a tripod's stability makes for noticeably sharper pictures is a matter of some debate. There are pros who swear that tripods guarantee sharper pictures at all speeds, and consequently they use them all the time. This may be excessive, though, especially since 35-millimeter cameras are treasured for their quickness and portability.

Another reason for using a tripod—and another reason some pros tend to rely on them even in bright sunlight—is that they allow precise control of framing. Even those of us with rock-steady nerves cannot entirely freeze our body motions, and as our bodies move so does the scene in the viewfinder. The control a tripod provides is especially important when the subject is small, as in close-up photography, or marked by vertical and horizontal elements, as in pictures of buildings.

Both sharpness and precise framing depend, of course, on the tripod's ability to steady itself and the camera firmly and without slippage. These two qualities are the first to look for when shopping for a tripod. Unfortunately, as a rule, the heavier the tripod the more likely it is to dampen vibrations from the camera and the environment. Yet the heavier the tripod, the less likely you are to carry it. So the ideal tripod is as light as possible but also engineered for maximum strength and steadiness. Tripods are made of various materials including steel, aluminum, and wood. Wood is very good at absorbing vibrations, but it is also heavy and

A typical tripod of the kind designed for 35-millimeter photography. This one, made by Slik, features multisection legs that are locked in place by lever-actuated clamps, a brace that joins the three legs, and a head that can turn horizontally, vertically, and in circles. It's important that the tripod head allows the camera to be used in both vertical and horizontal positions.

breakable. Steel alloys and aluminum are indestructible compromises. Recently there has been talk of graphite tripods since graphite is light, strong, and flexible, but unless they inspire a wave of tripod buying, their prices will be astronomic.

In terms of steadiness, the thickness of the legs has an

influence, as does the quality of their construction. Neither tubular legs nor U-section legs are inherently superior, but the width of their cross sections is one crude way to judge at least the potential steadying effect of the legs. Also important is the way the leg sections slide together; any wiggle in the joints, and the whole leg goes lame.

A good tripod head should turn smoothly and lock quickly and positively. After all, you want your tripod to ensure precise framing, and if the head slips after you've lined up your shot, you might as well be holding the camera in your hands. The head should provide a full range of movements. For a 35-millimeter camera, this includes a side tilt of at least 90 degrees to allow for vertical shots. Separate controls for each axis of tilt offer the most precision, but a ball head, which has a single release, can be quicker to use.

There is a temptation to get a very substantial tripod—one designed for a heavy view camera, say—as a way of ensuring sharp 35-millimeter pictures. But try to resist. My 14-pound behemoth is perfect for my 8-by-10-inch view camera, but when I try to use it with my little Leica rangefinder, it is bulky and awkward.

For 35-millimeter cameras a tripod that weighs about 7 pounds is heavy enough and will also do duty with medium-format cameras. Three-section legs are the norm, as is a collapsed length of about 2½ feet and an extended height of 5 to 6 feet. Some examples of well-made tripods that fit this description include the venerable Tiltall, the Slik Master 322, and Gitzo's Reporter model fitted with a 2B head. These tripods and others of similar quality cost between $100 and $200. That's not inexpensive, but with a modicum of care a tripod should last a lifetime.

A REVIEW OF CHAPTER EIGHT

1. For owners of single-lens-reflex cameras, fighting the picture-taking blahs is as easy as changing lenses. The camera's normal lens can be replaced by telephoto, wide-angle, or zoom lenses; which you choose depends on the kind of photography you do.

2. Zoom lenses should be used actively rather than passively. If you change focal lengths, also consider changing your position to take advantage of the new focal length's particular perspective.

3. For close-up photography, an SLR equipped with a macro lens is the best (if not the cheapest) way to go. Macro lenses focus closely and all the way to infinity. Point-and-shoot owners can use supplementary lenses, if available, to achieve some limited close-up ability.

4. Filters range from those designed to correct color rendition to some that fracture the world into a dozen pieces. One of the most useful is a polarizing filter, which can eliminate reflections and intensify colors.

NINE

Caring for Your Camera

This camera is a precision instrument, the instruction books tell you. *Used with care it should give you years of service and satisfaction.* We all want our cameras and other equipment to last forever, of course. Herewith, some advice on how to come close to achieving that goal, plus how to carry and pack photo gear, what batteries to buy, and what to do when things break.

UNPACKING A NEW CAMERA

Suppose that it's your birthday and someone near and dear to you is going to give you a brand-new camera. What is the first thing you should do besides give your benefactor a thank-you kiss? Whether it is your first camera or your twentieth, its first excursion into the world outside its box is as fraught with fears as a baby's first day on earth. If there's anything wrong with it, you're going to find out right away. And if you're not careful, you may damage its future without meaning to.

The first thing to do, of course, is to open the box—gently, so as not to drop its contents on the floor or demolish the box itself, which will come in handy if the camera has to be returned or sent off for repairs. Most boxes that cameras come in are thin affairs, their main job being to hold together a thick foam sandwich. The foam sandwich encases the camera and whatever accessories are in-

Extricating a new camera from its plastic foam cocoon is exciting, but don't get carried away. First locate the instruction booklet, which you should read before loading the camera. (If you're like me, you'll be tempted to put it off.) Then look for the odds and ends that are packed nearby: neck strap, battery, case, warranty card.

cluded with it and should be handled with even more respect than the box.

With the typical camera package you'll find a shallow tray or depression on top of the top block of foam. In this tray you're likely to find an instruction booklet, a warranty card (unless, heaven forfend, this is a gray-market camera), and last but not least, the battery that empowers the camera's meter, shutter, shutter release, and who knows what else. Grab that battery wherever you find it because you'll have to install it in a minute. And try to resist the urge to put the instruction booklet down on the floor with the wrapping paper, from where it probably will never reemerge.

I'm not going to suggest that you read the instruction booklet now because if you're like me there's no stopping until you've first fondled the camera itself. Lift the piece of foam with the tray, and there the camera will be. Beside it may be other small items such as a neck strap or even a little sack labeled silica gel, which is a desiccant (it absorbs moisture, keeping the camera dry). Save it if you expect the humidity to be high where you store the camera.

Now you have it: the camera, the neck strap, the battery, the instruction booklet. Try to put on the neck strap, if you want, and

parade around as necessary. Do not, however, start trying to fire the shutter, spin the dials, load the film, or anything else until you have time to read the instructions. Never mind if it makes you a party pooper; guess wrong once about how something works, and there will be no pictures of this particular birthday.

Sit down at a relatively peaceful table with the instruction booklet, the camera, the battery, and a roll of film. Look at the diagram of the camera's controls and read about how they work. Read how to open the back and load the film; then try it. Follow the instructions on installing the battery. Your camera should be ready to spring to action, its meter poised for perfect exposures. With the instruction booklet digested and the battery in place, you're ready—almost—for picture taking.

But let's be sure the machine performs as advertised before we get Aunt Harriet to pose in front of the cake. Remove the film from the camera (you've read how to do that, haven't you?) and try firing the shutter a few times. (If your camera automatically loads the film, the film may have to be in position for the shutter to work; if so, waste some exposures.) If you can set different speeds, do so, and listen to the sound the shutter makes—or, better yet, look through the camera back—to check that the speeds are approximately what they say they are. Look in the finder and check that the information displayed there about shutter-speed and aperture settings corresponds to the settings on the camera controls. Focus the lens from its nearest to farthest points; it should turn smoothly and without any noise, like the noise of a loose ball bearing. Look in the lens to see that the aperture blades open and close smoothly.

If the shutter and the finder display fail to function, look again at the battery. Possibly you installed it incorrectly, with positive where negative should be. If that isn't the problem, try rubbing the battery's contacts with a pencil eraser to clean them. If the power still doesn't come on, it's likely you have a dead battery or, in the worst case, a dead camera.

If you take your time and learn about your new camera before you use it, chances are it will function properly. Go ahead and have a field day. But if your preliminary check of its functions reveals a glitch, don't waste time trying to remedy the problem. Today's cameras are complex organisms that are upset easily by amateur

surgeons. Instead, wait patiently until the store reopens and take it back to the seller, repacked in its original foam and box. (You did save that box, didn't you?) Insist on a new sample of the same model and don't be talked into having yours sent out for repair. Even without a warranty card in the box, the camera is warranted by its maker against manufacturing defects.

CAMERA CASES

Hemlines rise and fall, lapels go thick and thin, ties wax and wane. We live in a world of fashion, it seems, and photography is not immune to its influence. Fashion is especially a factor when it comes to how we tote our cameras around.

Once 2-inch-wide, brightly embroidered camera straps were *de rigeur;* now they're considered slightly gauche. One year we may be sporting fly-fishing vests with pockets crammed full of lenses and filters, then a new fall line of canvas camera bags comes along and vests are out.

One of the latest fashions is the camera holster. Looking somewhat like a stuffed animal, this gunslinger knockoff is hung from a shoulder strap and rests comfortably on the hip. It is padded with foam and covered with tough synthetic fabric to protect its fragile contents.

In my opinion, wearing one of these form-fitting cases may put you at the forefront of fashion but only at the expense of practicality. Many camera holsters are designed to hold a single-lens-reflex camera with a moderately long zoom lens attached. To start shooting, all you have to do is open the top flap and grab the camera—simple, right? Unfortunately, there is no space provided for other lenses, flash units, filters, or even rolls of film. These, presumably, have to be packed in a separate camera bag, carried on the other shoulder.

But the main drawback to this kind of camera carrier isn't its lack of space. If that were the only problem, it could be solved by switching to a padded shoulder bag big enough to carry the whole kit and kaboodle. No, the problem I have with camera holsters is

the same one I have with most camera bags and so-called ever-ready cases: they keep the camera in cold storage.

I remember once giving what I thought was a particularly stirring motivational pep talk to a group of workshop students. They were revved up and eager to take pictures. Off we all went, out of the classroom and into the real world, determined to seize life on the fly. But a half-dozen yards down the sidewalk I looked around and stopped in my tracks. All the eager-beaver photographers in tow were walking along with their cameras safely encased in their assorted holsters, shoulder bags, and backpacks. How, I asked in my most mellifluous voice, did they expect to photograph anything flitting in front of their eyes if their cameras were tucked out of sight?

As any drill sergeant would have done, I ordered the troops to halt and barked at them to present arms. Out came the cameras from their padded enclosures. Someone had the temerity to hang the camera strap from his shoulder. I frowned. The ready position for picture taking, I told them, was to have the camera in front of you, chest high, where you can see the settings at a glance and get it to eye level in a trice. Then a small voice piped up from the back of the ranks: "What happens if I bump something? Shouldn't the camera be in its case so it doesn't get scratched and dented?"

Well, friends, if your aim in photography is to protect your camera from the environment at all costs, then leave it in the holster. Better yet, leave it and the holster at home. That way you'll be assured your equipment will remain in mint condition, a true collector's item. Of course the shutter may freeze shut from lack of use, but the outside will still be pretty.

Real photographers—that is, picture takers who seriously pursue their endeavors—usually have cameras that look like vintage World War II army surplus. The pentaprisms have been smashed into hexaprisms, and the paint is worn down to bare brass. I've been told that Henri Cartier-Bresson, the world's best-known user of Leica cameras, had to paint his own f-stops on lenses because he habitually wore off the manufacturer's markings. And this wasn't from camera abuse, just hard use.

Don't get me wrong. I'm not against camera bags and holsters any more than I'm in favor of banging your camera around until it's

If you keep your camera slung around your neck, it's a simple matter to grab it with both hands, in the manner shown here, and have it in front of your eye in a trice. Using both hands helps keep the camera steady, which prevents blur.

knocked senseless. But if you're going to be shooting pictures, it sure helps to carry your camera in your hand or around your neck where you can get it to your eye in an instant.

This advice may seem to be directed mainly at "candid" photographers, those of us who shoot on the street, at friends' weddings, or at Thanksgiving Day parades, but it applies as well to those who shoot buildings, flowers, landscapes, and other slow-moving subjects. When your camera is tucked away, there is a natural reluctance about getting it out. You wonder whether it's worth it, whether what you are seeing is really important enough to immortalize in a picture. "Why bother?" becomes a question bouncing around in your mind.

When you start playing this nasty psychological trick on yourself, your days as a photographer are numbered. Wearing your camera around your neck can be a talisman against this kind of photographer's block—and besides, it's a lot easier on the back.

CASES FOR YOUR GEAR

Tripods are great for holding cameras steady during long exposures, but they're the world's biggest pain to pack. Mine seems particularly egregious although it has the same unwieldy construction as the rest of its species. Its legs stick out one way while the handles used to position the head stick out another. The head, which is fat enough to hold a view camera, is also chubby enough to bump into every doorway I go through.

For years I made do with a tripod travel bag that was clearly not designed for my tripod. It consisted of a zippered cloth sling and a wraparound shoulder strap. The trouble was that the zipper wouldn't close because of my tripod's thick platform, which meant that the tripod was always in danger of falling headfirst out of the bag. Why I put up with this for so long I don't know. What I do know is that it caused me to hesitate when deciding whether to take my full set of photographic gear on a trip. After all, one of the joys of travel for photographers is taking pictures, and it's hard to take pictures if we leave our equipment back home in the closet. There are untold numbers of photography enthusiasts who started out loving the opportunity to take pictures on vacation and then, having become "sophisticated," loaded themselves down with so much gear that they never wanted to take a vacation again. This

My form-fitting tripod bag, which I bought only after years of suffering with another case that wasn't the right size. Note the luggage tag, which so far has kept the bag from going astray at dozens of airports.

shouldn't happen since cameras, lenses, and accessories sufficient for most purposes do not weigh as much as, say, a sixteen-pound "portable" computer. I'm convinced that the heart of the problem is the lack of a good carrying case.

Every outfit needs a case appropriate to its size, weight, and function. If what you are packing is one 35-millimeter SLR body and a zoom lens, a small, padded ditty-type bag should do the trick. You can stick rolls of film in the empty spaces and carry the whole kit onto the plane with you. The nice thing about carry-on baggage is that the airline doesn't have a chance to lose it.

If you're more sophisticated or less trusting of technology, you might want to carry two SLR bodies, a flash unit, a couple of zoom lenses, plus two or three single-focal-length lenses. These you can cram into a medium-sized bag that also will fit under an airplane seat, although it will be a tight squeeze. The bag should have adjustable padded partitions inside for a custom fit, and both shoulder and hand straps for lugging it around.

Pros, who carry even more than this, usually check at least part of their gear as luggage. They rely on hard-shell cases with aluminum, plastic, or fiberboard shells that can take lots of punishment. Believe it or not, checking equipment this way is pretty safe, although it still pays not to advertise that you're carrying camera equipment. Plain, unlabeled cases are less ostentatious and thus less attractive to thieves.

Almost all tripods have to be stowed separately or hand carried due to their shape. One exception: Cullman manufactures an ingenious tripod model that folds totally flat so that it fits in the bottom of a carry-on bag designed especially for it. But it's a lightweight design, and with tripods, more weight often means more steadiness.

My best packing secret is the most unlikely. I stick half my photographic stuff into my regular suitcase. Lenses, film, and flash units seem ideal for filling the gaps beside my sneakers, shaving kit, and the like. Sometimes I have to leave out a shirt or two as a result, but I usually take too many anyway. I just make sure I pack the photographic pieces in the middle of the suitcase so that there's plenty of padding all around them. When I get to where I'm going, I reshuffle the contents of my suitcase into my shoulder bag, and

*Camera cases on parade: in the foreground is a
state-of-the-art camera bag made by Lowe-Pro for
medium-format photographers and 35-millimeter users with a
great deal of gear. Lowe-Pro's padded fanny pack sits atop it,
and two generic, unlovely hard cases—one aluminum, one
fiberboard—complete the picture.*

I'm off to take pictures. So far, knock wood, the system has never failed.

And I now have a new tripod case. The tripod nestles neatly inside its padded innards, the zipper closes easily, there's room left inside for my dark cloth, and an outside pocket holds odds and ends. It's so convenient that the tripod actually feels lighter; better yet, the airlines now check it through without a peep.

THE CASE FOR PACKS, NOT CASES

My favorite toting devices for serious walking with camera gear are backpacks and fanny packs. Shoulder bags, whether hard or soft, give me a backache because they put all the weight on one shoulder, throwing the body out of balance. Back and fanny packs distribute the load evenly on both sides of the body, even though you have to adjust the way you walk in a front-to-back direction.

The best packs for photographers are those made specifically

for cameras. These feature plenty of impact-resistant padding to cushion your equipment—not so much from falls but from the constant jarring of walking. However, many wilderness photographers use conventional packs that they've converted for camera use. They either add their own foam or simply wrap cameras, lenses, et al, in pieces of clothing.

If you're a point-and-shoot photographer, it's possible to get away with a small padded camera case that hangs on the belt. Lowe-Pro, a company that specializes in outdoor-oriented camera cases, makes one with an outside pocket that holds a couple of spare rolls of film. Camera and film—that's about all the average hiker needs.

For those of us more interested in photographing than hiking, however, a case of such minuscule proportions isn't satisfactory. In my fanny pack (also made by Lowe-Pro) I can fit a motor-driven SLR with a 35-millimeter lens attached, an 80-to-210-millimeter zoom lens, a hand-held exposure meter, a lens-cleaning chamois, a polarizing filter, and about five rolls of film. That's what I need for an afternoon's stroll down the garden path.

A backpack will hold even more. If you want to cart a full range of single-focal-length lenses or need to lug along a 300-millimeter tele or a flash, most backpacks can accommodate them. They also have enough spare room for such day-tripper necessities as trail mix, bug spray, and a compass. Many backpacks designed for camera use also have straps at the bottom that will secure a lightweight tripod.

But try to resist the temptation to take the candy store along with you if you're going to be exerting yourself. Remember, every pound you add at the start of a hike will be a pound you'll curse at the end. For most purposes, covering a range of focal lengths from 35 millimeters to 100 millimeters should suffice. If you want an ultra tele look, think about getting a 300- or 500-millimeter **mirror lens.** These designs are much lighter and less bulky than their conventional counterparts.

BATTERIES

Way back when, all photographers ever needed to know about batteries was their sizes. There were AA "penlight" cells and C- and D-size "flashlight" cells. Of course those were the days when cameras were mechanical marvels full of gears and springs, and flash units looked like potato mashers.

Today, nearly every picture-taking function requires battery power. The list is almost endless: focusing, shutter speeds, exposure metering, film winding and rewinding—even film loading. Battery-hungry flash units are built in. As the electronic functions of cameras have gotten more complex, batteries have become more specialized.

The first exotic batteries to find their way into cameras were the little "buttons" designed to power the first cadmium-sulfide (CdS) exposure meters. These come in either mercuric-oxide or silver-oxide versions. But when camera makers added other chores besides exposure measurement to the battery assignment sheet, these little buttons no longer could do the job.

So camera makers started using the same batteries that flash makers had discovered years before: alkaline-manganese cells in AA and AAA sizes. Alkalines, as they're commonly called, put out 1.5 volts apiece and in their photographic applications last up to five times as long as their similarly sized forerunners, carbon zinc batteries. (Carbon-zinc cells are still sold because they are better than alkalines when a low constant current is required.) To house them, camera makers added hand grips to the front of their SLRs, a feature that is now all the rage.

When alkaline or carbon-zinc batteries are used up, you throw them away and buy new ones. Nickel cadmium cells (NiCads), however, can be recharged using a transformer and household current. Though more expensive initially, they are cheaper to use in the long run, but because the electrical characteristics of NiCads are different from those of alkaline batteries, they cannot be used interchangeably. Unless the manufacturer specifies that your flash or camera can use NiCads, don't tempt fate by trying.

The latest newcomers in batterydom are lead-acid and lithium cells. Lead-acid batteries are similar to car batteries but with a

gelatin electrolyte; they are used increasingly as a power source for electronic flash units. Some high-powered portable flashes are designed for lead-acid power; in addition, independent manufacturers are selling "after-market" battery packs. These packs (Quantum is one popular brand) clip onto your belt with a wire running from the battery to the flash head atop the camera.

The advantages of lead-acid for flash use are capacity and rechargeability. They will power more flashes per charge than NiCads, and they don't have "recharge memory" problems. (Unlike NiCads, they don't lose performance when partially recharged.) The only trouble is that they are relatively expensive to buy and aren't designed for every flash unit on the market. But for wedding photographers and paparazzi used to lugging around heavy high-voltage batteries, these modern "gel cells" are a blessed relief.

Lithium cells are the latest innovation in camera-battery design. They will last for up to five years depending on how much they're asked to do. Best of all, they don't mind sitting around on the shelf before they are used or after being partly used. Whereas other battery types, alkalines included, lose power in storage, lithiums have remarkable patience.

But lithium batteries can only be used in equipment designed for them. To keep the unwary from sticking lithium cells into cameras engineered for alkaline power, camera makers and battery

The battle of the batteries; from left to right: conventional, reliable, easy-to-find AA alkaline cells; a new-style lithium unit, designed to offer longer life and quicker flash recycling; and the newest kid on the block, a rechargeable lead-acid battery, found in Canon's Xapshot still-video camera.

manufacturers have conspired to package lithium cells in a strangely shaped unit. What's nifty about the arrangement is that you can install alkaline AA cells in the space where a lithium unit will fit, but you can't fit a lithium unit in a space designed solely for alkaline cells. Translation: most cameras that use replaceable lithium batteries can also be powered by a set of alkaline cells, but not vice versa.

Some cameras have their lithium cells built in. When these lose their power you have to send the camera to the manufacturer's repair station for replacement. But with a growing enthusiasm for the replaceable units (even at nearly $20 apiece), the built-in lithium probably has become a thing of the past.

Does it matter what brand of battery you buy? Are Copper Tops better than Supralifes? Let's put it this way: the best slogan any battery maker has been able to come up with so far goes something like: "No battery lasts longer than the Infinity Blitz battery." In other words, within category (alkaline, lithium, NiCad, and so forth), the top brands are pretty much the same in terms of lasting power. What is important is getting factory-fresh batteries and using them soon thereafter.

BREAKDOWNS AND REPAIRS

"In-the-field" equipment breakdowns are the bane of every photographer. Hardworking pros know enough to plan for them by packing redundantly. Instead of one camera, they take four; instead of one flash unit, they take three. They also know what areas of equipment are most prone to malaise, such as flash cords with PC connectors, and they periodically take their cameras in for lube and adjustment jobs at qualified repair stations.

For the occasional photographer, however, buying more equipment than you'll ever need seems like a waste of money, and having the camera checked out by a repair shop is usually the last thing on our minds when it comes off the shelf and goes into action. Indeed, many photographers have never seen the inside of a camera repair shop, given that today it can be as expensive to fix a disabled camera as it is to buy a brand-new one.

A once-a-year cleaning, lubrication, and adjustment (CLA, in the trade) should keep your equipment in good working order (especially the shutter, which is a moving part of some complexity). But even if the camera makes it all the way to Canberra and then quits on you, all is not necessarily lost.

First and last, do not try to force any piece of equipment that is jammed. This may sound like an elementary warning, but it is surprising how great the temptation is to give that recalcitrant lever or switch just one more little tug. Hope springs eternal, but stripped gears and mangled cams do not.

In this day and age, first check the condition of your battery. Many of today's automated cameras lie down and play dead without battery power, so if the shutter isn't working, your repair bill may be the price of a new battery. If it's not the battery, rewind and remove the film, remove the lens, and look into the camera's innards. You may see a shutter off its tracks or jammed halfway across the film. Either condition calls for a repair person.

Usually the trouble will be less obvious. If the shutter curtains look fine but the mirror is locked in the up position, look for a lever in the baffled mirror box that lets you lower it manually. Sometimes, as if by magic, this clears the jam. If not, try the self-timer. If that doesn't work, quit while you're still ahead. Do not get out the screwdriver on your Swiss army knife and start taking the top off the camera.

Lenses present other opportunities for things to go wrong. Diaphragm blades can slip off their pins, causing the aperture ring to freeze in place. Lens elements can become unglued and start rattling around inside the lens barrel. Filters can get their threads bent, so normal wrist force will no longer remove them. Apart from attempting to remove the sticky filter with an opener designed for a wide-mouth jar, there is little the average photographer can do about these conditions. The same goes for delicate exposure meters that stop functioning and for high-voltage flash units, which are dangerous if opened by the nonexpert.

Fortunately, there is a middle ground between total despair and the three or more weeks of down time you face if you ship your equipment back to the manufacturer. Most cities and towns of any size have a photographic repair shop qualified to do strip-down

type repairs on the premises. They can often come to the rescue in a day or two when you are traveling and disaster strikes. If you need parts, you may have to wait longer for a functioning camera, but at minimum you'll learn exactly where the problem lies. To find a repair shop, ask at a local camera store (which, as a rule, is not itself able to do repairs).

A REVIEW OF CHAPTER NINE

1. When unpacking a new camera, please, please, please take time to read the instruction booklet before trying to snap a few quick pictures. If you don't, you could be sending it off to the repair shop.
2. Camera cases should serve to protect your equipment from the hazards of travel, but they shouldn't keep you from taking pictures. When shooting, wear your camera around your neck so that it is always at the ready. (Don't forget to take that lens cap off!) If you like to hike and photograph, a backpack or fanny pack can help distribute the load.
3. Batteries come in different sizes and types. For photographic purposes, alkalines, lithiums, and lead-acid "gel" cells are most common. Be sure that you don't mix types or attempt to install a lithium cell where alkalines belong; such ingenuity can spell electronic disaster.
4. The best camera repairs are those done before the camera breaks. A once-a-year cleaning, lubrication, and adjustment (CLA) is as good an idea as an oil change every five thousand miles.

TEN

A Pop Quiz

Please remove all books and papers from
your desk. You are allowed to use one
pencil or pen. No talking during the exam.

Okay, I admit that you deserve a degree just for getting this
far. You've already digested more information about pho-
tography than most people learn in their entire lives. Or have you
just skipped from the introduction to this chapter to prove to me
how smart you are? No matter. We're about to discover how well
you have assimilated the principles of picture taking.

The questions below test your knowledge of fundamental
photographic relationships. While they may seem hypothetical or
even theoretical, they actually relate to real-life picture-taking
situations. I designed them to cover a broad spectrum of photo-
graphic problems, so even if you don't get an answer right, you'll
learn something new that you can use in your photography. At
least I hope you will.

Now get out a pencil and paper, and try not to look at the
answers first. (They're printed on a separate page to make it
tougher on would-be cheaters.) Don't be intimidated if the test
seems difficult: it's supposed to teach you some new tricks, not
discourage you. Some of the answers will seem easy to experts, of

course, but there are a couple of tricky questions, too. If you score 100 percent, then you are qualified to teach a workshop of your own. Or better yet, to review this book in *Time* magazine. Here goes:

1. What is the relation of f/16 at ⅟30 second and f/4 at ⅟500 second?
2. Does Caucasian skin reflect more light or less light than the average photographic subject, and to what extent?
3. In photographing a black cat in a coal bin, you rely on the meter built into your camera and expose as it indicates. Will your picture be underexposed or overexposed?
4. What is the slowest shutter speed you should use when hand-holding a 50-millimeter lens? A 200-millimeter lens?
5. Your exposure meter goes on the blink far from civilization. On a bright sunny day, with Kodachrome 64 in the camera, what is your best-guess exposure?
6. With Kodachrome 64 film, an exposure of 1 second at f/5.6 is the same as ½ second at f/5.6. True or false?
7. You're photographing a friend in the park. The light is coming from behind his face. In which direction and how much would you adjust exposure?
8. You're photographing two friends, one 6 feet and one 12 feet from the lens. Where would you focus to get the best possible sharpness in both subjects?
9. You take a series of pictures indoors, using transparency film. The processed slides look orange. What happened?
10. You're shooting close-ups of flowers. At one-to-one magnification (meaning that your subject will appear its actual size on film), how much more exposure is needed than when shooting at infinity?
11. The day is overcast and glum; you want to increase the contrast of your pictures by switching to another transparency film. Do you change to a higher or a lower speed film?

And now turn in your exam books, please.

The answers:

1. They're the same exposure. This is an easy question for anyone who knows that lens apertures and shutter speeds are reciprocal. Opening the lens one f-stop and shifting to the next faster shutter speed results in no change of exposure, just differences in depth-of-field and action-stopping capability. Thus, all these exposures are equal: f/16 at ⅟30, f/11 at ⅟60, f/8 at ⅟125, f/5.6 at ⅟250, and f/4 at ⅟500.

 Note that as f numbers on the lens get numerically larger, the physical aperture gets smaller; f/16 is a smaller opening than f/11. Remember, too, that while shutter-speed numbers are doubled or halved whenever you make a one-stop change, *f numbers* are doubled or halved every other stop.

 (For more explanation, see Chapter Two.)

2. Average, untanned Caucasian skin is lighter by about one stop. Knowing this is useful when it comes to metering; in taking a tight head-and-shoulders portrait, for example, it pays to open up a stop from what the meter suggests. It also serves as a rule of thumb—or rule of palm, if you will. When metering a far-off subject such as a landscape where the meter might be overly influenced by the sky, average-skinned Caucasians can "read" the light reflected from their palms and increase exposure one stop. The method is similar to incident metering.

 What if your skin is darker or fairer than "average" Caucasian? Then you'll need to check the reflectance of your palm against that of an 18 percent gray card, the standard measure of an average subject. Simply add in your personal exposure factor when calculating a palm reading.

 (For more on exposing, see Chapter Two.)

3. Overexposed. Every camera metering system is designed to turn whatever it "sees" into a subject of average reflectance, which, as mentioned above, is 18 percent gray. Thus the black cat in a coal bin would be rendered as a medium-gray cat in a medium-gray coal bin. To keep the cat black, you would need to decrease the recommended exposure by two stops or more, depending on the film in use.

 (See Chapter Two.)

4. For a 50-millimeter lens, $\frac{1}{50}$ second or faster; for a 200-millimeter lens, $\frac{1}{200}$ second or faster. With a mechanical shutter the speeds would be $\frac{1}{60}$ and $\frac{1}{250}$ second, respectively. The rule of thumb is to use the reciprocal of the focal length as a minimum speed to prevent camera-induced blur. Because longer lenses magnify not only the subject but also the effects of camera shake, correspondingly shorter speeds are required.

 (For more on focal lengths, see Chapter One.)

5. If the subject is in full sun, f/16 at $\frac{1}{60}$ second. This is the "sunny f/16 rule." Setting the lens at f/16 and the shutter at the speed closest to the reciprocal of the film's ISO speed will give you a ballpark exposure. If the subject is lit from the side, open up to f/11; if backlit, try f/8.

 This is an easy system to remember in case of emergencies, but there's an even easier solution to meter failure. Just look inside the film box, where most manufacturers provide handy exposure information for the most common lighting conditions.

 (See Chapter Six for more.)

6. True, sort of. According to Kodak's data, a one-second exposure with Kodachrome 64 is subject to what is called reciprocity failure, producing a stop less light than one would expect. Essentially reciprocity failure (that is, the failure of the law of reciprocity) means that at very long and very short shutter speeds, film emulsions do not behave in the theoretically correct manner. They slow down and change their response to colors, leading to underexposed pictures with strange tints. Turning the shutter-speed dial one step no longer produces a one-stop change in density on the film.

 The only time to worry about reciprocity failure is when you are taking very long exposures on a tripod—at dusk, say—or automatic-flash pictures at very close range. Then you'll need to refer to film makers' charts to determine the appropriate corrections, which usually involve opening the lens aperture and adding a color-correction filter.

 (See the section on reciprocity in Chapter Six.)

7. You would want to increase your exposure, this being a classic backlit situation. Most meters are "fooled" by the intensity of the background light and thus underexpose the human subject.

How much you increase the exposure depends on the film you're using and the contrast between foreground and background, but generally the increase is in the range of from one to three stops. Some simple cameras have backlight-compensation buttons that supply the extra exposure on demand; some sophisticated cameras have metering systems that detect backlighting and compensate automatically.

(For more on backlight compensation, see Chapter One.)

8. Eight feet. The reason is that at 8 feet you are taking the most advantage of the lens's depth-of-field, the range of acceptable sharpness in a picture. It's important to know that this range is not equally divided front to back. About two thirds of the depth-of-field area extends behind the point of focus, and only one third in front. If you don't want to take my word for it, examine a lens with depth-of-field scales and see for yourself.

(See the section on zone focusing in Chapter Four.)

9. Chances are you used daylight film under tungsten illumination. All color films are designed to reproduce colors accurately under only one kind of lighting, be it daylight, photo lamps, or quartz lights. Tungsten films, designed for photo lamps, will reproduce daylight subjects with an overall blue cast unless a correction filter is used. Fluorescent lighting usually turns daylight film a vile shade of green. To take indoor, incandescent-lit pictures on daylight film, use a blue filter designed for daylight/tungsten conversion or, with nearby subjects, use electronic flash, which is balanced for daylight.

(See Chapter Six.)

10. Two stops. The extra exposure is needed because the light has to travel farther than usual from the lens to the film and loses intensity. At less extreme close-up distances lesser "magnification factors" are needed. Luckily, today's automatic-metering SLR cameras read the light through the lens and thus eliminate the need to calculate any exposure adjustments. But the light losses in close-up work coupled with the need to stop down the lens for adequate depth-of-field make it wise to choose a relatively high-speed film.

(See Chapter Eight.)

11. As a rule, low-speed (small ISO number) films have inherently more contrast than higher-speed ones. As a result they are often less forgiving of exposure errors. They also offer more color saturation (especially in the case of slide films exposed for slightly less than the manufacturer's recommendation). But high-speed films often *look* more contrasty because they render a somewhat narrower range of tonal values, and manufacturers may "juice up" their contrast to compensate. What's the answer? Test your favorite films in identical conditions and examine them for contrast, then decide. Or, since overexposure of print films increases their contrast, stick with the same film and open up a stop.

(See Chapter Six for further explanation.)

What's a passing grade? Anyone who answered five or more questions correctly deserves to be called a photographer. Eight to ten correct answers means you are a master of the medium. A perfect score? You're smarter than I am. I'm still puzzling over question 11, which I got wrong the first time I answered it!

ELEVEN

Sticky Shooting Situations and How to Handle Them

What the instruction booklet didn't tell you about photographing portraits, weddings, babies, works of art, landscapes, travel, strangers on the street, and things that quiver and quake.

Sure it's nice to know all about how films react to light, and how automatic exposure and automatic focusing work, and what kinds of cameras there are in the world. But the object of all this technical know-how is to take pictures, and in the real world, where practice doesn't always correspond to theory, you have to think on your feet and improvise as you go.

Not everything is unpredictable, however. In my years of shooting I've noticed that certain problems surface again and again. You might say they're typical of the kinds of sticky situations average photographers get themselves into. So, based on my forays into the real world, here is some advice on how to cope.

PORTRAITS

It's the kind of offer you can't refuse. A friend calls, one of the nicest people you know, and explains that she needs her picture taken in a hurry. She knows you're a capable photographer; you've done it before and she liked the results. How soon does she need it? How about tomorrow?

If you're like me, the flattery of being asked to do what you like to do anyway is too much. And as the Kingston Trio once sang, in the saga of the Boston subway rider who was a nickel shy on his fare, "Remember, friends, this could happen to you."

I often think that taking portraits would be a piece of cake were it not for the matter of light. Usually there's not enough of it, and when there is it's usually the kind conducive to shadowy bags under the eyes. Consequently, pros who shoot portraits for a living always bring their own lights along. By and large they use high-power flash units that have separate, weighty power packs. They also employ agile young assistants to carry the power packs.

Those of us without assistants have to improvise or else end up consulting a chiropractor. I sometimes take along my Lowell Tota-Light set, which I use mainly for copying. Tota-Lights are lightweight, AC-powered quartz lights originally designed for

My favorite lightweight, portable lighting supply, a Lowell Tota-Light unit. The quartz-halogen bulb in the center puts out 500 watts of tungsten-quality light over a life span of several hundred hours.

location film work. I love them despite their one flaw: unlike flash, which is balanced for daylight film, quartz lights are balanced for tungsten film. Unless I am willing to totally block out any ambient sunlight in the room, I end up with color pictures resembling a stew.

More often I reach for my small, shoe-mount electronic flash. It isn't powerful enough to take the place of daylight, but it puts out enough juice to supplement it. In addition I take along what I refer to as my space blanket: a folding piece of super-light shiny silver foil. Called the Roscopak Featherflex reflector, it bounces light from one direction back the other way, providing "fill" light. With the electronic flash above the camera and the reflector to the side of the subject, I can get something close to a 2:1 lighting ratio, which is ideal for portraits.

It helps greatly if the light from the flash is diffused somehow. The most attractive and efficient lighting comes from an umbrella; the flash is pointed into the umbrella's center so the light spreads out widely and bounces back to the subject. (Use an umbrella designed for photographic purposes, not your everyday brolly.)

An umbrella designed for photographic purposes diffuses the light from a flash, spreading it enough to produce flattering illumination with soft shadows. Umbrellas generally come in plain white, but some, like the one here, have a reflective silver lining.

Professionals use a medley of light-modifying devices to get the effects they want, as this gathering of products made by Photoflex demonstrates. On the left are three sizes of soft boxes; at top, a shoot-through umbrella; and at right, a stand-up reflecting panel.

Alternately, you can diffuse the light with a so-called soft box, which can be purchased at professional photo stores, or with a few layers of handkerchief cloth placed over the flash reflector. Or you can bounce the light off a nearby wall.

If you're more sophisticated than I am and have three hands, you can get the same results using two electronic flash units, one at camera position and one mounted on a stand off to the side. You'll

need a **flash slave trigger** for the distant flash so that it fires at the same time as the one connected to the camera. Using two flashes allows you to vary the lighting ratios according to your whim or to use one behind the subject as a halo light or **rim light.** This gives the hair a golden glow.

I like to use my SLR with its motor drive attached so I get both precise framing and nearly instant recycling. In situations where all that's needed is a head-and-shoulders portrait, I use a 105-millimeter lens. If I'm trying for a more environmental look, I may mount a 28-to-85-millimeter zoom. Somewhere in the range between wide angle and slightly tele I should find my portrait, and having all the choices available in zoom form means no wasted time changing lenses in mid-expression.

Finally, I take along my tripod. It's indispensable not so much for preventing blurriness (the electronic flash keeps any subject motion frozen) as for locking in composition. At close-in portrait distances, it's especially important to watch the edges of the frame, and a tripod lets me refine my framing with precision. If I don't want to lug my big tripod, I'll take along my minuscule tabletop tripod, made by Slik, which just conceivably could supply an extra shade of sharpness at the marginal shutter speeds I expect. It manages to fit in the camera bag, and I can set it on a table or chair on location.

Once you have the lighting and camera set up, taking the portrait should be a piece of cake. Just remember not to get too obsessed with your equipment. Your subject needs to feel relaxed, so some conversation, no matter how inane, always helps.

The one thing I always watch for, however, is if the subject is wearing eyeglasses. If so, and you're not attentive, the glasses will reflect back the blinding light of your flash, obscuring the eyes. In shots taken with bounce flash, you can end up with a reflection of the wall behind you. To avoid this, ask your subject to turn his or her head slightly away from the direction of the flash. Then any reflections won't bounce back into the camera lens.

WEDDINGS

If you have ever been seen so much as holding a camera, chances are you'll be asked by someone to take pictures at his or her nuptials. You can be a nice person and give it a try, or you can follow my advice: say no.

Not that I have anything against taking pictures at weddings, mind you. I've even done it more than once. But unless you enjoy living with terror in your heart from the start of the ceremony until the prints are delivered to the happy couple, saying no is the better part of valor.

There must be a reason, after all, why countless romantic pairs and their parents are willing to pay seemingly exorbitant sums to professional wedding photographers. These photographers have the right camera equipment for weddings. They have shooting scripts that include all the saccharin pictures grandparents seem to

If you ever are called on to photograph a wedding of friends or family, try to be out of town. If you must attend, try to supplement what the wedding pro does by capturing offhand moments and unexpected scenes.

require, and they carry plenty of insurance in case the pictures don't turn out. You and I, on the other hand, are mere duffers, handicap players in a game that's practically life and death.

Not having the pictures come out at all—producing big blanks— is the greatest fear of the wedding photographer, second only to having the batteries go dead on the flash unit. Far more likely, and no less disconcerting, is that the pictures do come out but none- theless lack the romantic aura the bride and bridegroom antici- pated. The kissing-the-bride shot and the cutting-the-cake shot, blasted with on-camera flash, end up looking like mug shots. Grandma isn't pleased.

Again, professional wedding photographers have the edge. They deal unabashedly in schmaltz. Since the actual ceremony rarely matches the sentimental stereotype, they restage the whole event afterward. Groom kisses bride again, this time for the benefit of the camera. A diffusion filter over the lens ensures that the resulting image will look like a dream. Later, in the darkroom, the kissing couple may have their mugs inserted within a candle flame or some other hopeless cliché.

In real life, weddings wear a different look. The participants are distraught, anxious, tired, frazzled. Words are mumbled or mispronounced. Veils slip and trains are stepped on. These are slices of reality seldom glimpsed in wedding photography, and believe me, they are not what most young brides' parents want to show their friends for the next forty years.

If you have to take pictures at a wedding, either because you want to or because you can't say no, insist that someone hire a professional anyway. Make it clear that you are there as a backup, to record the incidental charming moments the pro might miss. By this tactic you'll free yourself from the burden of responsibility for the obligatory scenes, and you can photograph what really interests you. Then at least you'll like the pictures, even if the happy couple and the hundreds of relatives don't.

Of course you'll have to stay clear of the pro, whose sense of mission is as overreaching as his prices for 8-by-10-inch prints. Just tell him (or, rarely, her) beforehand that you're the semi-official second stringer, and don't try to steal the shots he takes pains to set up. Instead, you can photograph informally and candidly. As

counterpoint to the pro's dream machine, your pictures may eventually take on a documentary value even in the eyes of the newlyweds.

In terms of camera equipment, stick with what you already own. Most wedding pros use medium-format cameras because they yield a bigger negative than 35-millimeter. With color-negative films, this can make a real difference in terms of quality, especially when the images are greatly enlarged, but for semi-official wedding photographers, the convenience and speed of 35-millimeter cameras are more than sufficient compensation for any compromises in quality. A zoom lens that spans a range from moderate wide angle to moderate telephoto can ably handle most wedding situations.

Bring along a flash, too. Even if the festivities occur in plenty of light, it can help eliminate harsh shadows caused by the sun. But don't fire it during the ceremony itself unless all concerned (particularly the person doing the officiating) agree in advance. You may be a photographer, but you're still a guest, so be considerate.

Like the pros, use color-negative film. Not only is it forgiving of exposure errors, it allows you to order lots of prints to give the bride and groom, their in-laws, friends, and former spouses.

BABIES

After the wedding, what next? Babies, of course. As if by some agreed-upon plan, many friends who tie the knot one year will have tiny bundles of joy to show off the next. They are beautiful, they do amazing things, and they cry out to be photographed.

While baby photography is a specialized genre within the range of the portrait professional, it also is practiced by virtually all parents. Who better than the parents, after all, to record those never-to-be-repeated scenes of infancy and childhood? While the pro's studio pictures tend to look stiff and contrived, the parents' photographs can candidly capture the baby's true character in real-life situations.

At least they should. The trouble is that relatively few parents

Babies are cute, all right, and can look that way in photographs if you have enough patience. Try to avoid looking down at them from adult height, and get in close by using a close-up lens.

are equipped to deal with a photographic subject who is minuscule, squirmy, and likely to have no interest whatever in cooperating with the camera. For many parents the solution is to imitate the studio-portrait look. They prop their baby up on the bed, all dressed up with no place to go, and fire away. They get recognizable images, for sure, but not especially captivating ones.

Others attempt to document the child's early life, using whatever snapshot camera they have on hand. Poor baby soon gets used to having a blast of light in his eyes whenever he does something cute. In Pavlovian terms, the result is a child who learns to avoid pleasing his parents for fear of blindness. Photographically, the results are usually hit or miss. When the baby isn't out of focus, his face is badly overexposed. The parents proudly show these pictures to relatives and friends, who gamely ooh and aah over an indecipherable blur.

The first thing to recognize is that babies are, by definition, small. To show them as they really should be shown requires a lens

that focuses close to the subject and frames it accurately. This rules out point-and-shoot cameras. Most so-called normal lenses on single-lens-reflex cameras focus to between 1 and 2 feet, which is barely adequate. It's much better to buy a macro lens, which can focus to within inches of the lens as well as to infinity.

Polaroid's instant-picture SLRs, the venerable SX-70 and the newer Spectra, focus very closely without requiring an additional lens. Unfortunately, at least with the one I have, there is a discrepancy between what appears in the viewfinder and what appears on the film. Baby's head gets cut off at the top, which isn't what anyone wants. This parallax problem can be solved by remembering to adjust the framing before shooting, but this is an unnecessary bother.

These Polaroid cameras and practically all point-and-shoot auto-focus cameras feature flash units very near the lens. Often the flash output is controlled by the auto-focus distance sensor. If baby moves and the camera mistakenly focuses on the floor, baby will be overexposed as well as unclear. And in any event, the on-camera flash will produce mug-shot-style lighting that is no more flattering to a baby than to an adult.

To make a long story short, the ideal equipment for candid baby pictures is a 35-millimeter SLR with a macro lens and a flash unit that can be adjusted to yield indirect lighting. By bouncing the flash's light off the ceiling, a wall, or a small reflector mounted on the flash itself, you spare baby's eyes and get a more natural look in your pictures.

Bounce flash used to require setting the flash to manual and opening the aperture approximately two or three stops wider than would be called for with direct flash. Today, no such guesswork is necessary. Most automatic flash units manage to keep their sensors pointed straight ahead even if the flash is directed skyward. And many modern electronic SLR cameras—and practically all auto-focus ones—manage to "read" the flash output to ensure correct exposure.

So much for equipment. The next problem is getting a decent picture with it. Getting down to the baby's level is one step in the right direction. Too many baby pictures look as if they were taken from Mount Everest. The baby appears much like a butterfly in a

display case, flattened out by the overhead perspective. I don't like to have the top of my head photographed, and I don't know why anybody's baby should, either.

As for coaxing and cajoling the infant into some stage of cooperation or acquiescence, Dr. Spock is a much more authoritative source on the subject than I could ever be. Photographing baby, after all, is one more part of that educational process we now call "parenting."

WORKS OF ART

Artists often ask me to reveal the secret technique of photographing works of art since the slides they make of their paintings, drawings, watercolors, et al., fail to accurately convey how they appear in the flesh. This is not an uncommon lament, and having once assayed to copy artworks as a means of making a living, I know too well the problems involved. In copying art, as in all its other functions, photography is not always the faithful witness it is cracked up to be.

In theory, copying any two-dimensional object of modest dimensions using 35-millimeter slide film is not that difficult. One merely needs an adjustable 35-millimeter camera (preferably a single lens reflex), a tripod or copy stand, two light sources, a roll of color film balanced to the lights in use, and a small level. One positions the camera so that the lens is precisely aligned with the middle of the painting. One arranges the lights an equal distance from the subject, at an angle between 30 and 45 degrees from the plane of its surface. One then meters for an average gray tone and fires away.

This is easier said than done, of course, and there are complications. The camera, besides being centered on the painting, should be tilted so that its film plane is parallel to the plane of the painting. The level comes to the rescue here; one first checks the angle of the painting (it is rarely perpendicular to the ground when hanging on a wall) and then sets the camera to the same angle, both horizontally and vertically. The result will be a slide in which the painting is "square"; that is, true to its original shape.

For copying any kind of flat material, such as artwork or old photographs, use a copy stand or tripod to keep the camera back parallel to the paper. Two lights at equal angles and distance from the art, as shown, will ensure even illumination.

Getting the lights equidistant and at identical angles can be complicated, but the chore is made easier by using a tape measure or two equal lengths of string. To test that their output is the same, meter the painting with one light on and the other off, and vice versa. The two readings should match. It also is important to check the lighting at the edges of the painting as well as in the center so that even illumination is assured. If the readings are inconsistent, move the lights farther away. If the painting is of mammoth proportions, four lights instead of two may be needed.

As you may have suspected, the lights I am talking about are the continuous-output type—photofloods or quartz lights. They are easiest to set up and to meter, and you can see exactly what their effect will be. Flash units with modeling lights can be used, and some like them because they are balanced for daylight films, not tungsten. But with flash one often gets unwanted surprises, such as reflections, that negate their usefulness.

How, exactly, does one meter as I have suggested without

having to constantly remove the camera from the tripod? The "secret" is a hand-held meter. It can be used in reflected-light mode together with a gray card held in front of the painting or, less easily, in incident mode, pointed back at the camera. In setting up the lighting for a painting, I often take meter readings a dozen times. And when it comes time to shoot, I bracket exposures a half stop in either direction.

In my working days I used mostly Ektachrome tungsten films, balanced for 3200 Kelvin on the color temperature scale. (That's the scientific way of saying yellowish light; daylight, which is more blue, has a color temperature of about 5500 Kelvin.) But because of Kodachrome's fabled longevity and consistency I also called on Kodachrome 40, which is balanced for 3400 Kelvin—not exactly tungsten, but not daylight either. To balance this film with my cherished 3200 K Lowell Tota-Lights, I placed an 82A gelatin filter over the lens.

With all this technical knowledge, equipment, and preparation, did the slides I took consistently "match" the originals? Seldom. After listening to artists complain about my results, I knew that writing had to be an easier profession. The problem, however, was not in the slides but in the expectations of the artists.

A color slide, made-up dyes deposited on a transparent film base, will never exactly match a painting consisting of pigments on paper or canvas. This is not the film maker's fault; dyes and pigments are two different beasts. Modern color films come remarkably close to reproducing all sorts of colors, but there are specific pigments that color films inherently misrepresent. These differences can be small—small enough so that only the artist would notice them—or they can be dramatically large. Some white pigments, for example, are notorious because they appear a sickly blue-green in photographs. No reproduction, I'm afraid, can ever accurately replace an original.

Landscapes can be vast or intimate, colorful or monochromatic, scenic or despoiled. But the best landscape pictures are usually taken early in the day or in the evening, when the sun provides dimensional shadows. A UV or polarizing filter can help, too.

LANDSCAPES

Taking a breathtaking landscape photograph requires more than a breathtaking piece of scenery. This lesson is learned almost immediately by all photographers who venture into the great outdoors. But for some reason—perhaps discouragement—many of us never discover the techniques to help overcome this disparity between the camera and the eye.

Our eyes have the marvelous capacity to adjust to various levels of illumination, from sunlight to street light, and to perceive distances, colors, and a breadth of detail in a glance. Cameras and the color films made for them are more limited. Whereas our eyes interpret any light between 5,400 and 27,000 Kelvin (the scientific measure of what's known as **color temperature**) as broadly constituting daylight, photographic film understands it only as a single temperature of about 5,500 Kelvin. This is why pictures taken at midafternoon, when the color temperature of daylight is at its highest, turn out unexpectedly blue. Photographers who under-

stand the nature of color film learn to take their landscapes early in the morning or late in the day, when the light is more yellow than blue. In addition, the oblique shadows cast at either end of the day help the camera distinguish fine detail and lend a sense of depth to the picture.

But even early risers can be disappointed by their results if there is too much haze in the atmosphere. While to the eye atmospheric haze is merely one more means of judging distance, to the camera it is like a muslin sheet hung in front of the lens. Colors and contrasts, which the eye helpfully interpolates even when they are barely there, disappear in the picture.

One way to bring the camera's way of seeing closer to that of the human eye is with an ultraviolet (UV) filter. Usually supplied as a screw-in accessory that is mounted on the front of the lens, it helps pierce atmospheric haze and eliminates much of the extra blue color recorded in landscape pictures. It works these wonders by preventing UV light from reaching the film, which otherwise responds to UV as if it were blue. Since a large part of haze is at the end of the spectrum near ultraviolet, the film "sees" less of it.

Unfortunately UV filters—and skylight filters, their close cousins—are not cure-alls. Photographs taken with them in flat, unpleasant light will come out looking flat and unpleasant, and therefore knowledgeable landscape photographers depend on un-usual light for their bread and butter. Sometimes it is soft and misty, and sometimes it is stark and dramatic, but it nearly always requires single-mindedness and patience to find and capture.

If you are really serious about landscape photography, you need to schedule the rest of your life around it. A photographer I met recently decided he wanted to photograph mountains; he ended up camping out in freezing weather near high peaks so he could start photographing at the crack of dawn. His pictures, needless to say, were filled with fantastic light. Even so, his slides seemed a bit flat until he discovered what is probably the ultimate weapon of color photography: the polarizing filter. Under sunny conditions it seems to add saturation to landscape pictures because it reduces the innumerable spectral reflections in any scene. It can also darken the blue of the sky. (For more details on polarizers, see Chapter Eight.)

Polarizers are not the only filters insufficiently used by photographers. Indeed, there are many so-called advanced amateurs walking around with expensive cameras and lenses who have never ventured to explore filters at all. Perhaps they have a UV filter on their lens, but many consider it merely a glass lens cap. This neglect of filters is too bad since filtering color film is one of the main keys to better-looking landscape photographs.

VACATIONS

Recently I ran into a colleague just back from China. He had a sour expression on his face. "I had a great trip," he said, "a once-in-a-lifetime experience, but I just got back my first roll of film and the prints look terrible. I think they're overexposed. There must be something wrong with my [expletive deleted] camera."

What kind of camera is it, I asked. "Oh, one of those new automatic-everything ones. I got it just for the trip so I wouldn't have to worry about anything technical."

No matter whether the camera was at fault or my friend simply hadn't learned to operate it correctly, he should have known better. There's a cardinal rule in travel photography: Never, *never* take a new camera on vacation unless you've run at least one roll of film through it beforehand and seen the results. Despite the temptations of today's shiny new equipment, it is better to lug along the tried-and-true than to tempt fate with an untested modern marvel. The same goes for flash units, interchangeable lenses, the works.

The urge to buy new equipment isn't the only problem facing photographers whenever it's time to go on vacation. How many lenses to cart along? What kinds of film to take? Will I need a tripod? Will airport X rays ruin my undeveloped film? Here are some words of advice for anyone wanting to take photographs on a trip, whether it's to China or Coney Island.

- Cameras and lenses: Take only equipment that you're familiar with and that you've used recently. In this way you will know

how to operate them correctly and will be sure everything is in working order. If you use single-lens-reflexes and have a "back-up" camera body that takes the same lenses as your mainstay, you should take both. That way if one goes on the blink, you'll still be able to shoot. This is called redundancy, which is not a bad word in travel photography. But take only as much equipment as you can comfortably carry. Otherwise you'll end up cursing those heavy zoom lenses and motor drives and kicking your tripod. In fact, if you never use a tripod when photographing close to home, you probably won't use one when you journey farther afield.

• Film: Here, too, resist the urge to try something new. If you are accustomed to slide film of a certain speed, take it. If you usually like to see your pictures as prints, take color-negative print film. The two types are exposed differently—transparency film likes slight underexposure; print film likes overexposure—and now is not the time to change gears.

Whatever choice of film you make, buy the film here. Film is generally more expensive abroad, and it is sure to be if you try to buy some, say, at the base of the Eiffel tower. Also, buy more than you think you will need—a good 50 percent more is a safe margin. You'll be less likely that way to hoard your exposures, and you won't feel guilty about "bracketing" (making more than one exposure of a single scene) to guarantee a pleasing result.

Try to buy film in what the pros call "bricks": twenty-package units wrapped in plastic, all with the same color and speed characteristics. Test one roll of the bunch before leaving and you'll know if you need to adjust your film-speed dial and/or filtration. And to save luggage space, buy the longest rolls available (for 35-millimeter film, usually 36 exposures) and take only the plastic containers, discarding the cardboard packaging beforehand.

• X rays and security abroad: If you plan to fly, you and your luggage will be passing through X-ray scanners. X rays affect films in a negative way, in extreme doses creating "fog" or blurry patches. In the United States and some countries in Europe it is possible to have your film inspected by hand—ask politely and hand it to the security agent in a clear plastic

bag—but there are places in the world where your request will be refused. Don't worry and don't get into a shoving match. Today, there is little chance of visible X-ray damage in your pictures unless your film passes through a number of machines en route (X-ray damage is cumulative) *and* you use very high speed film—ISO 400 and up. X rays damage faster films more quickly.

Will putting your film in your luggage avoid the whole problem? No. Checked baggage is often X-rayed as well, and you won't know when you claim it whether or not it has been scanned.

- Reentry: If your camera outfit is fairly new, you may have to prove to U.S. Customs on your return that you haven't bought it abroad. Pack a copy of the sales receipt or register the camera and lenses at Customs at the airport before your departure.

- The compleat travel kit: Besides cameras, lenses, film, filters, a flash unit, and possibly a tripod, any well-traveled photographer's bag should contain the following: lens cleaning tissues or a photographic chamois made for the same purpose, a small brush for wiping away dust, an air bulb or a small can of compressed air for blowing away the dust, extra batteries for the camera and flash unit, a small screwdriver (or Swiss army knife with same) for emergency repairs, a bag of nuts or raisins for emergency hunger pangs, a card with your name, address, and phone number in case your case is misplaced, and, if you have brought a tripod, a cable release.

 Optional equipment for the truly serious traveler includes back-up camera bodies, a hand-holdable exposure meter in case the camera's built-in meter malfunctions, a fold-up poncho for inclement conditions, and a penlight flashlight for reading dials and lens settings in dim light.

Okay, now we've got the nuts-and-bolts part down pat, but what about the pictures? Vacation photography, I've found, can serve either of two purposes. It can reinforce all the pictorial clichés we've ever seen, or it can give us a license to try out new techniques and new equipment. We have to get past the first to explore the second.

I should admit straightaway that I am a patsy for postcard shots. Despite my deep-rooted scorn for pictorial cliché—best epitomized, perhaps, by the shopworn image of a huge red sun setting on the ocean—I can't help myself when in the presence of a conventionally beautiful landscape. My shutter finger flexes involuntarily. For example, on a recent trip to southwest Florida I found myself snapping away at distant cormorants, ibises, and other magical birds. I even attempted to photograph an alligator who was basking in the sun a good 200 feet away, but because I had wanted to travel light, I came equipped with only a 35-to-135-millimeter zoom lens. This outfit, plus a point-and-shoot camera with a 38-millimeter lens, was not exactly ideal for pursuing either flying or crawling wildlife.

I would have felt pretty foolish snapping away with my meager equipment except that my friends, photographers all, were compelled to do the same. We must have seemed an odd bunch to the

Getting beyond the postcard image isn't always easy when you travel. Perseverance in sticking with a subject helps—at least it helped me when shooting these shore birds in Florida.

real bird photographers on the island who were toting around giant 400- and 600-millimeter telephotos mounted on heavy tripods.

I quickly recognized that close-up portraits of roseate spoonbills—exactly the kind you see on postcards—were beyond my capabilities. My equipment forced me to invent another approach. Instead of trying to isolate the birds in the frame, I started to consider them as elements of a constantly moving and always fascinating pattern. To pursue this notion I returned to the beach at sunset, but instead of paying attention to the sun, I focused on its reflection in the water. The red wash it created served as a perfect foil for the movement of dozens of sandpipers and other birds hugging the shore. Instead of staying with the cliché, I was headed off in a direction I hadn't expected. Not knowing in advance what the pictures would look like was part of the fun.

Since I was using a recent-model, auto-exposure SLR, I wasn't sure what its sophisticated metering system would make of the scene. I wanted a hefty red background, with the birds arrayed in silhouette, so I bracketed a stop in either direction. The need to bracket taught me how to use the camera's exposure-compensation switch.

Now I was on a roll, but that postcard image of the setting sun was still gleaming in my eye. How could I make an image that didn't resemble thousands of others? Then I remembered that on a previous trip I had lugged along my 8-by-10-inch view camera and used it for making panoramas. I simply leveled the camera on my tripod and swung it after each shot to create a multiframe, contiguous image.

I knew I didn't need a view camera to make a similar panorama, but I could have used a tripod. Unfortunately, the sun was setting and the tripod was back at the hotel. I decided to take a stab at making adjacent exposures by hand. I lined up the horizon in the middle of the frame as a simple reference point and took the first shot looking down the beach to my left. Then I swung the camera until the left side of the frame matched where the right side had been in the first shot. I stopped after three such exposures, but I could have kept going all the way around. How many exposures it takes depends on the focal length of the lens in use.

*You can break out of the mold by breaking out of the frame,
as I did in making this panorama taken at sunset in Key West.*

Metering the scene was a bit of a trick. To get a correct exposure
at sunrise or sunset you need to take a reading of an area of the sky
that's less bright than the sun. A good way to do this is
to swing the camera until the sun is just outside one side of the
viewfinder. Once your camera has "read" the sky, you have to
keep the reading locked in while you recompose. With all but
manual-exposure cameras this calls for an auto-exposure lock.
Some cameras provide a special button that serves this purpose;
others simply hold the exposure reading for as long as you hold
your finger on the shutter button. But if you're making a series of
adjacent images to form a panorama, you have to settle on the
exposure first and then keep it the same for every shot. Otherwise
you'll find that each print has a different density. For obvious
reasons I find it much easier to switch to manual mode when I'm
working this way.

Naturally, print film is recommended for snapshot panoramas
unless you have enough projectors at home to project several slides
at once.

ON THE STREET

Taking pictures of strangers is something beginning photographers find enormously difficult. It's partly a psychological problem: they fear that their camera will be viewed as an unwanted intrusion on someone else's privacy. But it's also an equipment problem: most beginners try to take candid pictures with exactly the wrong lenses. With the right stuff, much of the psychological worries will disappear.

I have a rule of thumb: The longer the focal length of a lens, the worse its performance at street level. There is a built-in conflict between a small aperture, needed to get all of the scene in focus, and a high shutter speed, needed to avoid blur due to camera shake and subject motion. No matter what your film speed, you can't

Street photographs like this call for nerves of steel, lightning-quick reflexes, and a wide-angle lens prefocused to take advantage of as much depth-of-field as the lens can muster.

always have both at the same time. What's the solution, other than compromise?

What most serious "street shooters" do is opt for a wide-angle lens, usually a 35-millimeter or 28-millimeter. Short-focal-length lenses have several advantages: they generally focus closer and faster than a longer lens, they give a relatively greater depth-of-field at a specified distance, and they don't require shutter speeds much above $\frac{1}{125}$ second. Perhaps most important of all, they allow photographers to work close to their subjects.

Many beginners assume that the best way to get "candid" shots of strangers is to stand across the street from them and fire away with a long-length zoom. On the contrary, almost all of the street pictures I admire were taken up close, sometimes literally within inches of the pedestrians they depict. Paradoxically, a photographer who works in the thick of things is usually less noticeable to passersby than one who takes the standoffish approach. Try both and you'll see the difference.

About the only use a long lens has in terms of street shooting is if the photographer plans to rise above the madding crowd. Perch on a balcony or shinny up a light pole, and you'll be in position to take telephoto pictures that exaggerate the already heavy sidewalk traffic. But a few pictures of this sort go a long way, so keep a wide-angle handy.

Almost all serious street shooters use Leica rangefinder models because they are quick and reliable, and because they accept a variety of lenses. They are also expensive, which is why an alternative might be a simple rangefinder camera with manual focus. Why manual focus? Because the subject of street photography seldom sits in the center of the frame, which is the only place automatic systems are able to focus. With manual focusing you can also preset the focus, freeing whatever is left of your concentration for other tasks.

SHOOTING FROM MOVING VEHICLES

Didn't someone once say, "The telephone always rings twice"? Mine seems to, anyway. One day it was a friend asking if I could

tell him about photographing from a helicopter. The next day it was another friend who wanted to know how to take pictures while on a motorboat. Now I don't understand the first thing about helicopters and only a bit more about boats, but I know there are at least two items that both photographers in helicopters and photographers in motorboats have to worry about: one is falling out, and the other is getting sharp pictures despite the movement that accompanies these modes of transportation.

Almost all photo textbooks treat the subject of motion as if it fell neatly into two halves: camera motion and subject motion. Most warn that below certain shutter speeds—$\frac{1}{125}$ second is the common denominator—"camera shake" can occur. This can be due either to the photographer, whose hands may be less than steady, or to the internal mechanisms of the camera itself. The typical text then goes on to discuss how action can be photographed in two ways: freezing it with a fast shutter speed or giving the effect of movement by **panning** with a slow shutter speed.

Photographing from a moving platform—such as the train I was on when I took this shot—calls for a shutter speed high enough to eliminate any camera shake. Stopping subject motion is another task, one I chose to ignore here.

At the bottom of the page you'll find a chart that lists the minimum speeds needed to get a sharp picture of a moving subject. A water skier should be snapped at $\frac{1}{500}$ second, a swimmer at $\frac{1}{125}$. Of course it all depends on the magnification of the subject on the film and on the direction of its travel relative to the camera. No recommendation for photographing helicopters is supplied; the closest equivalent might be a fast train, which is frozen at $\frac{1}{1000}$ second.

My friends aboard the chopper and the Boston whaler were confronting a third kind of motion, which comes not from the camera or the subject but from the platform from which they are shooting. Nor are they unique; anyone who has tried photographing out the window of a car, bus, train, or plane has faced the same situation. Not only are these conveyances moving at sometimes rapid rates of speed, but they are also vibrating, bucking, and tossing.

It is safe to say that most photographs are taken on earth; that is, one usually has one's feet planted firmly on terra firma when the shutter release is pressed. Although I've been told that the earth moves around a great deal relative to other celestial bodies, from our point of view it is as stable and solid as a fallout shelter. Any blurriness that happens in pictures taken from ground level can only be blamed on the subject or the photographer. Not so when one photographs from a moving vehicle or pleasure craft. The

Minimum Shutter Speeds	
To Prevent Subject Motion	
Pedestrians, swimmers, tennis players	$\frac{1}{125}$
Water skiers, bicycle messengers, pole vaulters	$\frac{1}{500}$
Automobiles, trains, skiers, galloping horses	$\frac{1}{1000}$
Race cars, airplanes on runway, track sprinters	$\frac{1}{2000}$ *and up*

Note: Action stopping depends not only on the speed of the subject but also on its distance from the camera (the closer it is, the higher the shutter speed needed) and on its direction of travel (movement across the film plane requires a higher speed than movement toward the camera).

subject can be as still as Mount Rushmore and yet appear blurred in a photograph because of vehicle motion. The conveyance's speed is translated to the still subject. Thus the fast shutter speed needed to freeze a passing train should also be used when you're photographing from the train itself. That is, if you want the scenery to be perfectly sharp.

In practice, of course, nothing is as strict as the rulebooks say. I have photographed from train windows in Europe at $1/125$ and even $1/60$ second, and my subject has not suffered. But then I was taking pictures of the Alps, which were off in the distance. Closer objects, such as crossing signs and cornfields, virtually disappeared. Just as moving subjects will appear blurrier the closer they are to the camera (all other things being equal), so will stationary subjects when the camera is moving.

Moreover, as Einstein pointed out, speed is relative. If I photograph my companion on the train while she is seated across from me, we are standing still relative to each other. The same goes for my motorboating friend when he aims for pictures of his pals in the same boat. In these situations the shutter speed can be the same as what you would use on dry land—with one amendment.

The amendment is that the shutter speed should be fast enough to overcome the shaky effects of motor-induced and motion-induced vibrations. Cars and buses shake because of bumpy roads, trains roll and sway, motorboats and helicopters jiggle even at rest because of their engines, so for the sake of sharpness the shutter speed needs to be fast enough to overcome vehicle, camera, and subject motion at the same time.

As is probably clear by now, the triangular relationship of sharpness, motion, and shutter speeds can be fairly complex. It pays to experiment a bit to discover for oneself the limits and advantages of a particular shutter speed in a particular situation. The only hard-and-fast advice is that for stopping motion the faster the shutter speed the better.

A REVIEW OF CHAPTER ELEVEN

1. When shooting portraits, direct flash is less pleasant than bounced or reflected light. A main light from an umbrella or soft box, together with a rim light behind the subject, produces a classic result.

2. When shooting at weddings, try to avoid the standard pictures that pros take and concentrate on a more candid view of events. Use equipment you already know: a 35-millimeter camera, a zoom lens, and a flash.

3. Babies are small, so when you photograph them a macro lens comes in handy. Get down to baby level when you use it, and get in close.

4. To copy works of art, use a 35-millimeter SLR with a macro lens, a copy stand or tripod, and two lights, placed equidistant from the work. Tungsten light is better than flash for copy work; use tungsten-balanced color film.

5. When photographing landscapes, pay attention to the quality of light. Most places look better earlier or later in the day than they do at noon. To eliminate excess blue in a scene, use an ultraviolet filter; to boost the intensity of colors, use a polarizing filter.

6. On vacation, try to find a new way of looking at things so you don't just duplicate the postcards. *Don't* take along a brand-new camera, and take plenty of familiar film with you.

7. Street photography requires a wide-angle lens with plenty of depth-of-field and a fairly fast film to freeze the action.

8. When shooting from a moving vehicle, use a shutter speed high enough to eliminate camera shake. With fast-moving subjects, a high shutter speed is more important than stopping down for depth-of-field.

TWELVE

Shooting Advice for All Seasons

Like the proverbial mail carrier, photographers should be prepared to brave all four seasons of the year. Unlike the mailman, however, we have environmentally sensitive cameras to keep dry, clean, and in working order. Starting with the beginning of the year, here is how you and your equipment can survive nature's worst.

WINTER

There are three problems with photographing in the real winters I know: snow, cold, and condensation. Let's tackle each in turn.

Snow

Picture a smooth, pure white landscape—trees laden with powdery snow, cross-country ski trails, and a lone woodpecker knocking against the trunk of a birch tree. For many, the urge to photograph at a time like this is too powerful to resist.

There's no need to resist the urge, of course, but having taken my share of snow-covered pictures I've learned that making them

work is not the same as falling off a log. Since exposure meters, built in or otherwise, go by the rule that the world is a dull shade of gray, they invariably underexpose pure white snow. With color and black-and-white negative film the result is a dreary, grainy print. With color transparency film you get a slide that's overly dense; the snow is neither white nor gray but usually has a blue tint to it. The blue appears because snow and the winter sky combine to reflect great amounts of blue light. The "blue snow" effect is especially noticeable in shadows or on cloudy days when the sun's yellow rays are not around to compensate.

One solution to the exposure problem is to take a meter reading that excludes the snow. Pros sometimes "read" the palms of their hands and then open the aperture a stop. (Remember, the average Caucasian palm is a stop lighter than the average gray.) Even handier, if the camera is automatic and has an exposure-compensation dial, is setting the dial to give plus-two f-stops, the approximate correction needed for a sunny, snow-covered land-scape. Lacking such an adjustment one could change the camera's ISO setting manually to read a quarter of the given speed of the film—from 100 to 25, say, which is a two-stop change. Or, if the camera has a backlight button, pressing it will give much the same result.

Exposing correctly for the snow will cure some of the "winter blues" but not necessarily all of them. For that you need to rely on a slightly yellow filter. A yellow filter designed for black-and-white use will give too much yellow; better to try a CC10Y Kodak color-compensating filter in acetate form. A UV or Skylight filter will help somewhat, too. With both filtration and exposure, some trial-and-error testing is recommended.

Cold

If the weather is cold enough, it can stop your camera dead in its tracks. This is especially true if the camera relies on batteries for its functions, as most now do, so keep it close to your chest, under whatever miracle-fiber garment is keeping you warm. Pull it out from your jacket or parka to take the shot, then put it back.

To further ensure that the camera's batteries keep functioning,

some camera makers offer remote battery cords, which let you keep the camera at the ready while keeping the batteries warm in a pack close to your skin. Winterized pros love them for their motor drives, but even if the batteries stay warm, the camera can still freeze up because of the temperature limits of its lubricants and seals.

In extremely cold weather the metal on the camera's top plate can actually freeze onto warm fingers or foreheads. To avoid this, wear thin glove liners and sunglasses, or else put tape temporarily over the bare metal.

Finally, a cautionary note to those who like to snow-ski and photograph: remember that snow is merely crystallized water, and if your camera goes tumbling lens-first into a snowbank, the effect will be much the same as if you wore it while taking a shower. Protect it from the elements as much as possible, perhaps putting it in a resealable plastic bag until it is time to shoot. Or eliminate risk altogether and buy an all-weather point-and-shoot 35-millimeter camera. These are made by Fuji, Nikon, Olympus and others.

Condensation

Like the leaky old storm windows on my house, cameras can become coated with a layer of water because of the difference in temperature between them and the adjacent air. Especially troublesome are the front element of the lens and the rear viewfinder. The reason is easy to grasp. In the case of my windows, the water appears on the inside of the panes. That's because cold air holds less moisture than warm air, the cold night air makes the glass cooler than the inside of the house, and so moisture suspended in the inside air condenses on the surface of the cool glass. A similar thing happens when you take your camera out for a fall hike or for a long ride in the car trunk. It cools off, and then when you bring it inside a warm house, water condenses on the surface and you end up with a wet camera with a foggy lens.

To prevent such occurrences, try keeping the camera warm at all times. Outside, keep it tucked under your coat where the heat of your body will supply some warmth. This will be difficult if

you've acquired the bad habit of carrying the camera on your shoulder, so do what the pros do and sling your camera strap around your neck. Then it's an easy process to unzip your coat, put the camera to your eye, shoot, and tuck the camera away again.

If you're taking the camera in the car, keep it in the passenger compartment, not the trunk. It will stay as warm as you do, and it will be much more pleasant to hold and use as a result. Of course I wouldn't park the car and go off with the camera sitting there in plain sight, and I wouldn't put it on the dashboard or rear shelf to warm up in the sun's rays. Too hot a camera is as bad as one that's too cold.

In really cold weather, though, it is almost impossible to keep cameras and lenses from getting at least a chill. When they come in from the cold, some condensation is inevitable. The classic solution to the problem is the plastic bag. Before coming into your abode, put the camera into the bag and seal it with a twist tie. The condensation then appears on the surface of the bag and not on the camera itself.

I've followed this procedure a few times in the dead of winter, and it works like a charm. Food-storage-size bags are my personal favorites, but by and large I don't walk around with plastic bags in my pocket. If the camera gets cold and I'm bagless, I wrap the camera inside my coat when I come inside. The coat acts like insulation, buffering the temperature differential and letting the camera warm up slowly. The great advantage of this technique is that it doesn't contribute to plastic-bag pollution.

Condensation can also plague photographers out of doors. I once stepped out on the porch with my SLR to record a frosty morning and found myself staring at an opaque viewfinder. In bringing the camera to my eye, I had inadvertently breathed on it, fogging over the viewfinder glass. Since my breath was warmer than the camera surface, its water vapor condensed there.

If you are in the otherwise admirable habit of checking the front of your lens to make sure no dust or other motes are clinging to its surface, you have probably fogged your lens in much the same way. This can make for some pretty spectacular special effects, with landscapes and portraits acquiring a spectral, soft-focus glow, but if what you want is a conventional view, you'll have

to wait a minute for the fog to dissipate. Resist the temptation to wipe it away with the sleeve of your sweater—you'll only end up with a watery mess.

If your camera or lens does get wet from condensation, your only recourse is to dry it off promptly. Use a high-quality chamois or a clean cotton cloth for the metal, leather, and plastic parts, and lens-cleaning tissue or a photo chamois for the glass. Try especially hard to get any moisture out of the cracks and joints where it might seep into the inner mechanisms. And, as always, keep your mitts off the fragile instant-return mirror and shutter of your SLR.

SPRING

The spring is a time of rejuvenation, not to mention spring cleaning. This goes for your camera gear as well since it most likely has been sitting idle for much of the winter.

Camera Check-up

A camera that has not been used for several months needs to be given a once-over for several reasons: its batteries may have worn out in storage (or worse, leaked inside the camera); its moving parts, including the shutter and lens diaphragm, may have become sticky or sluggish; and it may have acquired a coating of dust and grime that threatens to creep inside.

If things are really bad, it could be time for a true spring cleaning—better known as a CLA (clean, lubricate, and adjust)—at your friendly camera-repair shop. As jovial as he may be, however, your repairman is going to charge you a quarter of the cost of the camera or more to do the job. Far better, then, to find out for yourself if you have any specific problems and to remedy them at home if you can.

Batteries are easily checked if the camera has a battery-condition indicator built in. If you have an external battery tester that measures actual output, so much the better. In any case, don't be shy about replacements. Alkaline cells can be tossed without too

great a dent in the wallet. Don't automatically throw out your lithium batteries, however. They're expensive, and ordinarily they last for several years.

If the battery checks out fine but the camera is getting insufficient power, try cleaning the metal contacts in the camera. Rub them and the battery's contacts as well with a pencil eraser, and avoid touching them with your fingers.

Shutters, lens diaphragms, and other mechanical assemblies found inside even the most electronic of cameras normally have their skids greased with lubricants. These special oils can evaporate over time or set with disuse, causing the moving parts to perform sluggishly. This usually leads to overexposed pictures. To check the shutter and diaphragm, fire the camera several times, without film inside, running through the range of shutter speeds and aperture settings. Listen to the speed of the shutter and look into the front of the lens to check that all is working properly.

This brief warm-up also serves as spring training for your shutter finger and focusing hand. If the lens feels stiff to turn, focus back and forth a few times. If it remains too stiff to move comfortably, it may be time to visit the repairman. Metal rubbing against metal is not a pleasant sound.

You can easily eliminate much of the dust and grime coating a camera that has been stored over the winter. For my view camera, with its cavernous bellows, I get out the vacuum cleaner and suck the dust from the inside with the venetian-blind attachment. That's too much power for a 35-millimeter camera, though. Try using a battery-operated vacuum cleaner or simply blow the dust off with a can of compressed air.

Do not—repeat, do not—direct compressed air inside the camera. The burst is powerful enough to dent the shutter curtains, and it contains a propellant that can permanently foul the instant-return mirror. For these delicate areas try wiping out any dust with a small, soft watercolor brush.

Finally, it's time to clean the surfaces of lenses, viewfinders, and auto-focus windows. For true grime I use Q-Tips dipped in isopropyl alcohol and squeezed out, followed by a careful wiping with a special camera-lens chamois. Prepared lens cleaning fluid and lens tissues can do a similar job; just don't drench the glass.

Spring camera cleaning includes getting the dust off your lens. A can of compressed air (Dust Off is the brand used here) will do the job, as shown, but keep the can upright to avoid getting oily propellant on the lens.

Inclement Weather

Photographing in the rain may not be everyone's cup of tea, but in the spring it's hard to find a day when it's not raining. In fact, rainy day photography can be lots of fun. There's only one hitch: keeping the camera dry.

I'll never forget the first time I assayed taking pictures in a downpour. To prepare myself I read a photo manual that advised covering the camera with a plastic bag, then cutting out a hole for the lens, so I draped a food-storage bag over my trusty Leica M-2 and trimmed a circle the size of the lens barrel out of one side. Just to make sure the hole stayed in position in front of the lens, I wedged the lens hood on over some of the surrounding plastic.

I wasn't three blocks from home when I had to leap over a puddle to avoid getting soaked by an oncoming car. As I jumped, I had the sinking feeling some part of my rig was remaining behind. Sure enough, the lens hood had slid off the plastic bag, off the lens barrel, and into the puddle. As I turned around to retrieve it, the tires of the car neatly crushed it as flat as a tortilla. The cost of

Leica lens hoods being what they are, I waited several years before trying any more wet weather photography.

At that time the only camera that could survive the elements without any kind of special covering was the Nikonos, a high-priced underwater camera made by Nikon, but ever since the success of the original Minolta Weathermatic 110 camera, "all-weather" cameras for Everyman have become commonplace. Basically, cameras such as the Minolta Weathermatic, Nikon Action Touch, Olympus Infinity Twin, and Canon Aqua Snappy use rubberized seals and a clear cover over the lens to keep water, sand, and other nastiness out of their delicate (and rust-prone) insides.

These cameras and others like them are at home in downpours, at poolsides, or at the beach, but don't dive into the briny with one. A weatherproof camera, unlike an underwater camera, is not designed to withstand the pressures that come with even swimming pool depths. You can wade into the surf with it in hand; just be sure to wipe or rinse it off afterward to rid the body of salt encrustation. Rinse it off as well when coming in from shooting in the rain, which may be more acidic than you'd expect or want.

SUMMER

The statistics compiled by the photographic industry show that summertime is the peak time for picture taking in the United States, rivaled only by the Christmas holidays. This is partly because we often go on vacation in the summer, and vacation and photographs are firmly linked in our minds. But even when we stay close to home there are occasions for recording our lives: family get-togethers, picnics, trips to amusement parks, beach and mountain jaunts, and usually a wedding or two.

As someone who once had a camera's bare metal freeze to his skin in February, I can personally testify that it's infinitely more pleasant to take pictures in warm weather, but that doesn't mean we are any more free of the need to pay attention to what we're doing.

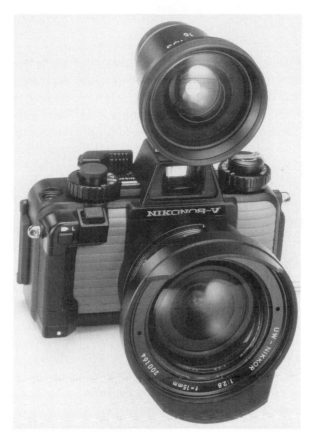

The exotic province of scuba divers, submersible 35-millimeter cameras like the Nikonos-V have been joined by all-weather amateur cameras for snorkelers. Waterproof cameras are immune to the perils of rain, snow, and beach sand, but are usually less sophisticated than fair-weather models.

At the Beach

For those on the coasts, the dog days of summer are best relieved by beating a path to the beach. There, ocean breezes cool the spirit and warm sands soothe the body. Since many such jaunts to the beach are with friends or family, there's a natural inclination to bring a camera along. What better time to record the family, after all, than when everyone is luxuriating in feelings of relaxation and relief?

Photographers shouldn't relax too much, however. Without some measure of vigilance, the camera that is meant to capture the

fun will turn into a nonfunctioning, landlocked barnacle. Four of the top camera enemies are the elements found in profusion at the shore: sand, sun, sea, and salt air.

It doesn't take a genius to recognize what sand can do to a camera's innards. Even the most electronic of cameras today rely on gears, springs, and other close-tolerance mechanisms, all of which are especially prone to dirt and grit. The question, then, is how to keep the sand outside the camera where it belongs.

The standard ever-ready case, once found on nearly every 35-millimeter camera, is so porous it offers no help at all. Perhaps that's why such cases are now mostly collectors' items. A camera bag with a floppy flap at the top offers a bit more protection, but a bag with a zipper to seal itself is best. The trouble is that it only keeps sand away from the camera as long as you don't open it. It's when the camera is being used and the moments in between that are the most threatening to its health. Set it down on a beach towel for a minute, and it will have sand on it. Grab it when you're fresh out of the surf, and it will have sand on it. The only way to keep it sand-free is to keep your hands and forehead clean and dry, hold onto it the entire time you're taking pictures, and return it to its shelter whenever you want to do something else.

Some photographers like to keep the camera sealed inside a plastic bag whenever it's not being used. This has the advantage of saving it from such untoward incidents as when little Donnie accidentally kicks over the camera bag and spills its contents halfway to the lifeguard stand.

Keeping the camera tucked away when it's not being used also protects it from sun damage. Since a lens focuses light, it acts like a magnifying glass when it is left pointing up in the direction of the sky. Just as the sun and a magnifying glass will burn a hole through paper, the sun and your lens will burn a hole through the camera's shutter curtain. The results will be some light-streaked, unexpectedly creative pictures.

Salt water is a problem if you are photographing the kids splashing in the surf or if a freak wave floods your beach blanket. By all means try to keep the camera dry. If it gets splashed, immediately dry it off to prevent any water from getting inside. When salt water does get inside a camera, it's a major problem

because of the water's highly corrosive qualities. Visit a repairman as soon as possible. If the camera has been completely immersed, some recommend reimmersing it in a bucket of fresh water and taking the bucket to the repair shop. The theory is that serious corrosion won't start until the metal hits the air.

You can avoid the perils of sand, sun, and sea with a little care and a few precautions but, as the song from "Hair" goes, the air is everywhere. The salty, sticky atmosphere of the seashore deposits a film on lenses, viewfinders, and bodywork. This coating won't destroy any mechanisms, but it will result in smudgy pictures. It's best to clean the camera as soon as the trip to the beach is over, using a soft, all-cotton cloth to wipe the body and lens-cleaning fluid and tissues on the glass. Isopropyl alcohol can be substituted for prepared lens-cleaning fluid; its fast-drying quality also makes it useful for cleaning bodywork on new-generation camera bodies made of polycarbonate compositions.

Coping with Brightness

Keeping cameras out of harm's way isn't the only problem photographers face at the beach. There's the small matter of taking pictures. The problem usually isn't subject matter. For most visitors to the shore, subject matter presents itself in abundance. There are kids building sandcastles, dogs catching Frisbies, bronzed bodies in alluring states of repose, gorgeous sunsets, you name it. If you can't find something to photograph at the beach, you might want to consider donating your camera to a worthy cause.

The picture-taking problem, such as it is, is one of exposure. Since we tend to go to the shore on bright, sunny days, light levels are usually very high. Moreover, the sunlight is reflected by the water and sand, which increases its intensity. The result is sometimes more brightness than certain combinations of cameras and film can handle.

A typical point-and-shoot camera may have a top shutter speed of $\frac{1}{500}$ second and a minimum aperture of f/16. This means, of course, that the smallest amount of light it is capable of transmitting to the film occurs at a setting of f/16 at $\frac{1}{500}$ second. Using a

high-speed film with an ISO rating of 400 or higher in bright light will give you a good chance of seeing a little red light go on in the camera's viewfinder. It's warning you that the light is beyond the camera's capabilities.

If you are shooting color-negative or black-and-white film, there's no need to panic. As a class these films are tolerant of moderate overexposure. The situation is more dire with slide film, which loses density and color saturation when exposed even half a stop too much. If slides are your game or if you want more exposure-control capability overall, an SLR might serve you better. Their top shutter speeds are typically $\frac{1}{1000}$ to $\frac{1}{4000}$ second.

But—and it's a big but—there's another factor at work that throws off all normal exposure considerations: the matter of subject brightness. As you may recall from Chapter Two, most cameras are dumb beasts that see the world as a vast arena of middle gray. When their exposure meters tell them what settings to use or tell you what settings to set, the calculations are based on seeing "average" gray. But at the seashore, precious little average gray exists.

Indeed, a typical sunlit shore scene is much brighter than your average gray scene by as much as two stops. To render it as bright as it appears to the naked eye, you need to tell the camera to give more exposure than it wants to. Otherwise you'll be underexposing, which is something slides can tolerate but negative films can't.

You can override your camera's desires in several ways. If it's a camera with manual-exposure capability, you can adjust either the shutter speed or the lens aperture—the choice is yours. Lacking such controls, you can search for a "backlight compensation" button (sometimes labeled BLC), which was designed for precisely this kind of situation. Failing that, you can cheat by adjusting the ISO film-speed dial, as discussed earlier in this chapter. If your camera automatically sets film speeds and lacks any of the controls I've mentioned, you're plumb out of luck.

Increasing exposure at the beach is especially important when taking a picture of someone against an expanse of sand, sea, and sky. Without an adjustment the human face will be rendered much too dark because the camera sees the bright background as the dominant part of the scene. With an adjustment the face will

When taking pictures of people at or near the shore, fill-in flash is often necessary to give enough exposure to their faces. Left on its own, the camera would have exposed this scene based on the dominant brightness of the background.

appear normal although the background will be overly bright and washed out.

To get both the background and the face adequately exposed in one and the same photograph requires a bit of flash fill. Here point-and-shoot cameras enjoy something of an advantage since they can synchronize with electronic flash at all shutter speeds. Many of the latest, most "intelligent" cameras know automatically when to fire their built-in flashes and how much exposure to give for a good-looking picture. Of course they're guessing, but then again so are most photographers who figure it out for themselves.

Fill-flash calculations aren't that difficult in fully manual mode, though. The trick is to focus on the subject first and use that distance as a guide. If the distance is 10 feet and the flash says to use f/11 at 10 feet, then set the lens aperture between f/11 and f/16. Use whatever shutter speed the camera's meter suggests (biased, in this case, toward overexposure). Unfortunately, if the shutter speed is faster than the camera's maximum flash sync

speed, as can happen with SLRs, all bets are off. The only solution is to change to a different camera, flash unit, and/or film.

Heat

For photographers, the trouble with high temperatures isn't a matter of possible sunstroke or heat exhaustion—although we have to be alert to their symptoms as much as anyone else. The real dire problems have to do with the temperature of our equipment and our film.

It has been said countless times that one should never keep a loaded camera in the glove compartment or on the dashboard of a car. New Yorkers may think this advice has to do with the likelihood of having their windows smashed by Midnight Auto Supply, but its real meaning has to do with the consequences of heat. A dashboard behaves in summer like a stove, and a glove compartment like an oven. The microscopic layers spread across film emulsions are not only light-sensitive, they're also heat-sensitive. Give them a good frying, and they'll give you all sorts of unpleasant colors.

Baking a camera does as much damage as baking your film, especially when the camera is an all-electronic marvel that relies on heat-sensitive circuit boards, memory chips, and other components. If you're lucky, all you'll lose is the use of the built-in exposure meter. At worst, the entire camera will crash. But you have to be really careless to damage a camera this badly.

Fashionably black "professional" cameras will absorb much more light than the lowly chrome-topped models of yore. As we all know from exposure lesson number one, black absorbs light while white reflects it, so you have to be careful with all-black cameras all the time. Put one down uncovered on the beach in the morning, and by afternoon it will be ready for use as a charcoal starter.

The black plastic containers and lids Kodak wraps around some of its films are ideally suited for overheating what is inside them—they're like Dutch ovens for film. I wish the company would go back to the metal cans it used in the '60s, which reflected most of the light that hit them and were also customarily recycled.

There are ways to avoid baking cameras and film, thank

goodness. The neatest is to pack them in an insulated bag or chest. On the beach, this will also keep sand and surf away. Some pros throw in a frozen container of chemical "blue ice" or similar prepackaged material to keep their outfits extra cool. If you do this, make sure the camera and film are stored in plastic bags to keep the condensation from the ice pack out of range.

If you don't have room in your cold chest for photo supplies or don't own a cold chest, do the next best thing: keep the camera covered up with a white or light-colored towel. And if you must leave it in the car, put it on the floor under the seat. I would never leave it there myself, but then again I live in New York.

FALL

Compared to the other three, fall is a fairly placid season for taking photographs. If Indian summer comes along, act as you would in August. If it rains, take the same protective measures recommended for the spring. If it snows, pretend it's winter. But as a rule, you don't have to worry about environmental conditions or exposure as much these days—unless, that is, you live in Circle, Alaska.

Turning Leaves

What's the secret of photographing fall color? Happily, no special techniques are called for. Unlike white snow, which is much brighter than the "average" scene your meter expects to see, fall foliage is pretty much in the middle of the reflectance range. Put simply, you can follow your meter blindly in most situations.

You might want to experiment with exposures, however. Again, when it comes to slides, underexposure is better than overexposure. Many pros set the film-speed dials on their cameras to a number slightly higher than the ISO number of their film, or else they set the automatic exposure-compensation dial to minus one third or one half stop. (I often expose Kodachrome 64 at ISO 80, a third of a stop increase.) The result is slides that are denser and thus more "saturated," meaning that the colors seem more colorful.

Photographing autumn's natural glories isn't hard, but with slides sometimes a bit of purposeful underexposure gives the scene an extra bit of intensity. With color-negative film, stay on the side of overexposure.

With fall leaves, this approach can work wonders by emphasizing the color of a given scene, but it also can be heavy-handed. There are other times when a little overexposure gives a better effect. Slight overexposure of a third of a stop or more decreases slide density, making colors more transparent and ethereal. In the case of fall leaves, this can produce an impressionistic feeling that is airy and light.

There's no doubt in my mind that the world looks better on sunny days than it does when it's rainy or cloudy, but color film sees things differently. Some of the most beautiful pictures I have seen of fall scenes were taken in overcast conditions. Again, saturation is the key: the diffuse quality of light caused by moisture in the air creates a kind of natural glow. Raindrops on fallen leaves reflect hemispheres of color. Subtle shades of red and yellow intermingle with warm browns. Mist envelops tree limbs and picket fences.

Of course there's no need to shun sunlight. During this time of

year the sun is increasingly oblique in the sky, which is ideal in terms of the shadows it casts. Instead of having to rise at 6 A.M. to catch the sun's early rays, we can sally forth at 9 and still find good light. As always, early morning and late afternoon sunlight give the nicest modeling for landscapes. There is also more yellow light during these times than at midday, which "warms" the color in the scene.

My favorite films for fall shooting are the standard Kodachromes 25 and 64. Both are very adept at rendering leafy colors with an uncanny clarity, and Kodachrome 64's knack for rendering reds more red than red is an extra bonus. If you want to see your results within a week and don't live near a specially licensed Kodachrome processor, you might want to try one of the medium-speed Ektachrome or Fujichromes. Save your high-speed films for subjects that move faster than falling leaves.

If I seem to be recommending slide films instead of print films, there's a reason. With slides, what you see is pretty much what you get, within the limits of the film's fidelity. With print films, the color negative may record the scene perfectly accurately, but then the printer (these days, a computerized machine) has to interpret what it sees. Being able to match the colors of a mix of oak, maple, and birch leaves is no easy trick, even for humans. This means that your prints have less of a chance than usual of matching your memories.

There's more to fall photography than taking pictures of leaves, however, and this is why it pays to have a variety of focal lengths to choose from in the form of a zoom lens or a number of different lenses. For the leafy part I tend to favor my macro lens for close-ups and a telephoto lens of between 100 and 200 millimeters for long shots. For scenics and people pictures, I bring along my trusty 35-millimeter wide-angle lens, too.

A REVIEW OF CHAPTER TWELVE

1. In winter, compensate for the brightness of snow by giving the scene more exposure than the meter indicates. Keep your

camera and film warm, and wrap them inside a plastic bag when you come indoors to keep away condensation.

2. In spring, do a bit of spring cleaning on your camera and lenses. Check the batteries, blow or vacuum dust off, and try the shutter at all its various speeds.

3. In summer, protect the camera from too much heat and keep it away from sand and surf. As is true of snow, the beach will fool the meter and cause underexposure; compensate by adding a stop or two of exposure, or use fill-in flash.

4. In autumn, relax and watch the leaves fall. Expose normally unless you want to experiment with varying the density of slide films. Pay attention to the light, which can be beautiful this time of year.

THIRTEEN

What Went Wrong?

Yikes! Just when you thought you had everything under control, kaboom . . . something goes haywire. Maybe your pictures don't come out. Maybe they don't look the way they should. In this chapter we inventory some of the many foul-ups and gremlins that can plague photographers, and we learn some of the usually painless cures.

DREADED PARALLAX

Your prints come back from the lab. You're all excited, as is the rest of the family. You open the envelope. What's this? All the heads are cut off at the temples. Little Donnie and Lucy and Aunt Harriet don't look at all like themselves.

Do you blame the lab that made the prints? Nope. You blame the viewfinder of your camera. Here's why:

A point-and-shoot camera sees things differently than an SLR because its viewfinder sees things differently than its lens. With an SLR what you see is what you get, give or take a few hairs, because the image in the viewfinder comes through the lens that takes the picture. In a point-and-shoot camera, as we've learned, the view-finder has its own, independent optical system, above and off to the side of the lens. As a result the viewfinder image does not precisely match the image "seen" by the lens. This disparity is called

Here's what the evil effects of parallax can look like: a person you thought you were capturing completely has his head cut off by the camera.

parallax. It becomes obvious at close focusing distances for reasons any theoretical physicist can explain.

Camera designers are not oblivious to the phenomenon of parallax. They can't stop it from happening, but they have various strategies for dealing with it. In expensive rangefinder cameras, such as M-series Leicas, the bright lines that mark the picture area actually move around as the lens is focused to different distances. This kind of **automatic parallax compensation** is as much a godsend as are plastic garbage bags, microwave ovens, and anti-lock brakes. Unfortunately, it's also expensive to manufacture.

For most automatic cameras designed for us average Joes, a simpler system is used. Within the rectangular frame lines that appear in the viewfinder is a pair of abbreviated brackets. Called **parallax compensation marks,** these are meant to show us where the edges of the picture will be at close focusing distances.

With other cameras you'll find an additional mark on the lower left of the viewfinder, which indicates that close-in images recorded

The tiny brackets inside the finder lines of a point-and-shoot camera are meant to show you where to frame when focusing in close. Some cameras also include brackets at the top since parallax also has an effect there.

by the lens will shift toward the right as well as narrow at the top. Since these marks are merely reminders and not automatic adjustments, we need to adjust our sights when focusing on subjects within about 10 feet of the camera. Most family snapshots and portraits are taken within this range.

To make use of such parallax marks, simply pretend that the frame inside the viewfinder is smaller than it looks. Visually draw a horizontal line connecting the two top brackets and draw another, vertical line down from the left-hand interior bracket. The smaller rectangle you have just visualized is pretty much what will show up in your print or slide.

What if your camera doesn't have these handy markings? If it's an SLR design, you haven't been paying attention. Parallax problems don't apply to SLRs. If it's a point-and-shoot camera, it means the manufacturer thought you'd be too dumb to notice that your pictures clipped off people's heads, but you can still survive. Just try to remember that every time you're shooting up close, the

actual picture area is farther down and farther to the right than what the viewfinder is showing you.

MONSTROUS RED EYE

One of the enduring occupational hazards facing amateur photographers is the dread malady known as **"red eye."** If you've never heard of it, don't worry; it afflicts pictures, not the person taking them.

Red eye is named for the peculiar pigmentation the pupils of some subjects' eyes acquire when pictures are taken with the light of a flash. Pets and loved ones are the most frequent victims of the syndrome, which has spoiled otherwise joyful family reunions and holidays. The type of flash makes no difference; red eye can be caused by flashbulbs, flash bars, and electronic flash units in equal measure.

Fortunately, science has found a cause for this malady. It happens when the light from the flash enters the eye, bounces off the back of the retina, and reflects back into the camera lens. Since the retina's surface is lined with a network of blood vessels, the result is a bright dot of red glowing from the center of the subject's eyes. (In black-and-white photography, the red spots show up as vacant white holes.) The effect, needless to say, is often unnerving.

Science also provides a cure for red eye, based on the incontrovertible laws of physics. Light, you may remember from high school days, acts like a ray when it comes to reflections, heading toward a reflective surface at one angle and bouncing off at another angle. These two angles, according to my high school physics, are supposed to be equal.

What this means for your picture taking is that if the flash is right next to the camera lens, its light is going to reflect right back into the lens, with red eye the likely result. But if you separate the flash from the camera, the problem disappears—the angle at which the light reflects from the retina is increased to the point that the reflection misses the lens.

If you have an accessory flash unit that mounts atop the

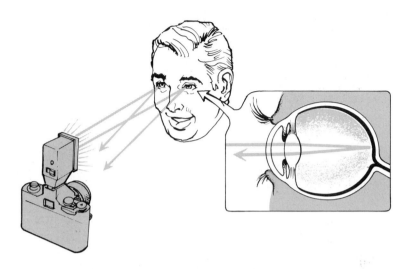

Red eye, perhaps the most common and pernicious gremlin of snapshot photography, happens when light from the flash reflects from your subject's retina back to the lens. Most of the blame for red eye rests with camera designers who position the flash too close to the lens.

camera, the solution is simple: take the flash out of the camera's flash shoe and hold it at arm's length. For this you will likely need an extension cord with a PC connector at each end; most camera makers and many accessory companies manufacture such cords. You can also buy angle brackets designed to hold the camera and flash unit so that the flash is above and to the side of the camera. An auxiliary benefit to separating the flash from the camera in this way is that the lighting effect is more flattering to the human face.

An alternative—especially for those who have complex, "dedicated" connectors between flash and camera—is to bounce the flash off a nearby wall or ceiling. This produces a softer, more flattering light without red eye and without having to detach the flash from the camera's hot shoe; however, the flash unit must have a hinged, tilting head. If the flash is of the automatic variety, be sure that the light sensor on the front points directly toward the subject.

What about the myriad owners of point-and-shoot cameras that include among their many features a built-in, pop-up electronic

flash? There's no possibility of stretching the distance between the flash and the lens without dismantling the camera, and few provide a PC socket that would permit using a supplementary flash unit. It would seem that these cameras were designed to create red eye problems. One can, however, decrease the chances of red eye appearing. One way is to compose the photograph so that the subject is off to the side of the frame, where the reflection from the retina is more likely to be trapped inside the eye than it is in the center. Some photographers suggest having the subject look away from the camera, a related idea, but that cure seems to be worse than the disease.

Red eye can also be minimized, if not eliminated altogether, by increasing the ambient level of light in the room. This should decrease the size of everyone's pupils, giving the light of the flash less of an opening to bounce out of. If red eye still results, at least it will have less of an Orphan Annie cartoon effect, especially in black and white.

Finally, red eye can be dispensed with once and for all by dispensing with flash lighting. Many of today's ultra-fast print and transparency films manage satisfactory results in average room light without flash. There are trade-offs, to be sure, such as decreased resolution, increased grain size, and a better chance for blur, but at least the dreaded red eye will not appear.

MID-ROLL REWIND BLUES

Like the monster in Mary Shelley's novel *Frankenstein,* automation can sometimes run amok. We're left behind, watching helplessly as the motorized innards of our cameras take on wills of their own.

Well, perhaps the analogy is stretching things a bit. Cameras aren't really monsters, and automation has yet to go on a rampage through the countryside. But there are times when we have to pay a price for the conveniences we demand in today's 35-millimeter cameras. A case in point: unintentional automatic rewind.

I admit I've never experienced this gremlin firsthand, but I've

heard testimony from my own kin, who were eager to have me "solve" the problem. Alas, if only life were so simple. All I could offer them was some commiseration and an explanation of sorts.

How does your camera know when it has reached the end of the roll? That depends. As discussed previously, there is a tiny little square on every DX-coded roll of film that is designed to tell DX-sensitive cameras the length of the film. When the square is black, the film is 24 exposures long; when it is silver, you have a 36-exposure load.

In an ideal world all cameras would read this square, remember what it indicates, and use the information to know when to begin rewinding. But in reality most cameras don't have the requisite sensor since the electronics involved would make them even more expensive than they are. Instead, they use the tried-and-true tension system. When the camera's built-in motor suddenly finds that it can't move the film forward any more, it switches gears and starts its rewind cycle. If you find yourself getting 25 or 26 exposures per 24-exposure load, then you know your camera's automatic rewind is keyed by the resistance of the film, not by the DX code.

Since all manner of mishaps can happen to film cartridges, not to mention battery-operated cameras, it doesn't surprise me to hear that a few photographers have had their film shuffle back into its shell at mid-roll as if it were a turtle surprised by an alligator. But I also suspect something else. Because film cartridges look the same whether they hold 24 or 36 exposures, I'd be willing to bet that at least some of these "incidents" can be blamed on humans. If you think you're packing 36-exposure film and it starts rewinding at 26, you've just discovered the film is shorter than you thought. I know because it has happened to me.

But let's consider the possibility that sometimes cameras do foul up and short-sheet the film. If the film is rewound totally into the cartridge, getting the leader out again is a ticklish task. But some cameras leave the tongue end of the film hanging out after rewinding. If yours is one, you can go into a dark closet, reload the same roll, and fire off as many shots as you know you've taken until you get to the unexposed part of the film. Or you can chalk it up to experience and reload with a fresh roll.

BROKEN METER

In this era of automatic-exposure cameras, you would think that exposure problems would have gone the way of the adding machine. Instead, photographers continue to open their envelopes and boxes of processed film with trepidation, fearful that somehow the results will be off the mark.

I once had a workshop student who was so advanced in terms of technique that he could have done much of the teaching himself. The president of his camera club, he was familiar with both 35-millimeter and larger-size cameras and made his own color prints from negatives. While he was struggling to find what the expressive purpose of his photography was, his prints were impeccable.

For the purposes of the workshop, everyone was required to shoot transparency film; in that way students' pictures could be viewed and evaluated the next day. The camera club president's film came back the second day and was, to his shock and mine, overexposed. Not just slightly overexposed, but a good one-and-a-half to two stops too light. The pictures looked as if they had been developed in laundry bleach.

Since he had been shooting color-negative film before the workshop, my quick diagnosis of the problem was that he had become adjusted to overexposure. Slide films, however, have little tolerance for too much exposure. The student readily understood the differences in using the two types of film, and off he went for another day's shooting. The next day we opened his slide boxes together, and we found, once again, overexposed slide after overexposed slide. Obviously exposure "bias" was not the problem. Off we went to compare meters, the next investigative step. Lo and behold, the camera club president's camera meter was barely working, the movement of its needle as gummy as cotton candy. A fresh battery failed to alter its performance.

Most professional photographers know when the recommendations of the camera meter are off; they are used to certain f-stops in certain lighting conditions, and if the meter tells them differently, they suspect it. But here was a man forced to shoot with an

unfamiliar film, with an ISO speed he wasn't used to. What was he or any other suddenly meterless photographer to do?

One fail-safe aid when the meter fails is the reciprocal film-speed rule: in bright sunlight, the correct exposure is f/16 at a shutter speed of one over the ISO of the film in the camera. For example, with Kodachrome 64, a best-guess clear-day exposure would be f/16 at ⅟64 second or the nearest practical speed, which is ⅟60 second.

Knowing this rule of thumb lets you extrapolate other exposures. On a cloudy day, f/8 at ⅟60 is a good bet. In urban shadows try f/5.6 at the same speed. If you prefer a higher shutter speed (which you should if you like your pictures consistently sharp), f/4 at ⅟125 is the same exposure as f/5.6 at ⅟60.

Does all this sound too complicated to remember? Luckily, you don't have to; just remember to look at the instructions packaged

DAYLIGHT EXPOSURE: Cameras with automatic exposure controls—Set film speed at ISO 200 **Cameras with manual adjustments**—Determine exposure setting with an exposure meter set for ISO 200 or use the table below. If camera has DX-encoding, this is automatic.

Bright or Hazy Sun on Light Sand or Snow	1/250	f/16
Bright or Hazy Sun (Distinct Shadows)	1/250	f/11*
Weak Hazy Sun (Soft Shadows)	1/250	f/8
Cloudy Bright (No Shadows)	1/250	f/5.6
Heavy Overcast or Open Shade†	1/250	f/4

*f/5.6 for backlighted close-ups
†Subjects shaded but lighted by sky

Light	Film Speed	Filter
DAYLIGHT	ISO 200	None
3400 K photolamps	ISO 64	No. 80B
3200 K tungsten	ISO 50	No. 80A

For through-the-lens exposure meters, see camera manual

FLASH EXPOSURE: Adjustable cameras—Use electronic flash, blue flashbulbs, or flashcubes. Divide flash guide number, from flash manual or flashbulb carton, by the flash-to-subject distance to determine the correct lens opening. **Automatic electronic flash units** or **cameras that determine flash exposure automatically**—Stay within flash range recommended in equipment manual.

Unsure that your meter is working properly? Check it against the exposure recommendations printed inside the box of film you're using. Even if your meter is kaput, Kodak's pearls of wisdom should produce printable pictures.

with your roll of film or printed inside the box. There you'll find exposure recommendations straight from the horse's mouth—everything from "bright or hazy sun on light sand or snow" to "open shade or hazy overcast." With this guide in hand (and it's available whenever you open a box of film) you need never be disabled by a meter breakdown.

Moreover, a film box's suggested settings can be compared to the meter's at any time just to make sure the meter is in the ballpark. If my workshop student had kept this in mind, those rolls of overexposed slide film just might have been averted.

BIG BAD BLUR

I've taken pictures with a wide variety of supposedly idiot-proof point-and-shoot cameras. I've looked at hundreds of color prints taken by friends and family, using the same sorts of "auto everything" cameras. And I have yet to see a roll in which every print comes out exactly the way I would want it to.

One of the most frequent failings encountered is blur. This is not a consequence of misplaced focus, which is another problem automatic cameras have, but of an insufficiently fast shutter speed. Most often, camera shake is the culprit.

Camera shake produces a different kind of blur than subject motion. If everything about your picture is sharp except Uncle Harry, then Uncle Harry probably moved during the time the shutter was open. But if everything in the picture is blurry, then *you* probably moved the camera during the exposure. That's **camera shake.**

Camera shake also produces a different kind of fuzziness than being out of focus. The difference is hard to describe, but in an out-of-focus picture usually something will be sharper than everything else. In a picture afflicted with camera shake, the whole image will look as though it is sliding off the paper. If there are light sources in the image, you'll see bright streaks instead of soft dots.

Camera shake is caused by a combination of the shutter's slowness and the photographer's unsteadiness. We all jiggle

A blurred image could be the result of several things—bad focusing, subject movement, camera shake—but the culprit here is the speed of the bicyclists.

through life with a degree of unsteadiness, but some hands are shakier than others. Sometimes we take pictures on the run, without bothering to brace ourselves and the camera before shooting. If the camera's shutter isn't fast enough, our involuntary motions become visible in the image.

Simple point-and-shoot cameras, with lenses in the 38- to 45-millimeter range, don't need especially high speeds to prevent camera shake, but their automatic-exposure programs frequently call for shutter speeds in the neighborhood of $\frac{1}{45}$ second, which are slow enough to blur grab shots taken with one hand while leaning out a car window.

When should we be careful to hold the camera steady? Unfortunately, most automatic cameras for beginning photographers won't say. The exposure is set automatically and mysteriously by a little computer chip. In some cases a "low light" bulb

inside the viewfinder may go on to tell you that the shutter speed is in the camera-shake range. With other cameras you have to guess.

You can, however, anticipate camera shake on your own. It's most likely to occur when light levels are low. With the lens open to its maximum aperture, the auto-exposure system's only alternative is to slow down the shutter. One solution to this dilemma: use a higher-speed film in dim-light situations; the one or two stops you'll gain may be enough to alleviate the problem.

Turning on the flash, if the camera doesn't do it automatically, is another option, but not necessarily a cure-all. To provide "fill flash" in daylight, exposure programs regulate both the aperture (to control the flash exposure) and the shutter speed (to control the daylight exposure). If the subject is far away and daylight is minimal, you'll get a combination effect: a part-sharp, part-blurry print. The flash part of the exposure will be short enough to make things sharp, but the ambient-light portion may be fairly long and add an overlay of sharpness.

A REVIEW OF CHAPTER THIRTEEN

1. The phenomenon of people's heads being cut off in point-and-shoot pictures is due to parallax, the difference between what the lens sees and what the finder image shows us.
2. Red eye is caused by the subject's eyes reflecting the light from the flash back into the lens. To prevent it, move the flash away from the lens, brighten the room, get closer, or don't use flash.
3. If you think your film has rewound itself in mid-roll, first check to see if it's a shorter roll than you thought. If the length checks out and the film tongue is hanging out, you can reload it and shoot "blanks" with the lens cap on until you get past your previous shots.
4. If your meter breaks, rip open the film box and follow the exposure recommendations printed inside.
5. Avoid camera shake by using a fast shutter speed (if yours is adjustable) or by turning on the flash.

FOURTEEN

Processing, Sorting, and Storing Your Pictures

So you thought your worries were over when you finished your roll of film? No way. First you have to survive the perils of the processing lab, then you face deciding which pictures to keep, which to send to Grandmother's house, and which to throw away. Finally, you've got to find a way to keep your pictures so you can find them again. But relax: these are relatively simple matters.

G etting your film developed and printed used to be a simple matter. You took your exposed rolls to the neighborhood drugstore, which put them in envelopes and sent them off. Two weeks or so later you picked up the printed and developed negatives.

But the number of ways to get film processed has multiplied, as has photographers' confusion about how to get the best looking pictures rapidly and reliably. The options now range from one-hour, on-the-spot minilabs to drug, department, and camera stores, which usually serve as collection agencies for a centralized film lab elsewhere in town.

All labs use essentially the same process to develop your film and the same kinds of chemicals and paper to make your prints. The differences lie in how precise and conscientious the lab is, especially in regard to replenishing the developers, and the kind of service it offers.

Here is a summary of the various ways to get your film processed, with my comments about their average level of quality, consistency, customer service, and price. The list is organized according to the speed with which the processing is done, with fastest service first.

- The "one-hour" minilab: Based on small, automated film-developing and print-processing machines that can fit in a large closet, so-called minilabs are the latest wrinkle in photo finishing. Many of these storefront operations are part of a franchise, while others are independently owned and operated.

 The virtue of the minilab is that it often will start work on your film right away. You can hang around and watch your prints roll off the line if you have an hour or two to spare. If you are on vacation and want to see your prints before it's time to head home, a minilab is one place to go.

 Minilabs offer convenience and quick turnaround of your film, but even if the sign out front says "one-hour photo," normal processing time may be one working day. Ask in advance if one-hour service is an extra charge. Since there are thousands of minilabs in operation across the country, there are thousands of pricing policies.

 The drawback of minilabs is inconsistent quality. The operators all too often are entrepreneurs with little or no photo-lab experience before starting their own business. Some learn on the job. Even experience is no sure solution if the experienced hand takes a lunch break while your roll is in the machine. The result can be prints without the full range of bright colors that the film is capable of providing or horrid overall color casts.

- Kiosks: Those little yellow huts in the supermarket parking lot don't have tiny processing machines hidden inside. They're simply drop-off and pick-up points for a processing lab located

elsewhere. They offer almost as good security for your film as minilabs do, and turnaround time is usually a day or two.

The quality of kiosk processing depends on the central lab receiving the film. Since most of the parking-lot and mall business is geared toward snapshot photographers, quality is fairly average.

- Neighborhood stores, including camera stores, drugstores, and supermarkets: Few of these have a lab on premises, although many camera stores are beginning to add them to their services. Most likely your film will be put in an envelope, picked up at the end of the day by the delivery van of a large lab, and driven back when it is processed and printed. These stores are therefore like kiosks and so are the prices, which are reasonable to cut rate.

It is possible that your local camera store uses the same processing lab as the supermarket and drugstore. You can sometimes tell by carefully examining the order envelope before you fill it out. But since camera store patrons tend to be finicky photographers, the labs they use tend to be quality conscious. They are also used to customers ordering special enlargements, cropping, and textures.

Stores are usually solicitous of their customers and will help you resolve any problem, such as lost negatives or a misprinted picture. At the same time they distance you from the people actually doing the work, adding to the chain of things that could go wrong.

- By mail: Mailing in your film, using a processing envelope supplied by the lab itself, is direct and, for the price of a stamp, convenient. It can also be inexpensive because no middleman is involved. But a wide range of labs offer mail-order service, some good and some not so good.

The best advice for quality and consistency is to use the film manufacturer's own processing lab. Kodak, for example, has long had labs scattered around the country for handling its lines of films. Once known as Kodak Processing Laboratories, these are now run by Qualex, Inc., which explains the "Kodalux" name now on the print envelopes.

The main drawback of by-mail processing is that it is slow,

frequently taking more than a week. But patience is usually rewarded by fine results. Qualex's lab prices are competitive but seldom the lowest around. And, of course, when using the mail one has to trust the postal service to complete its appointed rounds. In addition, it would be wise not to drop sensitive color film into a mailbox on the hottest day of the year unless a pick-up is due within the hour.

OUT, OUT, DARNED SPOTS

One of the most common and least understood photographic gremlin is the appearance of spots on processed film and prints. Sometimes they are perfectly round, and sometimes they look like short hairs. Sometimes they are white and sometimes black. In any case, they distract our eyes from looking at whatever is depicted in the picture.

Most such spots are caused by dust that settles out of the air and onto the film. Sometimes the dust is on the film when you take the picture. At other times it appears at the moment the print is being made. Being able to tell which is which is handy because you'll know whether to blame the lab that made the print or your own slovenly habits.

Let's say a speck of dust falls on the emulsion side of the film before you take a picture. It will act like an extremely small umbrella, shading the area underneath it from the light. The result: no exposure and a clear spot on the negative.

When the negative is printed, the clear spot caused by the dust will allow all the light of the enlarger to pass through it, creating an ugly (and enlarged) black dot. If the dot happens to be in a part of the picture that is already dark, you probably won't notice it. If it appears on Aunt Harriet's nose, you probably will.

A white spot often appears because dust has settled on the negative when it's being printed or, less frequently, on the printing paper. In black-and-white photography, such spots are considered run-of-the-mill, and custom printers customarily "spot" each print with water-soluble dyes to eliminate them. It's possible to spot

color prints as well, but I don't know anyone who is in the business of spotting snapshot-size prints.

In my experience black spots are worse than white spots. It's easy enough to fill in a white spot with some color or shade of gray, but a black spot has to be etched or scraped away, a ticklish process requiring a surgeon's skills.

Owners of SLR cameras with focal-plane shutters are often plagued by fuzz spots that appear on every frame of a roll of film. This fault is easy to find and fix: open up the camera back, lock the shutter open using a cable release, and then look around the shutter gate for a clinging bit of dust. Remember that if the negatives show dust along the bottom of the frame, you'll find the culprit at the top of the shutter gate. (Yes, Virginia, the photographic image is upside down inside the camera.)

So far I've been talking about what happens with prints when using negative film. Dust spots on transparencies and prints made from them are another ball of wax. Dust exposed with the slide will show up as black and, when printed, will remain black.

To avoid problems with spots on your pictures, keep your camera clean and dust-free inside and out. If you print your own pictures, keep your darkroom meticulously clean. If you use one lab and are plagued by white spots on your prints, you should think about changing to another, less slovenly one. The best processing labs today are as dust-free as an electronics industry "clean room." They should give you prints that are practically spot-free.

Of course not all spots are a result of dust; some are caused by air bubbles that cling to the film during development. But a good lab shouldn't give you any of these kinds of spots, either. And, lest anyone ask, spots on film or prints are not—repeat, not—caused by airport X-ray machines.

EDITING YOUR IMAGES

To a beginning photographer the world is an oyster; everything seems equally fascinating. As we gain experience, however, we can begin to discriminate between what looks interesting in life and

what looks interesting as a picture. One of the ironies of camera use is that tyro photographers, who need to take lots of pictures, are often stingiest with film. Pros, who know exactly what they are doing, think nothing of burning a dozen rolls at a time. As an old sage once said, compared to cameras, lenses, and other equipment, film is the cheapest part of photography.

Editing your pictures is more than a matter of deciding whether your images live up to some external standard of a "good" picture. There are scores of rules and thousands of photographers who have memorized them, but what makes photography fun isn't hewing to someone else's agenda, it's discovering your own. Deciding whether to keep a picture or throw it out is one of the most elementary but profound things a photographer gets to do. If you think about the process of editing in terms of building your own collection of images rather than of trying to please someone else, you may find unexpected pleasure in tossing photographs into the trash.

As photographers we are like our own curators: we need to recognize that our selection of our photographs represents our own special interests. At least it should. If chosen with a bit of care and sensitivity, your "keepers" will show you what you find interesting about the world. Maybe it's your spouse, maybe it's your car, maybe it's the scenery you see on vacation. Whatever it is (and it doesn't have to be singular by any means), it is telling you why you are taking pictures.

A photograph may clearly describe the visit a blue jay pays to a backyard bird feeder, for example, but for someone interested in collecting images of architecture, it's not all that interesting. On the other hand, it might be just the ticket for a bird lover's collection. Every collection—every archive, every edited selection of pictures—represents a distinct special interest. It may be broad, like architectural photography, or it may be narrow, like medical photography, but it provides a means for selecting one image over another.

For average snapshooters, the question of what to save and what to chuck comes up whenever we pick up a batch of prints from the processor. Of the 24 or 36 exposures on a roll, there are sure to be a handful that are so technically bad as to be too embarrassing to show anyone. There may be another half dozen or

so where the subjects are blinking or grimacing or looking in a direction perpendicular to the camera. In fact, if you're at all like me, after sorting out the "oops" pile and the "close-but-no-cigar" pile, you're lucky to end up with three or four pictures that are worth looking at a second time.

But we tend to hold onto pictures not on the basis of what they really look like but because of the memories they recall. Few photographers just back from vacation, for example, have the inclination or ability to edit their pictures down to a reasonable number. If our vacation consumed 24 rolls of film, then by jingo we're going to make our friends look at all 24 rolls. Never mind that one whole roll consists of different views of the Eiffel Tower or that every other print is a variant of another. To the person who took them, they're all treasured moments.

I can't tell you how many times I've heard the fretful cry, "I haven't had time to edit these yet," delivered just moments before hundreds of prints come spilling out onto the coffee table. People seem compelled to utter this exculpatory sentence as a way of avoiding the selection process altogether. Its real meaning would seem to be: "I don't want to edit these prints because every one means a lot to me. What do I care if you get bored?"

For the sake of friendship, at least, we should learn to cull. One way to start editing is to begin with those pictures in which the subject is out of focus, the lighting conceals what you wanted to show, or your spouse is grimacing in a most unpleasant fashion. Throw them away. Sure, you remember these as important moments, but if the pictures don't turn out, there's no way to reconstruct them.

A second run through the pictures will give you a chance to eliminate the overlaps—prints that essentially duplicate others. You'll have to decide which of any series of similar scenes is the best, of course, rather than letting your friends decide for you. Well, nobody said photography was easy. As consolation, the extras can be sent to relatives as proof that you really did step off the plane.

Finally, you might go through the pile a third time while thinking about proportion. If you took several rolls at Versailles but only a few shots at Fontainebleau, there surely was a reason, but it

might not be apparent to your audience. If your aim is to describe your trip in pictures, then make sure the pictures are organized in a way that suggests the full variety of your experience. You can do this by following chronological order, or you might put all the chateaus together, followed by all the cathedrals, and so on.

To do the best job of editing your own pictures, however, some time may have to pass. Only then will you be able to see the images of your experience for what they are: photographs. The distance a few months brings helps to strip away the nostalgia that makes us hang onto prints and slides that are clearly failures in pictorial terms.

FILING YOUR PICTURES

As gratifying as it is to take pictures, there's one heavy price to be paid: you have to put them somewhere. And after you put them somewhere, you need to be able to find them again. For those of us with an aversion to sorting, filing, cataloging, and other tasks best left to a librarian, organizing an archive of our photographs is as much fun as a trip to the dentist.

Fortunately, there are filing systems and equipment specifically designed to help lighten the load of getting organized. Some are intended for keeping track of negatives, some for prints, and some for slides. Within these broad categories, different approaches exist; which one you choose depends to a large extent on personal preference.

I like to think I have an adequate filing system for my various sizes of negatives and prints. Black-and-white negatives are filed in plastic sheets, with a number on the edge of the negative that corresponds to the number marked on the plastic sheet. With 35-millimeter or 120-size negatives, a whole roll fits in one sheet; with large-format negatives, each gets its own sleeve. The negative number is coded for year, film format, and sequence. A year's worth of negatives fits into a plastic box designed for the purpose.

My black-and-white prints are handled in much the same way.

They are marked on the back in pencil with the number of the negative, then put into appropriately sized, acid-free paper boxes designed for long-term storage of photographs.

So far so good. But then there are all my snapshots. Some of these are taken with a vintage Polaroid SX-70 camera, which get filed in Polaroid albums, and some with a 35-millimeter auto-focusing camera, which generally languish in the envelopes in which they return from the lab, together with their color negatives. Eventually I get around to putting them in plastic-paged albums in some semblance of chronological order.

As for my collection of a couple thousand slides—a combination of my own efforts and copy slides of others' photographs, which I use in lectures and teaching—my basic organizing principle is chaos. Some slides are in plastic sheets punched to fit a three-ring binder, twenty slides to a page, some are housed in the yellow cardboard boxes Kodak provides, and some are loosely filed with scores of others in the bottoms of shopping bags. My own disarray, I suspect, is fairly typical among photographers who lack an agency or employee to do their filing for them.

You can eliminate much of this chaos by investing in a filing system for slides. Several companies make slide cabinets designed for the job, among them Luxor and Neumade. These steel cabinets hold anywhere from five hundred to five thousand cardboard-mounted 35-millimeter slides and can fit on a desk or countertop. Heavy-duty office units can cost several hundreds of dollars, depending on dimensions, but there are budget versions available for less than $100.

Slide cabinets like these are ideal for organizing slides on an individual basis, but some photographers prefer to keep their slides in plastic sheets or pages. These can be stored in binders and relegated to bookshelves, or one can get fancy and invest in a special unit that combines holders for the slide pages with a lightbox for viewing them. This deluxe option can cost more than $1,000, however.

(Speaking of plastic slide pages, it's best to avoid the kind that use chemical softeners to keep the pages flexible. These are usually made of PVC and have a marked odor when you sniff them. The

chemicals, called plasticizers, have a nasty tendency to attack the emulsion of your slides. For this reason polyethylene and polypropylene plastic pages are preferable.)

Finding slide-storage equipment is not always easy. Some art-supply stores keep slide cabinets in stock, but at most photographic and art stores you'll have to be content with ordering from a supplier's catalog. On the other hand, practically every photo store carries the plastic negative and slide sheets needed to get your house in order.

Of course, getting the right equipment and supplies for organized storage is not the same as getting organized, as people who bought computers in hopes of bringing order to their lives already know. When you get down to it, it takes about as much time to keep your pictures out of shopping bags as it does to take them in the first place.

STORAGE AND CARE OF COLOR

Color materials in photography change over time because they are made with organic dyes. In this they are not unusual: textile dyes, paints used by artists, and even house paints are prone to lose their hues because of internal chemical reactions. Two things that speed up the changing process are light and heat, and so the first rule for keeping your color pictures colorful is to keep them cool and out of the sun.

Since the late 1970s color photography has become popular with art collectors and museums, and much research has been done into the "keeping" or storage characteristics of color prints. Some museums have built special freezer vaults to house their color collections. Other museums maintain that freezing and thawing pictures is more damaging than letting them fade very slowly at low temperatures.

In any case, few of us have the luxury of an empty walk-in freezer, so we have to take other measures to slow the destruction over time. Kodak's booklet, "Storage and Care of Kodak Color Films" (Publication E-30 from Eastman Kodak Company, Roch-

ester, New York 14650), details most of what to do. Besides recommending that you keep color materials cool and in the dark, it stresses that you keep them dry. Relative humidity in storage should be kept at 15 to 40 percent. If you live in a humid area, containers of **silica gel** should be used in the storage area.

Forget the basement (too damp) or the attic (too hot). A closet in the living quarters of your home or apartment is better, and it's the best many of us will do, short of dedicating a refrigerator to the task.

If you do have space in your fridge for long-term storage of your color films, first put the negatives in a moisture-proof package (Kodak sells storage envelopes for this purpose, or you can improvise). Keep film stored this way away from the pickle jars and peanut butter, and don't put six packs on top of the film.

If you already have faded color prints on your hands, try to find the original negatives. They may be in sufficiently good condition that new prints can be made with the full color restored. If negatives don't exist or are faded themselves, and the print is an especially valuable one (a wedding picture, for example), have it copied professionally soon. Once it has started fading, it's only going to get worse.

A REVIEW OF CHAPTER FOURTEEN

1. You can have your film processed quickly at a one-hour minilab or somewhat more leisurely by taking it to your camera store or by mailing it to a processor. In any case, consistency and service are as important as price.
2. White spots on prints are the result of dust accumulated in the printing process. Black spots on prints come from dust that was on the film when the picture was taken.
3. Store your pictures with care and keep them organized in cabinets and boxes designed for that purpose. Photographs last longest when kept cool, relatively dry, and in the dark.

FIFTEEN

A Shopping Guide to 35-Millimeter Cameras

In the market for a new camera? Here, from the hundreds of models available, is a bottom-to-top sampling of cameras I find interesting. Prices range from $10 to $3,000, but you'll be better off if you concentrate on the features you need, as explained below. If the categories of cameras confuse you, you should take a look at the discussion in Chapter One. Note that these cameras are all available as of 1989; new models will eventually replace or supersede them as technology marches on.

Y ou might think that shopping for a refrigerator has nothing to do with photography. In the abstract, all refrigerators are the same: they keep food cold. Okay, maybe some have freezer compartments on top and some have them on the side, but the basic idea is the same. But the last time I went to the appliance store I found scores of models, each with a list of features different from any other, and each with a different price tag.

So it is with cameras. All cameras are designed to take pictures, right? But some offer five kinds of exposure automation, two kinds

of automatic focusing, built-in flash units, motorized film advance, and on and on. Choosing a camera can be a simple matter if you first decide on the kind of picture taking you want to do. That's the hard part. When we look through a camera we have even more choices than a shopper in a home-appliance store. What do we want to take pictures of? What interests us? Is it the faces of our friends and family? The sights we see on trips to faraway places? The way nature remakes the world every season? The play of light on city streets?

Choosing one's subject is no inconsequential decision. Once we've decided what to take a picture of, we have to decide how to take the picture. Do we want to use a wide-angle lens or a telephoto lens? A fast shutter speed or a slow one? Color or black-and-white film?

Rather than face all the decisions inherent in taking pictures, many would-be photographers simply shelve their shiny new cameras after the first couple of rolls. Perhaps this is why so much emphasis has been placed of late on the idea that all-automatic cameras can make the choices for you. Camera advertisements in magazines and on television speak of decision-free photography, of electronic systems that free you from worrying if the picture will turn out. The cameras themselves have anxiety-lessening names such as "Freedom" and "One-Touch" and "Snappy."

Today's sophisticated automatic exposure and focusing systems are based on computer models of what the "average" photograph is. For example, amateurs tend to take pictures either in the 8-to-12-foot range or at infinity, either in bright sunlight or indoors in dim light, and therefore cameras aimed at amateurs are optimized for these conditions. Up-market auto-focusing SLRs are designed to meet more complex picture-taking situations by adjusting themselves to what the "average" user would consider pleasing. That's all fine if your picture taking fits the profile.

Still, photographers are fussy and opinionated people; what I think is the ideal camera is not necessarily your ideal. Some of us like dials instead of buttons; some like LCD displays; some want lenses that are as easy to focus manually as automatically. There are so many designs and features to choose from that emotions take over.

Often the deciding act is how a camera feels in your hands, so before you shell out your cold, hard cash, take the time to handle the camera models that interest you the most. If you've been honest about your current picture-taking abilities and future needs, the cameras on your short list should be in the same price range.

Where to buy? Some photographers like to shop by mail because they get good prices. Others like to patronize the local camera store because they get good service. I'm partial to the latter for camera shopping since I like to hold what I'm about to buy in my hands, and I want to take it with me after I've paid for it. I'll choose mail order only when I already know what I'm getting, as is the case with film. But the equation between price and service has as many answers as there are people.

DISPOSABLES: TODAY'S ANSWER TO THE BOX CAMERA

Fuji Quick Snap; Kodak Fling

Not every new piece of photography hardware can make waves by incorporating the latest technology. Sometimes a small splash from the undertow of the tide of progress has to suffice. Such is the case with the Fuji Quick Snap and the Kodak Fling. Fuji's and Kodak's least expensive 35-millimeter cameras look deceptively like boxes of film, complete with cardboard packaging. Inside the packaging there is a roll of film, but it comes surrounded by the rudiments of a camera—lens, shutter, and viewfinder. Buy the camera, expose the roll of film, and off it all goes to the photo finisher. End of camera.

Both companies see a realistic need for a disposable 35-millimeter camera, and I'd agree. Many are the times I've gone off on a trip and, on arrival at my destination, realized I'd neglected to pack my camera. And then there are the times I've purposely left the camera behind, figuring it was too much bother or that I wouldn't have time to take pictures, only to find myself standing in a perfect spot at a perfect moment with no means of recording it.

The Fuji Quick Snap, the pioneer of disposable cameras.

Kodak Fling: you press the button, they do the rest.

What's needed at such moments isn't a $500 auto-everything camera but something serviceable and affordable.

Fuji makes the film nestled inside the Quick Snap, and Kodak makes the film inside the Fling. Both are fixed-focus cameras with

a single aperture and shutter speed. You press the button, they do the rest. Only the processing lab is allowed to peek inside. Kodak also makes two variations on the theme: the submersible Weekend 35 and the panorama-format Stretch 35.

What do the pictures look like? Not bad, considering. The simple lenses do a credible job on snapshot-size prints, making everything from maybe 3½ feet to infinity look fairly sharp and capturing the kinds of details one wants in a snapshot. Sure, the finder image doesn't quite match what appears on film, but we're talking snapshots here, not fine art.

BUYING GUIDELINES: POINT-AND-SHOOT CAMERAS

According to Japanese trade industry figures, nearly four times as many point-and-shoot cameras were being sold in the late 1980s as single-lens-reflexes—over a million a month.

Perhaps you're in the market yourself, and you'd like me to answer the question, "Which should I buy, a Nikon, a Fuji, a Ricoh, or a Minolta?" Then there's Pentax, Olympus, Canon, Kodak, and several others. Indeed, there are so many brands of point-and-shoot cameras available and so many models within brands that keeping track of them all would be a full-time job.

Here are some of the features I've come to feel make point-and-shoot photography more enjoyable and successful:

- Focus lock: One of my biggest gripes about auto-everything cameras is that their focusing systems assume that my subject is precisely in the middle of the frame. (This is true not only of point-and-shoots but also of SLRs.) Most of the time I want the focus to be on someone or something off to one side. The solution is a focus-hold or focus-lock feature in the shutter release. Center the frame on what you want sharp, press the release partway down until the lens whirs into focus, and hold it there. You can then recompose to your heart's content with the focus locked in.

Most models have a focus lock, but on some the distance between locking the focus and tripping the shutter is so small it takes a surgeon's touch to keep the camera from firing unexpectedly. When examining a particular model in the store, try locking the focus, moving the camera, and then tripping the shutter to make sure its trigger is not too hairy.

- Exposure lock: This feature lets you overcome the camera's inflexible, programmed metering. If the overall scene is bright but the person you're concentrating on is in the dark, you can come in close, lock in the meter reading, and then recompose at leisure. Since the camera always sees life as "average" gray, a skilled photographer can use the exposure-lock button to make the camera perform like a manual-exposure camera. That is, he or she can lock on to an average tone in a scene, guaranteeing good exposure.

- Backlight compensation: This low-budget alternative to an exposure-lock button is often labeled "BLC" on the camera. It presumes that you are about to photograph a face against a bright sky, and it biases the exposure program to let in an extra stop or two of light. It's handy, though not as exacting as an exposure-lock button, and it only works in one direction— increasing exposure—even though there are times when less exposure is called for. The ideal advanced point-and-shoot should have both a backlight control and an exposure-lock button.

- Fill-in flash and no-flash controls: Virtually all point-and-shoot models have a flash unit built in, but not all flashes are the same. Some fire whenever the camera determines that some flash light is needed. To my mind, this kind of convenience is an obstacle. I much prefer having a red warning light in the finder that tells me to turn on the flash—if I want to. I also like a flash that can provide fill-in lighting when I want it, automatically balancing the flash output with the daylight exposure.

Failing a flash that I control, I like cameras that have one button to turn on fill flash and another button to squelch it. The squelch button has kept me out of trouble plenty of times at museums and cathedrals that have signs saying "No Flash Photography."

- Lithium battery: Once the flash goes off there's usually an agonizing wait for it to recharge, but some of the newest point-and-shoots are powered by lithium batteries, which can get the flash back to ready in a second or two. If you are into candid photography at parties, weddings, and the like, a camera with a quick-recycling flash is really the ticket.
- "Tele" or zoom lenses: The latest wrinkles in point-and-shoot designs are twin-lens and zoom-lens cameras. Often called "tele" models because they have supplementary lenses that produce focal lengths in the 60- to 70-millimeter range, the twin-lens designs offer a small dose of the convenience of interchangeable lenses. The "tele" focal length, while only moderate, does produce better perspective for portraiture than the customary 35- to 40-millimeter "standard" lens. In terms of lens flexibility, however, the leader of the point-and-shoot pack is the zoom model. It acts much like a wide-to-tele SLR zoom lens but weighs much less. Most cameras of this type have a motorized zoom control, which is fun to use but a whole lot slower than doing it yourself.

Naturally, my recommendations are biased. I like cameras that give photographers alternatives to the automatic controls. With them, anyone who takes the trouble to learn how cameras and film actually work can take better pictures and take them more often. Those who don't want to know or are intimidated by anything "technical" such as learning to press a button probably aren't reading this book anyway.

POINT-AND-SHOOT CAMERAS

Chinon Auto 3001 Multifocus

Simply in terms of its multi-beam auto-focusing system, the Auto 3001 Multifocus from Chinon stands at the top of its class of single-focal-length, point-and-shoot cameras. Chinon's patent-

*Chinon 3001 Multifocus, the first camera to expand the area
of auto-focusing sensitivity.*

pending "Multi AF" system uses three separate auto-focusing
beams. A microprocessor built into the camera compares the
different distances these invisible beams report and sets the lens to
provide the best overall focus.

You can tell what the three beams are aiming at by looking in
the camera's viewfinder. A central spot, like those found in many
conventional auto-focusing cameras, is flanked by what look to be
parenthesis marks. The space between them takes up about a third
of the finder's breadth, meaning that the auto-focusing beams
cover the central third of the horizontal picture area.

My test results with the camera were impressive. The camera's
auto-focusing system performed as advertised, focusing on faces
instead of backdrops. Chinon's engineers have done a very smart
thing, it turns out. Given a choice between a distant setting and a
closer one, the camera favors the closer setting. That makes sense,
both optically and practically. Most depth-of-field extends behind
the point of focus, not in front of it, and most of the time we are
interested in recording the things closest to us.

The camera handled even the tricky group shots I assayed,
with friends placed at oblique angles to the film plane. The
camera's uncanny powers of discrimination in this regard are due

in large part to the fineness of its focusing "zones." Where some inexpensive auto-focus cameras get by with three or four divisions, the Auto 3001 has sixteen. Together with the camera's programmed auto exposure (featuring stepless shutter speeds from ¼₅ to ½₅₀ second) and its automatic flash system, there's not much that can go wrong.

The lithium-powered Chinon camera is not infallible, however. If you put your subject close to the camera and on the edges of the frame, none of the three focusing beams will "see" it, and it will likely be out of focus. But as with conventional auto-focus systems, there's a focus hold provision to get around the problem. Center the subject, press the shutter button enough to activate the focusing system, hold the button, and recompose. The focus will remain locked onto the first distance.

Troubled by backlight? The Auto 3001's fill-flash provision, activated by pressing a tiny button atop the camera, functions marvelously, blending with the daylight exposure without overpowering it. And what about the times when you'd rather not have any flash at all? There's a thin sliver of a button labeled "Flash Off" that overrides the flash's own desires.

Minolta Freedom Tele, another point-and-shoot that doesn't focus only on the center of the frame.

Minolta Freedom Tele

Like Chinon's 3001, the Freedom Tele is a point-and-shoot camera able to "read" a broad band of the frame when making its auto-focusing decisions. This helps prevent shots in which your friends are out of focus but you can see every blade of grass in your lawn.

Acting like the Starship Enterprise, the Freedom Tele sends out five infrared beams to measure subject distance. Like its Maxxum SLR brethren, it links its automatic-focus system to its automatic-exposure system. Its flash is built in, and the lithium-powered, pop-up unit fires whenever the camera senses that fill light is needed.

The Freedom Tele does the Chinon 3001 one better by sporting two lenses, a 38-millimeter "standard" lens and an 80-millimeter "tele." Short of a zoom lens, this choice gives point-and-shooters some (but by no means all) of the flexibility of focal length enjoyed by SLR users.

Canon Sure Shot Ace

No doubt the neatest feature of the Canon Ace resides in the body's lower left corner. Pull on the corner with the right amount of body English and it detaches, instantly becoming a cordless remote release with an infrared trigger. You can astound and surprise your friends and anyone else with this butane-lighter-sized device. You can also put yourself in the picture without the standard mad dash that self-timers require.

The Ace's remote trigger works through the self-timer circuitry. As a result, two seconds elapse between the time you press the trigger and when the shutter fires. That's fine if you want everyone to say "cheese" but chancy if you're trying to capture junior's first shaky steps in your direction.

The Ace's other unique selling point is a waist-level finder atop the camera that lets you take pictures from bird's-eye and worm's-eye perspectives. Other than that, it has all the standard features of

Canon Sure-Shot Ace, with a remote trigger to amaze your friends.

a simple point-and-shoot camera in a good-looking package that should please the "fun photography" crowd.

Kodak S900 Tele

The Kodak S900 Tele, introduced in 1988, shows how far we've progressed since the original model Kodak appeared in 1888. It sports all the latest in automatic gizmos—auto loading and rewind, focusing, exposure, and flash—as well as a choice of wide-angle or tele lenses. It also marks Kodak's domestic reentry into the 35-millimeter camera market.

Previous Kodak models were contracted out to Chinon, so they bore the markings "Made in Japan." The S900 Tele, however, is made much closer to home—in Rochester, in fact. How does this home-grown product compare to the best the Japanese have to offer? In terms of features, not too badly. The dual-lens system is ingeniously engineered; instead of motoring the lenses into position in front of the film, Kodak has used a mirror that can shut off the wide-angle lens's view while reflecting the tele's image onto the film. An up-to-date, 6-volt lithium battery supplies power for both

the camera and the built-in flash. The flash fires automatically when needed but can also be shut off or fired manually.

The focusing system is not the highest of high tech, however. The 34-millimeter wide-angle lens is set at a fixed focus while the 62-millimeter tele ("tele" is used rather loosely here) focuses automatically to one of three zones. These days three zones is not that many. And the DX coding system for registering film speeds is fairly primitive, being limited to ISO speeds of 100, 200, 400, and 1000.

In terms of design and construction, the S900 Tele sends mixed messages. Its controls are well placed and well marked, and they fall naturally under the fingers. A rubber protrusion on the right front serves as a steadying handgrip, but the camera seems bulkier than it should be. Perhaps this is because its designers have taken pains to smooth any rough edges in what amounts to a streamlined chassis. The camera also seems solid enough, but it lacks the feeling of precision and refinement that Japanese camera makers have achieved. This isn't surprising since the Japanese have had a lot more experience in the last forty years.

Kodak S900 Tele, a made-in-the-U.S.A. camera with all the features of a Japanese point-and-shoot.

The S900 Tele's newer stablemates are the S1100XL and the S500AF. The top-of-the-line S1100AF has a 35-millimeter f/2.8

lens and a flip-up flash that serves as a lens cover when not in use. The S500AF is a basic single-lens, auto-focusing snapshot camera.

Minolta Weathermatic Dual, a snorkeler's camera with a choice of two lenses.

Minolta Weathermatic Dual 35

Two trends in contemporary camera design have converged in the Minolta Weathermatic Dual 35. As the name suggests, it is a 35-millimeter, automatic camera impervious to the elements—it even can be submerged to a depth of 16½ feet—and it offers a choice of two focal lengths. While there are a multitude of 35-millimeter cameras with one or the other of these features, this is the first camera to have them both.

Like garden-variety automatic cameras, the new Minolta entry provides auto exposure, auto focusing, auto film-speed setting, and an automatic, built-in flash. Its two focal lengths, 35 millimeters and 50 millimeters, are switched at the press of a button. A motor performs this particular chore, shifting two extra elements into or out of the light path.

In addition, the camera has a "smart" exposure and flash

system. The programmed auto exposure is designed to compensate for backlight and other tricky lighting situations, and the flash fires any time the camera's brain thinks a little extra light is needed. (This is a great idea except in museums and other low-light places that prohibit flash.) The camera can be powered either by four AAA cells or a 6-volt lithium pack; the latter has the advantage of flash recycle times of just over one second.

All of these features are nice, but none are revolutionary, except that they are gathered together in a housing that can be plunged into the drink or thrown about the beach. Two O-ring seals, on the camera's back and battery compartment, accomplish the trick of keeping moisture away from the insides, and the yellow-and-gray body is plastic-coated to prevent damage on the outside from surf, sand, or dirt. A glass plate over the lens protects the optics. The glass plate is slightly concave so that it functions under water as a positive meniscus lens, shifting the lens's maximum focus from infinity to about six feet.

Pentax IQ Zoom

The IQ Zoom was the first point-and-shoot camera to sport a motorized zoom lens. The lens covers focal lengths from 35 to 70

Pentax IQ Zoom, the camera that introduced zoom lenses to the ranks of point-and-shoots.

millimeters, from slightly wide angle to slightly telephoto. Since this represents a range of focal lengths often found in SLR zooms, the camera seems to be half SLR, half point-and-shoot. Of course one doesn't have the pleasure of looking through the lens at the exact scene that will be rendered on film, but the separate viewfinder does zoom along with the lens, giving the effect of SLR viewing. And since the viewfinder window is independent of the lens aperture, there's no dimness when shifting focal lengths.

Like the big-boy SLRs, the IQ Zoom has its own internal computer chips, an LCD panel on the camera's top plate, and several buttons and levers that serve to provide such functions as focus lock, backlight compensation, shutter delay (a self-timer), and fill-in flash. One sliding lever controls the zoom motor—the lens moves only under power. Like almost every other point-and-shoot, the camera features automatic exposure, focus, winding, rewinding, loading, and film-speed setting. It also has its own built-in flash, which is automatic as well.

Olympus Quick Shooter Zoom

The Olympus Quick Shooter Zoom takes after the enormously popular Pentax IQ Zoom. Its fixed-mount, 35-to-70-millimeter

Olympus Quick Shooter Zoom, with seven ways to shoot pictures built in.

zoom lens focuses automatically via an active infrared system from 2 feet (in macro mode) to infinity. Focal lengths are controlled by a wheel on the camera back. Push the wheel one way or the other, and a motor moves the lens from moderately wide angle to moderately telephoto. This may seem more natural to some users than the sliding switch on the back of Pentax's IQ Zoom, but basically it performs the same function.

Other features of the Quick Shooter Zoom include a built-in flash with provision for specialized flash modes such as fill and slow-shutter synchronization, plus seven—count 'em—shooting modes. These are listed as follows: single-frame, continuous shooting, macro, multiple-exposure, backlight-compensation, self-timer, and "filter." The last means that you can use extra-cost, special-effects filters without confusing the exposure system.

Nikon Zoom Touch 500 comes with a three-shot auto-zooming option.

Nikon Zoom Touch 500

Nikon's most feature-laden point-and-shoot adds a 35-to-80-millimeter zoom lens to the repertory of the Touch family, which also includes the One Touch, Action Touch, and Tele Touch.

Like the lens on the Pentax IQ Zoom, the Olympus Quick Shooter Zoom, and other cameras of its kind, the Zoom Touch's optics stick out from the camera in telephoto position and suck up

their barrels when switched to wide angle. The zoom action is controlled by a slide lever positioned just where your right thumb falls when you grasp the camera.

The Nikon Zoom Touch also offers continuous-sequence shooting capability, with an added wrinkle: the lens can be set to zoom automatically to three different focal lengths during the exposure sequence. That's ideal for photographers who can't make up their minds about what to include in the frame.

Chinon 5001 Handyzoom, the first camera to try to compose the picture for you.

Chinon Auto 5001 Handyzoom

Welcome to the brave new world of the "automated programmed zoom composing system." No, the camera doesn't swing around in your hands looking for a suitable subject, and it only fires its shutter when a human finger presses the release button. But the Chinon auto-composing system does zoom the lens to whatever focal length it decides is best for whatever is in front of the camera. How does it know what's in front of the camera? It doesn't, really. It only knows how far away the central subject is and, thanks to its three adjacent auto-focusing beams, how wide it is. From this data the

camera's microprocessor makes a preprogrammed decision about what the focal length should be. The noninterchangeable, motorized zoom lens has a range from 35 to 70 millimeters.

Judging from the behavior of the sample I tested, the Handyzoom's composing system isn't tremendously complex. If it senses something 5 feet away—a face, a chair, or whatever—it zooms to the 35-millimeter, wide-angle position. If it senses that the subject is 25 feet away, it zooms in to the 70-millimeter, semi-telephoto setting. The auto-focusing sensors that control the composing system divide the distance between 3 feet and infinity into sixteen zones.

I suppose some beginning photographers will find the auto-composing feature a bonus, and the Handyzoom seems at first to be designed for them, but Chinon has wisely decided to give the rest of us the option of turning off the auto-composing system. With the camera's rear-mounted power switch set to "Power" instead of "Auto," the Handyzoom functions as a regular zoom-lensed point-and-shoot camera. A rocker switch, mounted on the base plate of the camera's smooth-edged black body, lets you zoom back and forth with a minimum of fuss.

The Handyzoom has programmed exposure automation, a built-in electronic flash, automatic film loading, wind and rewind, and all the other goodies of the point-and-shoot brigade. Added features include switches for backlight compensation, flash fill, and flash off. There is also a button for converting the three-beam auto-focusing system to single-beam mode, and yet another button lets you take sequences at a speed of one frame a second.

NEW HYBRIDS

Despite the dramatic shift from mechanical to electronic controls in 35-millimeter photography, the outsides of cameras have stayed pretty much the same. But lately that has begun to change.

Rollei of West Germany may have started the trend in 1976 when it brought out a 35-millimeter SLR shaped roughly like a Hasselblad. But the newest entries in the strange-shape sweep-

stakes are all Japanese. In most cases it's not only the outsides that are different but the insides as well, for these cameras manage to combine salient features of both SLR and point-and-shoot photography. Most operate totally automatically, but at the same time they have such SLR-like functions as through-the-lens viewing.

Can these "hybrids" of SLR and point-and-shoot design do it all? Not by a long shot. They lack the flexibility of true SLRs, and they cost more than most point-and-shoots. But for snapshot photographers looking to impress their neighbors, these cameras offer pretty impressive technology.

Yashica Samurai, a hybrid design that takes half-frame seriously.

Yashica Samurai

The Samurai, a half-frame 35-millimeter camera, has all the aerodynamic curves of a Ford Taurus. It's made by Kyocera,

which sells its cameras on these shores under the name Yashica. The camera's nifty all-of-a-piece plastic body holds a motorized zoom lens, an automatic-focusing system, and all the other automatic gizmos known to point-and-shoot cameras. What makes it unusual is that it looks like a streamlined 8-millimeter movie camera.

You grab it by wrapping both hands around its tall, skinny body, and your fingers fall naturally onto the buttons that control zooming and the shutter release. The shape is made possible by the half-frame format, which puts the picture sideways on the roll of film, compared to full-frame 35-millimeter practice. Therein lies a rub: taking vertical pictures with the Samurai is fairly awkward. Also, the quality of prints from half-frame negatives is about half as good as full-frame negatives at any given print size, and finding places that process and print the film can be a chore.

But if you've always wanted to get 72 exposures out of one roll of film while fooling the unwashed into thinking you are making videotapes, the Samurai is the best way to go.

Chinon Genesis

Billed as the long-sought-after "bridge" camera that combines the best features of SLR and point-and-shoot cameras, the Chinon Genesis has a shape that combines new and old. Borrowed from video-camera styling are a hand-strap grip on the right side and smooth, molded-in control buttons on the top and left. But the overall orientation is horizontal, and its pentaprism bulge and flip-up flash head give away its 35-millimeter SLR origins. (Unlike the Samurai, this is a full-frame camera.)

Chinon calls the styling ergonomic, which means it's supposed to complement, rather than compete with, our faces, fingers, and thumbs. If it looks zoomy and space age at the same time, well, those are just benefits of good design. As for the functions of the camera itself, the Genesis has just about everything built in, from an auto-focusing, 35-to-80-millimeter zoom lens to automatic fill-in flash.

What makes the Genesis different from cameras of yore is its

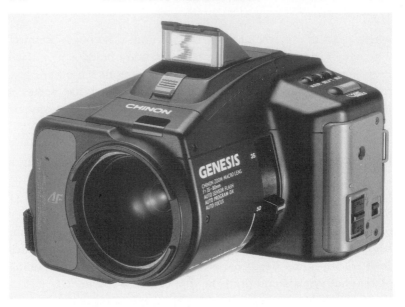

Chinon Genesis, an attempt to bridge the gap between SLR and point-and-shoot.

combination of through-the-lens viewing and metering (long found in SLR cameras) with "active" infrared automatic focusing. Chinon calls it a "stepless" infrared system, meaning that it's capable of making nearly as fine discriminations as its fancier SLR kin. In my experience, the Genesis's automatic focusing proved to be both accurate and sure. It can focus from infinity to about 3 feet or to 18 inches in macro mode.

What are the drawbacks of the Genesis approach to SLR focusing? There aren't many if you're content with the limited focal lengths of its built-in, noninterchangeable zoom. (An accessory teleconverter stretches out the long end to 105 millimeters.) But there are other trade-offs: the camera's top shutter speed is a moderate $\frac{1}{300}$ second, the finder image shows a mere 85 percent of what will appear on film, and the meter's sensitivity is less than awesome in low light (although, with a built-in automatic flash, it has its flank covered, so to speak). Manual controls? Not on the Genesis.

It also lacks a zoom motor, so different focal lengths have to be cranked in via a lever mounted beside the lens. That's terrible

news for the auto-everything set, which dotes on motorized stuff, but I actually enjoy having something to do with my hands while taking pictures.

Olympus Infinity SuperZoom 300

The Olympus Infinity SuperZoom 300 takes a sophisticated approach to do-it-all automation. It can be set to take either head-and-shoulders or full-figure portraits of people automatically. Point the SuperZoom 300 at someone, and the lens starts zooming back and forth until it finds the proper size. When it does, the camera gauges exposure and focus, and then takes the picture.

So how does an unthinking chunk of plastic, metal, and electronic parts know when it's looking at the head and shoulders of a human being? Simple answer: it doesn't. It merely assumes that whatever appears in the center of the finder is a person, and it uses its auto-focusing capability to judge the subject's distance from the lens. A built-in computer program does the rest. The one limitation is the lens's zoom range; the head-and-shoulders "portrait mode" only works between 4 and 10 feet.

Besides zooming automatically, the SuperZoom 300 sports

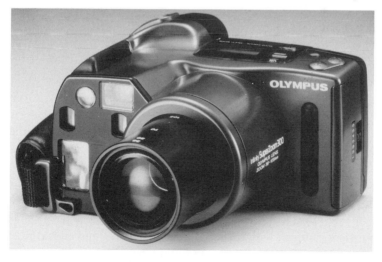

Olympus SuperZoom 300, a non-SLR with SLR-style auto focusing.

plenty of other upscale features. There's a built-in flash that zooms when the lens does, plus a provision for fill-in flash. There's a "servo" auto-focus mode, which basically means that the lens keeps focusing as long as your finger is on the shutter button. And the metering system can be set to take either center-weighted or spot readings.

You'd think from all this that Olympus has produced yet another auto-focusing single-lens reflex, but you'd be wrong: the SuperZoom 300 is a point-and-shoot camera. Like other point-and-shoots, its viewing system is separate from the lens. However, the camera does verge on being SLR-like in its automatic focusing system. Unlike the run-of-the-mill point-and-shoot, it does not project an infrared beam to measure distances. Instead, like auto-focusing SLRs, it has an internal contrast detector that does the job. The result is better accuracy although it may not be apparent in the average snapshot.

Olympus clearly intends the SuperZoom 300 as a "bridge" camera, one designed to lure point-and-shoot novices in the direction of feature-laden SLRs. Experienced SLR users, however, may find the camera's operation a bit too automated. Its motorized zoom can seem agonizingly slow, and its exposure system occasionally misses the boat. Despite these shortcomings, though, the SuperZoom is an intriguing messenger of a new era in camera design.

Ricoh Mirai

The Ricoh Mirai embodies most of the features of the new breed of hybrid cameras as well as their distinctive look. Like the others it is sleekly shaped, with a contoured polycarbonate body designed to fit neatly into the hands. Its built-in, fixed-mount zoom lens is an integral part of the body, as is its folding, multiposition hand grip.

Inside, the Mirai features all the automation of a point-and-shoot, coupled with through-the-lens viewing and a focal-plane shutter. Its wide-ratio, 35-to-135-millimeter lens zooms in and out via a motorized switch, even though technically it isn't a true zoom lens. It's a variable-focus design, which means that as you change

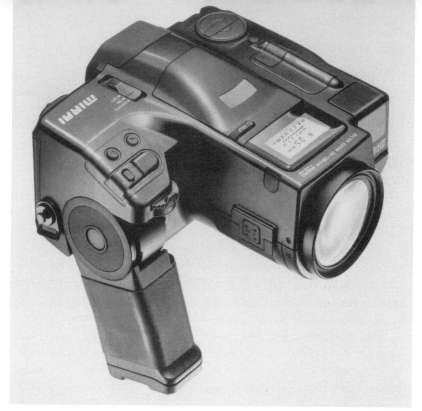

Ricoh Mirai, a hybrid with a 35-to-135-millimeter zoom lens and flip-up flash.

focal lengths, the focus also changes. Since the Mirai's internal, contrast-sensing auto-focusing system readily restores precise focus, the difference is barely noticeable.

Just like modern-day SLRs, the Mirai has a programmed exposure system that adjusts to both the focal length of the lens (the longer the focal length, the higher the shutter speed) and unusual lighting conditions (specifically backlighting). A built-in, swing-out flash can be used in either fill-in or total darkness modes.

Film loading is "sprocketless," meaning that the take-up spool doesn't have to engage any of the little perforations along the film edges. Instead, optical sensors monitor the film's position and its passage through the camera. In rewind mode the camera can either totally rewind the film into the cartridge or let the film leader protrude slightly—you get to choose.

In terms of letting the user know what it's doing, the Mirai is

fairly friendly. Visible in the finder are the shutter speed and aperture in use, focus indicators, a flash-ready arrow, and several other handy indicators. Atop the camera is an LCD panel that shows the focal length, the focusing distance, battery condition, film transport, and multiexposure mode.

AUTO-FOCUSING SINGLE-LENS REFLEXES

These are the cameras that have brought single-lens-reflex photography back to life. Besides offering automatic focusing, they also feature automatic exposure and, in most cases, automatic flash control as well. Why buy an SLR to get the same features as a point-and-shoot? Because they provide more versatility, including interchangeable lenses, more precision, and—once you've mastered their operation—a variety of operating modes. The more advanced (and expensive) models tell you what exposure they're setting, and they give you the option of choosing to control both focus and exposure manually.

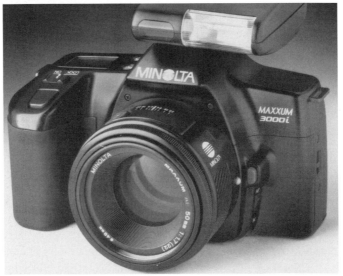

Minolta Maxxum 3000i, an "intelligent" auto-focus SLR aimed at the tyro.

If I were buying a camera for a college student with an interest in the visual arts or for anyone with a real yen to take photography seriously, I would look at one of the entry-level, auto-focusing SLRs. The advantage of being able to see through the lens is one reason. Another is the provision for more advanced control, such as manual focusing and aperture-priority exposure automation. In short, these cameras have more growing room built in.

Minolta Maxxum 3000i

Minolta is the company that started most of the auto-focusing fuss with its line of Maxxum SLRs, and it hasn't been resting on its laurels. The entry-level 3000i is the less expensive one of two second-generation Maxxums, both of which have improved auto-focusing and exposure-metering capabilities.

The little "i" in its name means "intelligent," according to Minolta, not "incomprehensible." The 3000i is an SLR that can be used like a point-and-shoot camera but with a big difference in results. One indication of its sophistication: its automatic exposure system is linked to its auto-focusing system.

Why would anyone want to base exposure on focusing data? Because presumably you want whatever you focus on to be your main subject, and you want your main subject to have the best exposure. Of course sometimes that subject is backlit, and sometimes it fills the frame. So the 3000i biases its exposure readings according to the distance of the subject and—an added fillip—the focal length of the lens. It works because the meter reads two sections of the finder image, one in the center and one around the edges. A computer program does the rest.

Speaking of program, that's the one and only kind of exposure system the 3000i has to offer. You press the button, and it figures everything else out. There aren't any numbers in the finder or the top-mounted LCD display to let you know what's happening. For recent graduates of the point-and-shoot school of photography, that's all well and good; for distrustful dinosaurs like me, it's anxiety-provoking.

Further evidence of what the "i" in 3000i means is provided by

an off-the-film flash system that is designed to provide daylight-balanced flash exposures automatically. Best of all, the auto-focusing system, based on a newly developed CCD sensor, is said to remain sensitive down to EV 0. That's enough to focus on a candlelit dinner, if not on your black shoes under the table. The focusing spot is larger than on previous Maxxums, and the system will even "predict" the distance of a subject that moves between the moment of focus and the shutter release.

A built-in motor drive performs all the loading and film-winding chores, in one-frame-at-a-time mode. The flash is an accessory, with a special mount that does not conform to the standard hot-shoe-mount of anyone else's camera.

Nikon N4004S, with a three-zone metering system and built-in flash.

Nikon N4004S

Nikon is a camera company best known as a supplier of professional equipment, including rugged camera bodies, crisp lenses, and fuss-free accessories. That's all true, but the Nikon N4004S is

something else again: an amateur-level auto-focus camera intended to fill a marketing gap between point-and-shoot cameras and grown-up SLRs.

The N4004S has an advanced auto-focus detection module, which sports two hundred tiny sensors arrayed in two rows. Instead of being arrayed horizontally or vertically, as in most other auto-focus systems, the sensors are aligned diagonally. This means that the camera has a greater statistical chance of finding something to focus on since the world is neither entirely horizontal nor entirely vertical.

The advanced sensing system is mated to a camera that allows only one auto-focusing mode: single-shot. This is a bit like harnessing a Porsche to a surrey. Lacking a continuous mode that would permit continuous auto-focusing at motor-drive speeds, the N4004S runs the risk of being considered a glorified point-and-shoot camera.

In terms of automatic exposure control and total electronic integration, however, the N4004S is more advanced. It features choices in the realm of metering sensitivity (a three-zone, auto-compensating system or traditional center-weighting) and exposure modes (program, both aperture- and shutter-priority, and manual). A tiny flash tube is nestled in the pentaprism, and its output is read and regulated by the camera's central computer chip. Fill-in flash and regular flash exposures are automatic and metered through the lens.

The N4004S accepts virtually all Nikon lenses, but it can strut its auto-focus and auto-exposure stuff only with AF Nikkor lenses.

Canon EOS 750, 850

Unlike every other camera maker I know, Canon likes to number its models backwards. That is, the most advanced and expensive EOS model is the 620, followed by the 630, 650, 750, and 850.

Besides being at the rear of the EOS pack, the 750 and 850 are virtually identical. They use the same electronics-laden lens mount and speedy auto-focusing system as their older and more feature-filled brothers. What they lack is mostly a matter of exposure

Canon EOS 750 and 850, capable cameras with one little difference: the 750's built-in flash.

modes. Unlike the 620 and 650, they have no aperture-preferred or shutter-speed-preferred automation and no manual mode. No exposure information is shown in the finder, and you won't find an LCD display panel on the body's top deck.

The 750 and 850 do, however, offer programmed exposure automation with "smart" readings based on six zones within the frame. They also incorporate one of the 650's neatest innovations: "depth-of-field" auto exposure. Basically, this system sets the aperture according to information supplied by two auto-focus readings so that both far and near subjects will be sharp.

The two junior Canons would be identical twins except for one bright idea: the 750 possesses a built-in, flip-up flash. Set to "auto" position, it pops open and fires automatically in dim light, providing automatic exposure via a through-the-lens feedback system that is integrated with the camera's aperture and shutter-speed controls. It also will provide flawless fill flash when the camera thinks it would be useful. Or you can shut it off completely.

The 850 can be rendered flash-ready with the addition of Canon's Speedlite 160A, a slim add-on flash that lets the camera do everything the 750 can. Both cameras' flash units have built-in infrared beams for night shooting, and they are powered by lithium batteries.

Yashica 230 AF

Part of what makes the 230-AF unique (or at least differentiates it in the marketplace) is the number of user options it offers. The people who market it speak of three different auto-focusing modes and nine exposure modes (that's counting five flash modes). If ever a camera were à la mode, this is it.

Some of these modes are more interesting than others. The "trap" mode in auto focus is one: it allows a sports or wildlife photographer to prefocus the camera at a distance where the action is anticipated, and whenever something crosses the field of view at that focus, the camera starts firing on its own.

The camera's most interesting flash mode uses its auto-focusing capability to "tell" the camera how far away the subject is, at which point a computer sets the lens aperture for proper flash exposure.

Yashica 230AF, with trap focus and distance-sensitive flash control.

This mode is in effect with the Yashica CS-110 AF flash, a miniature unit that mounts over the camera's pentaprism like a cowl. Because of its shape and light weight, and because it is powered by the camera's lithium cells, it can be considered part of the camera itself.

There is, needless to say, a price to be paid for capabilities such as these. First, there is the matter of power consumption. Using the CS-110 AF flash half the time, the lithium battery is claimed to be good for twenty-five rolls of 24-exposure film—that's about seventeen rolls of 36-exposure loads. Replacement batteries have a list price of about $13. That averages out to fifty cents a roll for batteries, at best.

The other price is complexity. Setting the "trap" focus mode, for example, involves changing the auto-focus switch, resetting the focus mode to "trap" and the motor to continuous run, attaching an accessory shutter release, manually focusing, and locking the

shutter release. For operations like this, the camera should come with a built-in slot for the instruction booklet.

Pentax SF1N

Within the ranks of auto-focusing SLRs, the SF1N is an aristocrat with democratic urges. Like the competition, it has its share of selectable exposure modes and focusing modes. Its claim to fame lies in being the first auto SLR with a built-in automatic flash unit controlled by through-the-lens metering.

The flash unit sits flush atop the camera's pentaprism housing until it is needed, at which point it pops up like a clam gasping for breath. It is powered by the camera's lithium battery, which reportedly will get the camera through at least three hundred flash exposures. (Without flash, the battery will last for four times as many shots, according to Pentax's specs.) There's also an optional hand grip that uses AA-size batteries.

How good an idea is it to have a built-in flash? Other than

Pentax SF1, an easy-to-use SLR that doesn't sacrifice capabilities.

draining the camera's power and raising the specter of red eye, an integral flash has no real negative consequences. It's small enough not to add much size or weight, and it's much better than having to lug around a separate piece of equipment that needs to be constantly attached to or detached from the camera's hot shoe.

What also makes the Pentax SF1N interesting is the way it leans over backwards not to seem complicated to the average, nontechnical photographer. The wave of the future, in cameras as in computers, may be user friendliness, and it's likely to take the form of a camera as simple to operate as a point-and-shoot but as sophisticated and versatile as an SLR—one very much like the SF1N, now that I think about it.

Canon EOS 650

Together with its more sophisticated siblings, the EOS 630 and 620, the EOS 650 changes some of the engineering ground rules of

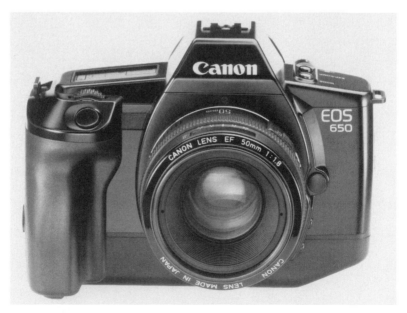

Canon EOS 650, a hardworking SLR with auto-focusing motors in its lenses.

SLR automatic focusing. Instead of having a motor in the camera body to power the lens into focus, it utilizes tiny motors in the lenses themselves. Because the motors are in the lenses and not in the body, the need for a mechanical linkage between them has been eliminated. This goes as well for the automatic lens diaphragm, which is controlled by an electromagnet, not a lever. One result is a lens mount that has eight electrical contacts and no mechanical ones. Another consequence is a much quicker and quieter camera.

Canon has also bypassed the standard CCD (charge-coupled device) used to establish focus in everyone else's auto-focus SLR, electing instead to develop its own sensor. The patented sensor it developed gets down to a claimed EV 1, making focusing possible in near-dark conditions. A lithium battery powers this and all the camera's other automatic functions (auto load, auto wind, auto rewind, auto exposure, etc.) for a claimed minimum of one hundred rolls of 36-exposure film.

Nor did Canon's designers skimp on features. Like most of today's new-wave SLRs, the 650 has a polycarbonate body, an aluminum-chassis, an LCD display on its top panel, an integral hand grip, an array of buttons for setting exposure and auto-focus modes, a bright, information-packed viewfinder, and an interchangeable back. One gets one's choice in metering of aperture-preferred or shutter-preferred automatic, programmed automatic, or—wonder of wonders in a camera this sophisticated—manual control. The meter itself is an "intelligent" version that reads various areas of the finder and decides on its own when exposure compensation is needed, or it can be changed to read a semi-spot pattern.

There are two systems for auto focusing: one-shot mode, for locking onto still subjects, and servo mode, for action shots. As much as anyone, Canon has managed to keep the controls for these options and many others relatively simple to operate and understand, but if a user should find it too much to comprehend, there's yet another option: a "green" mode, marked on the camera's on/off switch, turns the camera into the equivalent of a simple (and much less expensive) point-and-shoot camera.

The vacation slides I shot with the Canon EOS 650 proved

consistently well exposed, and the focus is right on the money. If I had it all to do over again, however, I might use the camera's exposure-bias feature to program in a consistent half-stop under-exposure. Primarily I used the camera in its "S," or single-shot motor-drive mode, and its "one-shot" auto focus mode; that is, as if it were simply a rather expensive point-and-shoot camera. But I also experimented with its "C," or continuous-firing mode, together with its "servo," continuous-focusing mode. Used in combination, the continuous-firing motor and servo auto focus let you shoot at a rate of three frames per second. With the camera set in this fashion, I had a friend photograph me as I ran as fast as I could manage. She got off five fast shots in practically no time, and each is in sharp focus.

Nikon N8008

Like the manual-focusing Nikon FE-2 and FA cameras, which it has supplanted in Nikon's SLR line, the N8008 is intended for the "advanced amateur enthusiast." It has acquired a large and enthusiastic following among those whose needs and pocketbooks fall short of the Nikon F4 (see below), including a fair number of professionals.

For auto focusing, the N8008 uses the same charge-coupled device (CCD) sensor as its junior cousin, the Nikon N4004S. The sensor, plus a new-generation motor for moving the lens and an eight-bit computer chip, lets Nikon claim "the world's fastest auto focus" in an SLR. My short and subjective experience with the camera suggests that the system is darn quick but not obviously faster than competing cameras from Minolta and Canon, for example.

Nikon also claims that the system will work under lighting conditions as low as -1 (minus one) EV, about equal to the light of a candle at one foot. This puts the N8008 at the head of the auto-focusing class in terms of sensitivity, at least for the moment. But like all SLRs with so-called phase-contrast focusing systems, the camera still gets bamboozled by painted walls and other broad, featureless areas.

The N8008's metering system greatly resembles that of the

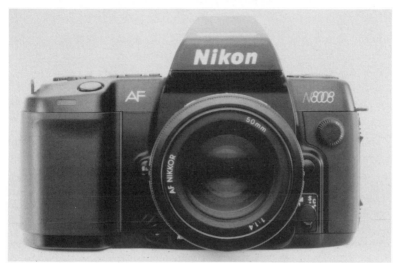

Nikon N8008, with a second-generation, highly sensitive auto-focusing system and lots more.

outmoded Nikon FA but with significant improvements. What Nikon used to call AMP metering (Automatic Multi Pattern metering) is now called Matrix metering. Essentially, the picture area is divided into five segments, each of which is read individually. The results are analyzed by yet another computer chip, which compares brightness and contrast levels and then "tells" the camera what exposure to set.

For those of us who rebel at the thought of having the camera make our decisions for us, the N8008 also incorporates Nikon's beloved (and much simpler) center-weighted metering system, only instead of the traditional 60-40 split between the center of the frame and the periphery, the proportion has been upped to 75-25.

There are a host of exposure modes to go along with choice of metering systems, including three of the "programmed" sort, plus aperture-priority and shutter-priority settings. Best of all, there is also provision for full manual control of exposures, with the settings displayed on an LCD display within the finder. The same goes for the focusing system: if you want to, you can switch off the automatic system and turn the lens by hand.

Virtually all Nikon F-mount lenses will work on the N8008; Nikon takes particular pride in sticking to its standard bayonet

mount at a time when other manufacturers are forced to revamp theirs. Manual-focusing lenses take advantage of focus indicator arrows in the finder, which show which direction to turn the lens to achieve focus, but the programmed exposure modes and the Matrix metering system check out unless an AF Nikkor lens is used.

In looks and feel, the N8008 is right up there with the best of the breed. Its controls, however, will take some getting used to. Atop the camera is a heady combination of buttons, dials, and rocker switches, as well as an LCD display of considerable complexity. Nonetheless, word on the street is that the N8008 delivers the goods whenever you ask it to.

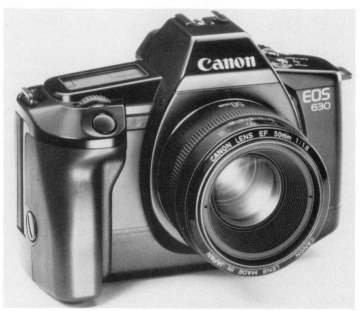

Canon EOS 630, which has stolen the limelight with its situation-specific camera settings.

Canon EOS 630

The Canon EOS 630 brings a new level of integration to the various and sundry automatic functions built into modern-day SLRs. Its "Programmed Image Control" system brings together

the traditionally separate functions of automatic exposure, focusing, film wind, rewind, and film-speed setting, and coordinates them in a way new to cameradom. These auto functions are interlinked according to seven predefined picture-taking options, ranging from "Landscape" to "Sports."

This sounds more complicated than it is. In landscape mode, for example, the auto-exposure system uses its small-aperture program for maximum depth-of-field, the auto focus sets itself to one-shot mode, and the film-wind motor does its thing one frame at a time. Switch to sports mode, however, and the exposure program gives fast shutter speeds priority, the auto focus goes into "servo"—or continuous—mode, and the motor drive keeps the shutter clicking for as long as you keep your finger on the release.

The 630's other built-in picture-taking modes are "Quickshot" (for pictures of children and pets), "Portrait," "Close-Up," "Indoor" (with or without flash), and the ever-popular "Standard." Unfortunately, the camera's top-mounted LCD information panel doesn't display these names but numbers from one to seven.

If you think the Canon EOS 630 is a beginner's camera, think again. What beginner's SLR, for instance, offers built-in automatic exposure bracketing? The 630 does, providing a three-shot sequence with up to five stops of exposure variation. The 630 also features Canon's unique depth-of-field auto-exposure mode, an improved auto-focus sensor, and a predictive auto-focusing capability in servo mode. ("Predictive auto-focusing" simply means that the camera's brain guesses where a rapidly moving subject will be when the shutter curtains open.)

Numerically, the 630 is nestled snugly between Canon's advanced-amateur EOS 650 and high-end EOS 620. Since in Canon's ordering system lower numbers signify higher capabilities, the 630 is near the top. Indeed, the only thing the 620 has that the 630 doesn't is a faster top shutter speed.

Minolta Maxxum 7000i

The Minolta Maxxum 7000i is a pleasant handful, with a softly rounded, streamlined body. But its looks and feel are the least of its charms.

Trumpeted by Minolta as an "intelligent" auto-focus SLR, the 7000i is an automatic camera through and through. Its computer brain is so smart, it does things beyond the ken of human beings, not to mention beyond the capabilities of competing SLRs, including its forebear, the Maxxum 7000.

Exhibit A: Predictive automatic focusing. The 7000i can judge a moving subject's direction and speed of movement and then adjust the focus up to the moment the camera's shutter starts to open. It even figures out how much the subject will move while the instant-return mirror is traveling upward, so the final focusing point corresponds to the subject's "real time" position.

Exhibit B: A wide focusing area. Like the newest generation of point-and-shoot cameras but unlike any competing SLR, the Maxxum 7000i's focusing system "reads" a lozenge-shaped area instead of a central dot or circle. Three sensors combine to cover this field; the lens is focused on the nearest subject found in any of

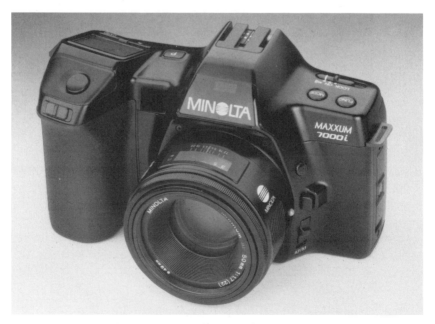

Minolta Maxxum 7000i, a wide-area focusing,
user-programmable update of the original auto-focusing SLR.

the three. Since two of these sensors are configured vertically and one horizontally, the auto-focusing system can distinguish more kinds of subjects than cameras with unidirectional sensors.

Exhibit C: A built-in auto-focusing illuminator. Minolta claims its auto-focusing system is sensitive to EV 0, but when light levels are very low, a red beam shoots out from beside the camera's pentaprism, giving the system a fighting chance to find focus. Although such beams are found in many flash units, having it in the camera makes more sense. With today's high-speed films, photographers should be able to focus in low light whether they're using flash or not.

The 7000i's exposure-metering system is pretty sophisticated, too. It uses meter readings from six areas to arrive at an educated guess of the best exposure—unless you press a button on the camera's back to activate spot measurement. Traditional center-weighted metering is in effect whenever focusing is set to manual. And a second, off-the-film exposure system comes into play when Minolta flash units are attached. The slides and prints I've taken with the camera have been uniformly well exposed.

The exposure system offers a choice of programmed automatic, aperture- or shutter-preferred automatic, and manual modes. No matter which you choose, the aperture and shutter speed are clearly displayed, both within the viewfinder and atop the camera's inch-wide LCD display, which is located above a well-proportioned hand grip. The program mode automatically adjusts exposure according to the focal length of the lens in use.

Then there's the built-in motor advance, which both loads the film and winds it after exposure, at a rate of up to three frames per second. At the end of the roll, the motor automatically rewinds the film, just as point-and-shoot cameras do. Power for the motor and all electronic controls is provided by a six-volt lithium cell that slides into the hand grip. Despite all its various capabilities, the Maxxum 7000i makes operating in alternate modes extremely simple.

I almost forgot to mention: the 7000i has a side compartment that accepts optional computer cards, called Creative Expansion Cards, that let the camera perform such derring-do as soft-focus effects and automatic bracketing. There's even a card that photog-

raphers can program themselves, modifying up to seven camera functions.

Nikon F4

Nikon, having built its vaunted reputation on the quality of its top-of-the-line models, does not bestow the "F" designation lightly. The F4—with an aluminum-alloy body casing, heavy-duty electronics, a rubber-cushioned exterior, and an ability to work with virtually every Nikon lens ever made—seems to fully deserve its moniker. Even the price is professional: almost $2,500 at the present time. That includes a detachable finder and motor drive, but no lens.

What does the F4 have that its predecessor, the F3, does not? Automatic focusing, for one, using the same Nikon AF lenses designed for Nikon's "amateur" SLRs, the N2020, N4004S, and N8008. For another, it has programmed exposure automation. The camera also has a top shutter speed of 1/8000 second, a choice of center-weighted, spot, or multiple-area exposure measurement,

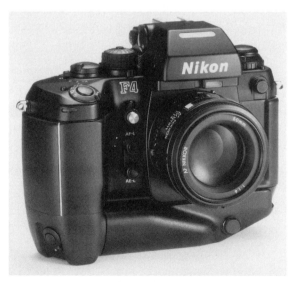

Nikon F4, the latest in Nikon's line of rugged, expensive SLRs for the professional.

motorized film loading and rewind, and the capability of reading DX film-speed codes automatically. That's just for starters.

Want more choices? Besides the three ways to meter (center-weighted, spot, and multipattern), there are five exposure modes (two program modes, aperture-priority auto, shutter-speed-priority auto, and manual). And you can easily switch off the auto focusing and turn the lens's focusing ring by hand, using indicator lights in the finder that Nikon calls an "electronic rangefinder."

Want more information? The finder shows 100 percent of the picture area, and little lighted boxes below and above it tell you what aperture and shutter speed are set, what metering system is in use, and even how many shots you've taken on the roll.

Want more options? The F4 was introduced with four inter-changeable finders, thirteen viewing screens with various dots and hash marks, two battery packs (taking either four or six AA batteries), two data backs, and enough lenses, electronic flash units, remote-control devices, and other accessories to make your head swim. It also sports no fewer than four release buttons—two remote releases and one each for shooting in vertical and horizontal positions.

You also get technical sophistication; one example: the finder that provides multipattern metering contains four position-sensitive mercury switches. These switches tell the camera's electronics whether you're taking a vertical or horizontal shot, and the metering system adjusts its calculations accordingly. And you get ruggedness. The F4's shutter is designed to have a duty cycle of one hundred and fifty thousand shots. Its shutter blades are impregnated with carbon fibers, and its openings are surrounded with moisture-resistant seals. While ordinary cameras will last a lifetime when used by casual photographers, cameras like the F4 are built to withstand ham-handed abuse on a daily basis.

There's one small exception to this "built-to-take-it" design philosophy, though: those AA batteries. Unlike the F3, when the F4 runs out of juice, it's as much a dead duck as the most primitive point-and-shoot camera.

NON-AUTO-FOCUSING SLRS

This used to be the category in which the world's most desirable cameras fit, but no more. Auto-focusing cameras have seized the glamour and the glory, not to mention the marketplace. But a few of us still cling to the remaining survivors of the pre-AF age. For us, and anyone else who's still interested, here are a few intriguing exceptions to current trends.

Nikon FM2, a beloved and reliable relic of the days of mechanical cameras.

Nikon FM2

I own this beast, and I hope Nikon keeps making it. It's basically an all-mechanical camera except for its battery-operated metering system, which uses Nikon's traditional center-weighted system. The shutter moves vertically across the film plane; titanium blades give it a top speed of ¼₀₀₀ second and a flash sync of ¹⁄₂₅₀ second. The only exposure mode is manual.

What else is there to know? To expose, you turn the shutter

speed dial or lens aperture until the plus or minus sign in the finder turns into a zero. To set the film speed, you lift the collar of the shutter-speed dial and turn until the correct number comes up. To focus, you grab the lens and twist the focusing ring. To rewind the film, you turn the rewind crank. Complicated, I know, but it seems like heaven to me. But then I'm a survivor of the Dark Ages.

Olympus OM-88

For those who want the latest SLR technology but can't abide the thought of automatic focusing, there's one odd face in the crowd: the Olympus OM-88. It's a low-cost SLR with "power focus," not auto focus. An integral motor spares you the onerous task of having to turn the lens barrel by hand, although you do have to finger a partly shrouded dial on the rear right-hand side of the camera. The dial sets the motor running in a direction determined by the direction you turn it. The "aero" style of the camera body encourages photographers to use their right thumbs to turn the dial.

Olympus OM-88, neither a manual-focusing nor an auto-focusing camera, but a power-focusing one.

Does electronic power focusing have any advantages over auto focusing? Obviously it's less elaborate and thus less expensive to produce, but its practical appeal may be that it lets grumps like me determine for ourselves where the focus should be. In effect it serves as a kind of bridge between modern-day electronic controls and models for those of us stuck in our old-fashioned ways. On the other hand, the OM-88's focusing system won't help people who have trouble deciding for themselves when the image is in focus. No lights come on or bells chime when focus is achieved; you're on your own.

In other respects the OM-88 is pretty much a standard-issue, automated SLR. Among its features are programmed exposure control, motorized film winding and rewinding, auto DX film-speed setting, and off-the-film flash measurement. To power focus, the camera must be fitted with the same Olympus AF lenses used by the auto-focusing OM-77AF, or else the new PF (power focus) lenses designed specifically for the camera. Otherwise, one has to perform that most dreaded of all photographic acts—turning the focusing ring on the lens by hand.

Leica R6

Traditionalists who can't stand the idea of automated anything may have another day in the sun thanks to E. Leitz, the German camera maker whose original little Leicas started the whole 35-millimeter craze in the 1920s. Leica's most expensive SLR is called the Leica R6. And guess what? It doesn't have automatic focusing, automatic exposure, or even automatic film winding.

Unlike its older sibling, the R5, the Leica R6 doesn't even have an electronic shutter. Instead, it has a metal-bladed model that features gears and springs and all those other quaint mechanical devices from before the computer age. One result is that it will operate within its range of $\frac{1}{1000}$ to 1 second without any batteries.

The R6 does require two silver-oxide "button" batteries, or their lithium equivalent, which power the center-weighted or spot-reading exposure meter. But even with them you have to dial in the recommended exposure using the aperture ring and shutter-

Leica R6, the ultimate fantasy of the traditionalist photo bug.

speed dial. In short, it's practically a new, improved, and much more rugged version of the mechanically minded SLRs of yore. It's also a bit more expensive, at a suggested retail of $3,150 (body only), which may dim its appeal somewhat for traditionalists used to good old-fashioned SLR prices. But nobody ever said that traditional values come cheap, did they?

IN THE CRYSTAL BALL: STILL VIDEO

"Still video camera" is the oxymoronic name given a device that records images on magnetic floppy disks, not conventional silver-coated emulsions. Kodak makes one, as does Canon, Nikon, and Konica, all names associated with traditional photography. Another player is Sony, which has brought us the Walkman, Watchman, and the Discman CD player.

Still-video cameras like Canon's $1,000 Xapshot utilize a 2-by-2-inch floppy disk that looks a great deal like the 3½-inch

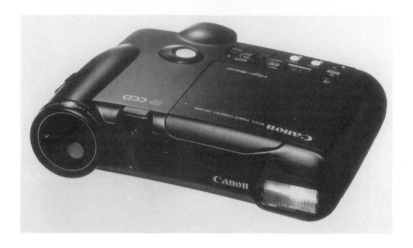

Canon Xapshot, a self-contained still-video camera priced to appeal to the consumer market.

floppies used in Apple Macintosh and IBM System 2 computers. (They aren't interchangeable, natch.) The diminutive disk can hold up to twenty-five high-resolution pictures or fifty lower-resolution ones. To ensure some degree of compatibility for the future, all adhere to a standard agreed on several years ago by virtually all major electronics firms and camera makers.

For now, these cameras are no threat to the conventional photographic industry. Their price tags are still astronomical in comparison with everyday 35-millimeter SLRs, and their applications are as yet quite specialized.

There is, however, a market for video imaging. Businesses that rely on visual presentations or random-access libraries of still imagery represent part of it. So do schools where, for example, interactive learning systems can be programmed via a still-video recorder and a computer. And there is photojournalism. Armed with a portable still-video camera and a transceiver at home base, a news photographer no longer will have to worry about getting to a darkroom, newsroom, or airport. Needless to say, the news business may be facing fundamental changes as a result.

The question is whether these changes will be for better or for worse. On the one hand, there's nothing wrong with having photojournalists enjoy the same luxury writers have, namely of

delivering their articles remotely by modem from laptop computers. On the other hand, the linkage of still-video technology with computer technology—which, in the final analysis, is what the fuss is all about—has its dangers. Already in the precincts of television news there are computerized "paint boxes" that allow colors to be changed, backgrounds to be eliminated, and mustaches to be shaved, all at the whisk of a light pen. Will still video cameras lead to a better picture of the news, or will they be used to manipulate it? It's a question that will be answered soon enough.

INDEX OF FANCY BOLD-FACED TERMS